STAN LEE'S

HOW TO DRAW SUPERHEROES

STAN LEE'S
HOW TO DRAW SUPERHEROES

Watson-Guptill Publications
New York

Co-writers: Danny Fingeroth, Keith Dallas, Robert Sodaro

Contributing artists: David Enebral, Javier Aranda, Ivan Nunes, Vinicius Andrande, Adriano Lucas, Alex Ross, Jack Kirby, John Romita, Jr., Frank Miller, John Byrne, Jim Lee, John Buscema, Paul Renaud, Jim Cheung, Mark Bagley, Ale Garza, Francesco Francavilla, Lucio Parillo, Joe Shuster, Mark Bagley, Will Eisner, Ed Benes, Steve McNiven, Tim Bradstreet, J. Scott Campbell, Phil Hester, Tim Seeley, Joe Jusko, and Chris Caniano.

Produced in association with Dynamite Entertainment

www.dynamite.com

Nick Barrucci, CEO/Publisher
Juan Collado, President/COO
Joe Rybandt, Senior Editor
Josh Johnson, Art Director
Rich Young, Director Business Development
Jason Ullmeyer, Senior Designer
Josh Green, Traffic Coordinator
Chris Caniano, Production Assistant

Library of Congress Cataloging-in-Publication Data
Lee, Stan, 1922- .
Stan Lee's how to draw superheroes.—First edition.
Includes index.
1. Superheroes in art. 2. Comic strip characters. 3. Figure drawing—Technique. I. Title.
NC1764.8.H47L44 2013
741.5'1—dc23 2012030528

ISBN 978-0-8230-9845-3
eISBN 978-0-8230-9846-0

Text and cover design by Ken Crossland
Cover illustration by Ardian Syaf

Special thanks to POW! Entertainment, Inc., Gil Champion, Michael Kelleher, Arthur Lieberman, Luke Lieberman, Mike Kelly, Heritage Auctions, Michael Lovitz, Digikore, Carol Punkus, Dave Altoff, Mike Raicht, Eli Bard, Gregory Pan and Eduardo Alpuente.

Printed in China

10 9 8 7 6 5 4 3

First Edition

TO ALL TRUE BELIEVERS—KEEP ON DREAMING!

CONTENTS

PREFACE

In the summer of 1941, readers were treated to the most unbelievable character of all time. On a hot, sticky day kids plunked down their dimes, bought *USA Comics #1*, and were treated to the chilling exploits of Jack Frost, my very first creation.

Back in those pioneering days, just about anything was accepted without question and, truth to tell, not a lot of thought went into these new heroes and villains. Each comic was 64 pages and there was a voracious need for new material, so I didn't have to think too hard about who he was and what made him a hero. It was, however, excellent on-the-job training.

After two decades of creating heroes, villains, funny animals, funny gals, and tons of monsters I finally got the hang of it and was ready to show what I could really do, when publisher Martin Goodman walked into my office in the spring of 1941 and said something like, "Gimme a superhero team comic."

I have been creating characters for sixty-plus years and have learned a thing or two. I've had to create them for print, for the Web, for sports teams, for television, and for other sources I never imagined back when my so-called career began.

From Jack Frost through my recent Mighty Seven, I have been creating new characters, and learning something with each one. Now, for the first time anywhere, I'm taking all that wisdom and experience and putting it in one volume so that you can learn how it's done.

In the pages that follow, you are going to learn how to create different kinds of heroes and heroines as well as their friends and foes. I'll even spend some time exploring the nature and history of being a hero. In every chapter I talk about what goes into the character, but also give you some nifty tips on how to turn your ideas into pulse-pounding visuals.

Now, in the world you and I inhabit, our heroes tend to be those performing above the expectations of their jobs. A hero can be Chesley "Sully" Sullenberger, the famed pilot who kept his cool when engines failed and managed to land his plane on the Hudson River right by Manhattan. A team of heroes can be like Brooklyn's Engine 201 Ladder 114 who, in 2011, rescued thirty-three people from a burning building without injury.

Acts of heroism and courage surround us, from the veteran learning to use prosthetics rather than sinking into despair to the eight-year-old raising money for charity by going door to door for months. Look around and you will see inspirational sights on a regular basis.

Now, for the purposes of dramatic comic book storytelling, imagine these courageous folk suddenly bestowed with that little something extra.

Your superhero somehow winds up obtaining amazing powers and abilities and doesn't know what to do with them. He can't punch out the office bully because he'd send the "villain" into orbit. She was raised right by loving parents so she doesn't want to commit selfish acts (such as charging for her good deeds). He doesn't want to tell people about his powers because he's afraid of ridicule or worse, the government wanting to "study" him.

What's a superhero to do?

When you can answer that, then you have successfully created your first hero. Stuck for how to do it? That's why you picked up this book, right? Now pay for it and let's begin.

I'll talk about the look of your characters, how to mix and match to form something unique and all yours. This will include supporting characters, vehicles, and even the super-secret lair.

But there's also a dose of imagination that has to come with each creation. I'll show you how I created some good guys and bad guys, and the sorts of inspiration I called upon when it came time to create their new features. You'll find your inspiration from your own experiences, and that includes the life you've lived and the stories you've absorbed since birth. What sorts of themes and characters most appeal to you? How can you channel that into creating something brand new?

I'll admit, it's gotten tougher since thousands upon thousands of characters have been created. Look at Jack Frost, for example. He may have been able to generate super-cold, freezing objects and the like, but he wasn't the only character to do that. Many years later, I reused those powers for Bobby Drake, who joined the X-Men as Iceman. There have been many villains like the Blizzard who have also used cold powers. But, no two creations are identical. Each received their powers or weapons through different means, and their personalities and motivations are vastly different.

It all comes down to how you use those powers and the kinds of stories you want to tell. It has less to do with the specific power and everything to do with how those powers are used.

I once more recruited my own team of heroes to help me compile and share these invaluable lessons. I am thrilled to be working with Danny Fingeroth, Robert Sodaro, Robert Greenberger, and first-time collaborator Keith Dallas. The guys and gals at Dynamite Entertainment make producing each one of these books a pleasure and I tip my proverbial cap in thanks for their efforts.

Now that I've whet your appetite with the promises of wonderment and a dash of learning, you're ready to see the nuts and bolts that go into designing your very own characters. Join me for a history lesson before the real construction begins.

Excelsior!

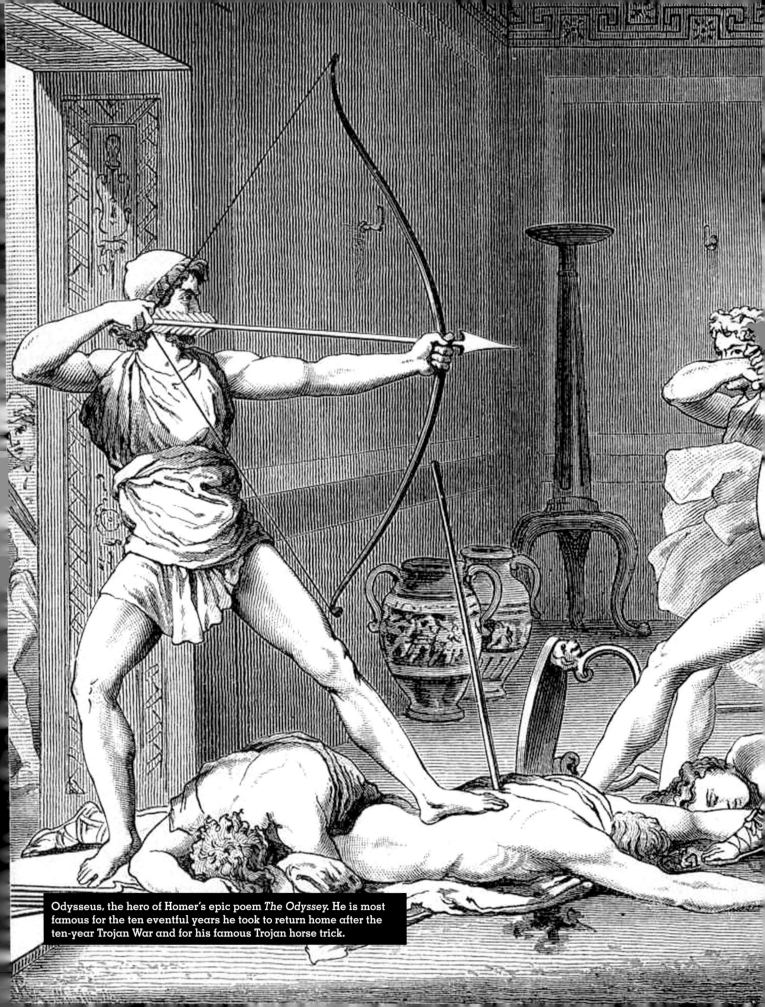

Odysseus, the hero of Homer's epic poem *The Odyssey*. He is most famous for the ten eventful years he took to return home after the ten-year Trojan War and for his famous Trojan horse trick.

THE BIRTH OF THE HERO

Growing up, my reading diet included lots of stories featuring larger-than-life figures. I found them in the books, magazines, and comic strips of my youth. I was constantly surrounded by these heroic figures and their equally ferocious adversaries, but it was awhile before I had a chance to learn where the notion of the hero came from.

The first heroes I studied in school were those of the ancient Greeks. Their literature blended gods, demigods, and mortals in epic poems like *The Iliad* and *The Odyssey*. In fact, the word *hero* is derived from the ancient Greek language. The hero was a demigod, that is, the offspring of a god and a mortal. Cults of worship were built around these figures, and their exploits were woven into the oral history that preceded their written counterparts.

DAWN OF THE HERO

There was another hero who came before those of the ancient Greeks.

The first recognized epic hero is a Sumerian, known as Bilgames in the earliest texts but since accepted as Gilgamesh. Around 2500 BC, he was the fifth king of the land of Uruk, where Iraq now sits. He was said to have reigned for 126 years and to have lived longer than that. He became the main figure in the *Epic of Gilgamesh*, one of the best-known examples of early Mesopotamian literature. In this work, he is described as a demigod, son of the mortal Lugalbanda and the goddess Romat (also known as Ninsun).

THE SPREAD OF HEROIC STORIES

Over time (and we're talking centuries, folks), the word *hero* came to denote individuals who, when confronted with adversity, display the characteristics that lift them above fear. They accept the challenge, consequences be damned, and do the right thing. Self-sacrifice for the greater good of society is a key component of these heroic tales. At first the term *hero* was used to describe those who excelled on the field of battle, but in time its usage was broadened to encompass those who performed extraordinary feats regardless of setting or challenge.

Among the Greek legends is, of course, the best known of the demigods, Heracles (or Hercules to you and me). His name means "the glory of Hera" despite all the stories showing how Hera, queen of the Olympian gods, tormented him. Zeus was his father, and Alcmene, a mortal woman, was his mother.

The Greek poet Homer took the heroic stories that had been told for years and melded them into his

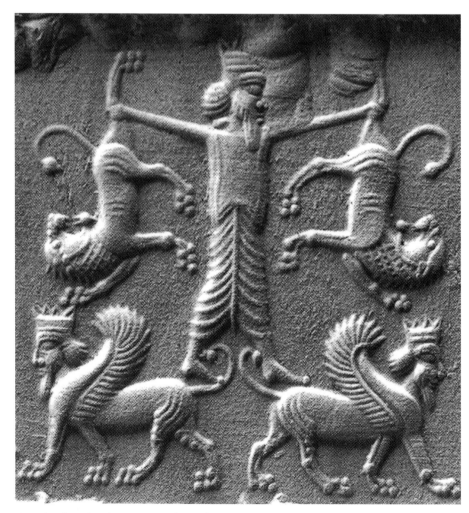

A carving featuring the amazing Gilgamesh. Gilgamesh is a demigod of superhuman strength who built the city walls of Uruk to defend his people from external threats. He is usually described as two thirds god and one third man.

Odyssey, an epic poem where, despite interference from the gods, Odysseus brings his army home from war. His amazing exploits include shooting an arrow through a dozen axes and using his crafty genius to devise the Trojan horse.

Heroes have complicated origin stories, some far more bizarre than being bitten by a radioactive spider. It used to be that a hero's arrival was foretold and some stories involve an attempt to kill the child before birth. Often there are stories told of the infant being spirited away from enemies and raised in secret. It's a universal story: Look at Moses, who was placed in a basket and sent down the Nile River to save him from his people's enemies, only to be found, raised, and returned as the man who led the Jews from Egyptian slavery.

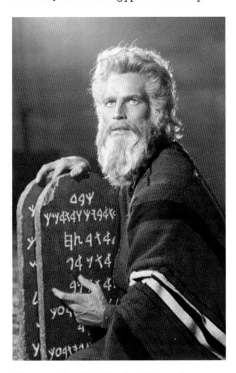

Moses as played by Charlton Heston in the movie The Ten Commandments.

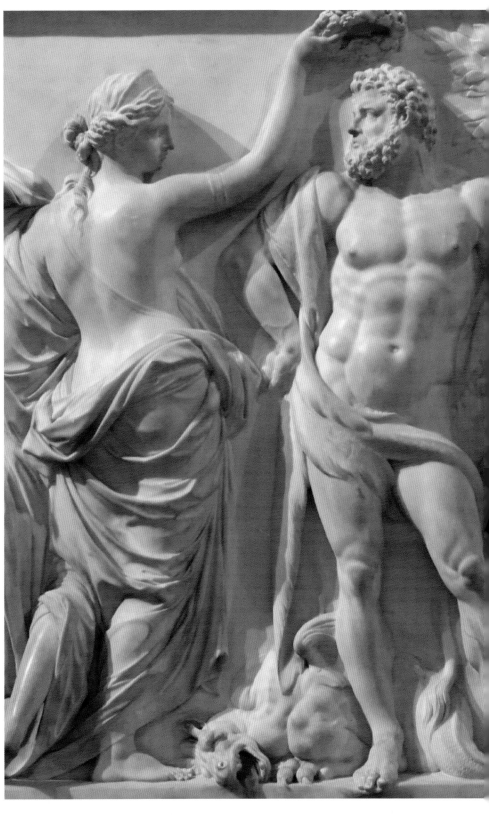

Sculpture of the powerful god Hercules. According to mythology, Hercules was the illegitimate son of Zeus and Alcmene, the wisest and most beautiful of all mortal women. Hera was enraged at Zeus for his infidelity with Alcmene, and even more so that her husband had placed the infant Hercules at her breast as she slept and allowed him to feed, which caused Hercules to be partially immortal, thus allowing him to surpass all mortal men in strength, size, and skill.

THE EVOLUTION OF THE HERO

Let Professor Lee walk you through a little ancient history and show how these story ideas spread. The agrarian cultures of Mesopotamia and Babylonia were among the first to develop high civilizations, deciding that like the stars, man lived according to an eternal mathematical pattern. Their king represented the Sun with the cosmos as the Mother Goddess, giver of life. That changed when the Indo-European Aryans arrived from the north with the Semites swooping in from the Arabian Desert. Each brought with them a male-dominated mythology, with warrior gods representing thunder.

These conquering societies prevailed thanks to the then-superior technology of iron smithing, and over time their mythologies blended with the mythologies of their subjects, reducing the role of the Earth Goddess. From here, the mythologies of Greece, India, and Persia (among others) flourished. The thunder god became, for example, Zeus, who in turn was known as Jupiter after the Romans conquered Greece and stole much of their culture and mythology. The testosterone-fueled new mythology meant the seemingly weaker aspects were out of favor; so Dionysus, god of wine and ecstasy, was demoted to demigod.

Such male-dominated mythology spread across the globe, leading to the earliest biblical stories that reduced the role and influence of women. Eve, who would have been worshipped as a fertility god in earlier cultures, was now easily seduced by a serpent.

Male dominance spread to the Far East and the gods ruled the island nation of Japan. For example, the respected warrior turned emperor Ôjin was the basis for the god Hachiman, a patron of warriors. It was said that when this leader died, he was reborn as a god.

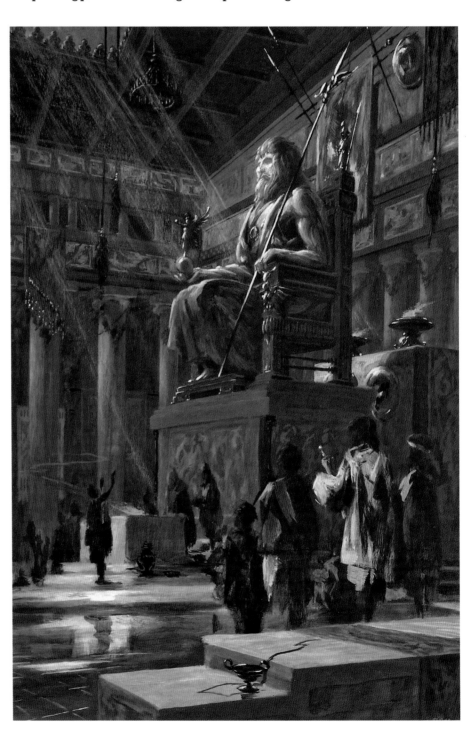

Zeus at Olympia. In the ancient Greek religion, Zeus was the "father of gods and men" who ruled the Olympians of Mount Olympus as a father ruled his family. He was the god of sky and thunder in Greek mythology.

THE FIRST HERO

The first person named Hero was actually a woman, a priestess of Aphrodite, the goddess of love. Hero lived in Hellespont and was loved by the youth Leander. She was bound by a vow of chastity so could not marry her would-be lover, causing Leander to deal with his sorrow by swimming from Asia to Europe, using a lamp in Hero's tower as a directional beacon. When the beacon was extinguished during a storm, he drowned, his body washing ashore just below Hero's town. Driven mad with grief, Hero threw herself into the sea and died.

As you can see, being a hero isn't all accolades and glory.

It wasn't until 1387 that the Greek word *hērōs*, meaning hero and warrior, was anglicized into *hero*.

THE DEATH OF THE HERO

Just like their namesake, heroes often have spectacular falls and deaths. Robin Hood, for example, fell in battle and his last act was to fire an arrow to determine where he should be buried. If you sift through the stories, heroes rarely leave heirs to continue their legacy. The hero's story is typically a singular one.

REAL-LIFE HEROES

In time, ordinary men and women who did remarkable things were considered heroes, often on the field of battle or from the comfort of a throne. In *On Heroes, Hero Worship and the Heroic in History*, written in 1841, Thomas Carlyle named mere mortals including England's Oliver Cromwell and Russia's Frederick the Great as heroes. Using the criteria from that text, Alexander the Great, who unified much of Asia, would also be considered a hero.

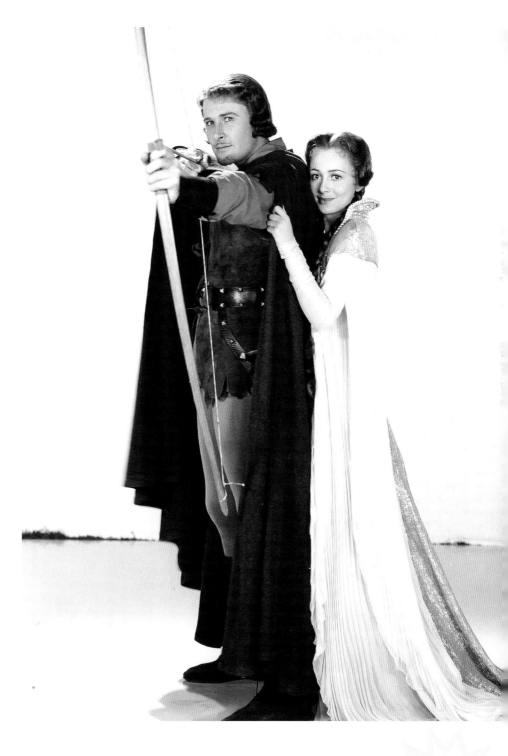

Robin Hood as played by Errol Flynn in the 1938 Warner Bros. film The Adventures of Robin Hood. *Robin Hood was a heroic outlaw in English folklore. A highly skilled archer and swordsman, he is known for robbing from the rich and giving to the poor.*

THE HERO AND HIS JOURNEY

Overall, people prefer heroes who are big and mythic. Around the world, every culture has, at its core, stories about such figures, those who fought gods or stopped natural disasters, who made the homeland safe for everyone. Vladimir Propp analyzed Russian fairy tales and identified that there are essentially eight dramatis personæ in these stories, one being the hero. The amazing Joseph Campbell studied the commonalities of heroes, summarizing his findings in his seminal 1949 work, *The Hero with a Thousand Faces*. To him, these legends all form a monomyth (a term inspired by novelist James Joyce's *Finnegans Wake*) with the key figure following a standard script, which we've come to call the "Hero's Quest."

Campbell once said, "[A] hero is someone who has given his or her life to something bigger than oneself." His study of the mythology, folklore, legends, and fairy tales from around the world demonstrates that time and again everyone needs a hero, although being a hero is never easy.

THE HERO'S GENDER

To illustrate how universal the monomyth had become, Campbell cited as examples the stories of Osiris, Prometheus, the Buddha, Moses, and Jesus Christ.

Where are the women, you ask?

One of the most interesting facts Campbell discovered while writing *The Hero with a Thousand Faces* is that many of the world's myths and heroic tales are from the male point of view. In order for him to find female heroes and a different perspective, he said that he had to turn to fairy tales, which are often told to children by women. But the great heroic tales, however, were told by men and often focused on male heroes.

The Hero's Quest
Broken down into its basic components, the Hero's Quest can be summarized as

- Call to adventure
- Receive supernatural aid
- Meet with the goddess/ atonement with the father
- Return

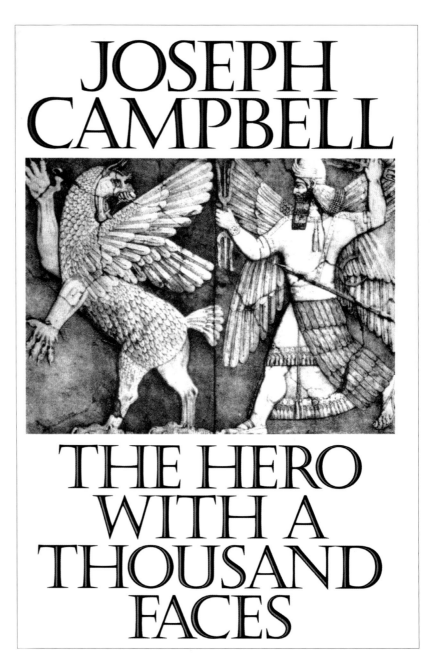

Joseph Campbell's The Hero with a Thousand Faces. *In this book, Campbell discusses his theory of the journey of the archetypal hero found in world mythologies.*

FURTHER EVOLUTION OF THE HERO

Many other heroes arose through the centuries, filling a yearning from the people to be delivered from fear or tyranny. Many of their legends became bits of stories grafted one atop the other until the figure took on mythic proportions.

For example, Arthur was a Briton credited with leading the uprising against the Saxon invaders whose exploits became the stuff of story and song. Within centuries, he became Arthur, King of the Britons, who ruled from Camelot, presiding over the Knights of the Round Table. After a vision, he sent his knights out on the fabled quest for the Holy Grail only to be betrayed by his bastard son and slain on the battlefield. Arthur was carried off to a misty isle where he would remain until England needed him once more.

The stories spread beyond England's borders, and the French embraced them but felt they needed a character of their own and created Lancelot, who was so compelling that Arthur's wife, Guinevere, committed adultery with him. Ever since, the Arthur story has been told and retold, while more practical archaeologists have tried to trace the true origins of Arthur as a historical figure.

As the Arthur story became solidified in the cultures of England and France, nearby Germany was also consolidating its legends, taking the Norse gods and goddesses and unifying their stories. Siegfried, or Sigurd, became one of the most popular figures around 1100 AD and was immortalized seven centuries later in the Ring Cycle of operas from Richard Wagner.

HEROES AROUND THE WORLD

Heroic figures are common throughout the world. Gods were heroes in Egypt, Japan, China, and even on the island of Ireland. The Celtic myths are some of the richest and can be traced through writings that first appeared in the ninth century. These were written versions of the oral stories of ancient Celtic lore that spread across Europe. The *Lebor Gabála Érenn* purported to be a history of the land dating back to before the time of Noah. During a series of battles for control of the land, the Tuatha Dé Danann (Peoples of Goddess Danu) prevailed over the Fomorians, led by Balor of the Evil Eye. When the Gaels arrived, though, they fled underground and evolved into the fairies of Irish legend. The various retellings, though, changed the Tuatha from gods to a shape-shifting magician population, en route to their fairy description.

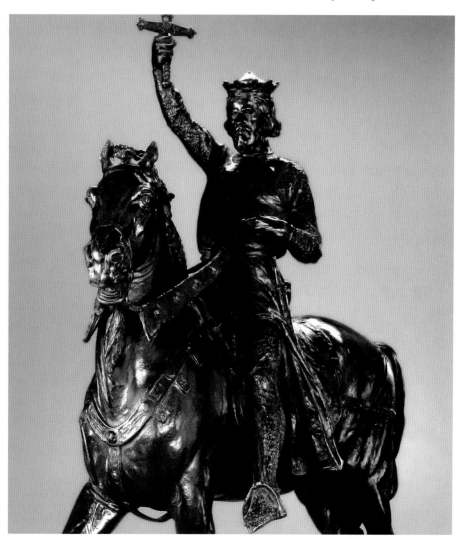

A bronze figure of King Arthur, a legendary British leader who, according to medieval histories and romances, led the defense of Britain against Saxon invaders in the early sixth century.

THE EMERGENCE OF THE AMERICAN PULP HERO

In the nineteenth century cheap printing allowed for the spread of cheap entertainment, including novels featuring recurring heroes, notably Nick Carter, the first American fictional hero—larger-than-life, with enhanced abilities and super-foes.

The success of Carter's stories led to the birth of the pulp magazine, which gave eager readers heroes of every shape and size. Today, we best recall the Shadow and Doc Savage, but in the first few decades of the twentieth century, the newsstands were overflowing with pulps featuring two-fisted pilots, cowboys, soldiers, lawmen, and vigilantes.

In 1912, Edgar Rice Burroughs gave us a new hero with John Carter, a Civil War veteran who found himself mysteriously transported to the world of Barsoom (or Mars to you and me). He followed up that success with Lord John Greystoke, an infant lost in the African jungle and raised as Tarzan. Men like Burroughs gave us new definitions of what it is to be a hero.

Tarzan and John Carter are examples of heroes featured in pulps. Pulp stories are best remembered for being lurid and exploitative and for their sensational cover art.

THE HERO AND THE COMICS

As the pulps matured, so did the comics section of the newspapers, as competing chains added new features with startling regularity.

Characters that started their careers in the pulps made the jump to newspapers, igniting the birth of the heroic adventure comic strip. Buck Rogers and Tarzan led the way on the same day in 1929, followed soon after by the likes of Scorchy Smith, Terry and the Pirates, and the first costumed character to battle evil, Lee Falk's The Phantom.

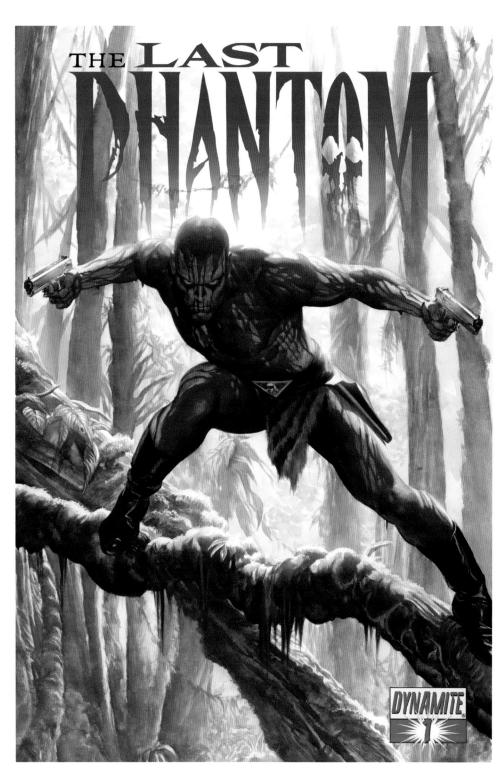

The Phantom is the twenty-first in a line of crime fighters that originated in 1536, when the father of British sailor Christopher Walker was killed during a pirate attack. Swearing an oath to fight evil on the skull of his father's murderer, Walker started the legacy of the Phantom, which would be passed from father to son, leading people to give the mysterious figure nicknames such as "The Ghost Who Walks."

THE DAWN OF THE SUPERHERO

When I was still in high school, the Great Depression gripped America. Society crumbled around the edges and people looked for deliverance. Two young men, steeped in the pulp adventures and the rise in popularity of the comic strip, devised their own savior. He came to Earth from another world, the change in environment granting him powers and abilities beyond that of mortal men.

Despite being rejected by numerous newspaper syndicates, they still held out hope until the feature was used as the lead in a new comic book, *Action Comics*. Superman, as envisioned by Jerry Siegel and Joe Shuster, gave readers of all ages someone to look up to. He was the symbol of hope at a time of hopelessness and his earliest stories made him a surrogate for his creators, righting social wrongs and fighting for truth and justice when few others would.

Not long after, America was on the verge of entering World War II and patriotic figures were required to lead the charge. MLJ, now known as Archie Comics, may have given readers the first such red, white, and blue crime

fighter in the Shield, but it was Joe Simon and Jack Kirby's Captain America who captured the public's imagination. (Having Cap smack Hitler on the first cover was a stroke of genius.)

Since the birth of the superhero, modern mythology has been filled

to bursting on radio, in movies and movie serials, animated cartoons, television series, books, comics, and role-playing games with heroes and heroines. They stand tall, are extremely attractive and muscular, and can dish it as well as take it.

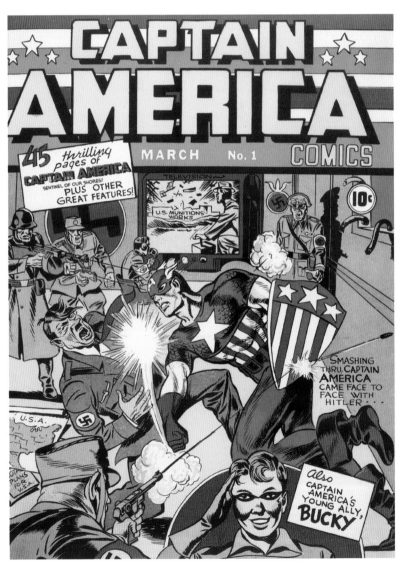

The first appearance of Superman in Action Comics #1. *Arguably the most important comic book of all time!*

Captain America Comics #1 *featured the first appearance of Captain America. I would later revive this character as the leader of the Avengers!*

Through the years, because of the voracious demands of comic book publishing, writers and artists have turned to the ancient myths to find their heroes and villains. A good historian can figure out who has appeared more often: Thor or Hercules (although Herc's usually the one in other media such as the classic *Three Stooges Meet Hercules*).

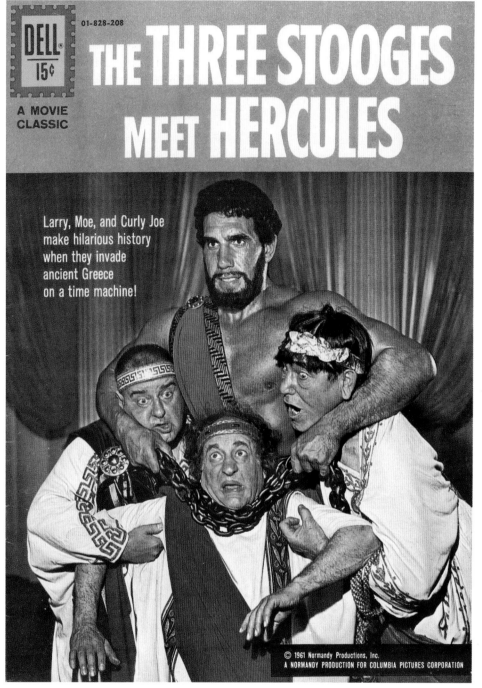

Hercules has appeared in many comics, such as The Three Stooges Meet Hercules. *There have been different interpretations of the character throughout these stories.*

THE HERO IN MEDIA

Comic books and pulp magazines were not the only places where modern mythology and heroes were explored. Joseph Campbell argued that artists, including Thomas Mann, Pablo Picasso, and James Joyce, explored the very same universal truths as those in the ancient myths. However, these artists explored them for a modern-day society.

Our movie heroes are those who come from modest circumstances and never give up, regardless of the odds. John McClane was just another cop when fate placed him in the occupied office building in *Die Hard*, while all Rocky Balboa wanted to do was something that had never been done before: going the distance against Apollo Creed.

Writer/director George Lucas was the first to acknowledge and publicize Campbell's template, stating that *Star Wars* was heavily influenced by Campbell's work. As a result, the 1977 blockbuster is seen as the best modern-day template for the Hero's Quest. An ordinary person (Luke Skywalker) sets out on a journey (to save Princess Leia), learning new skills (lightsaber and the Force), completes his task (destroys the Death Star), and is forever changed (he's the "New Hope").

Others paid plenty of attention to Campbell, including the animators at Walt Disney Studios, who followed the guidelines in the 1980s and 1990s when they produced some of their greatest films including *Aladdin*, *The Lion King*, and *Beauty and the Beast*.

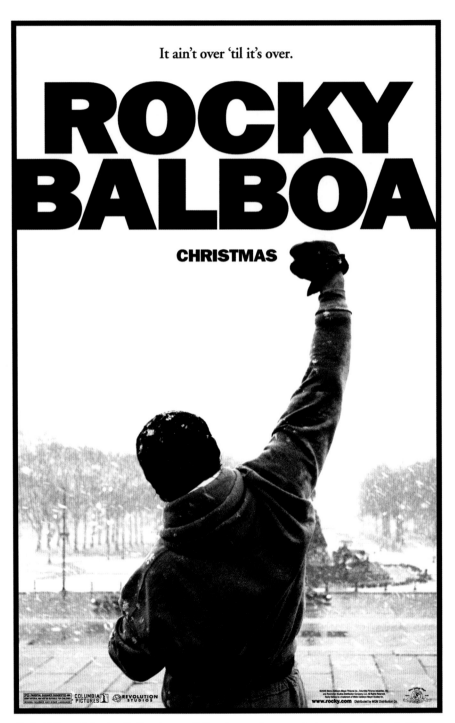

Rocky Balboa (Sylvester Stallone), a small-time boxer who seems to be going nowhere in life, has a chance to become a boxing champion. But if he wins the fight, who is really the winner?

Campbell's works became "must reads" for filmmakers, video game designers, role-playing enthusiasts, and other creators of modern-day stories. Even novelist Richard Adams pays tribute to Campbell's influence with the concept of the monomyth by using extracts from *The Hero with a Thousand Faces* as chapter epigrams in his classic *Watership Down*, which featured, by the way, heroic rabbits.

REAL-LIFE HEROES

Since World War II, acts of heroism have become the stuff of modern legend, recounted in magazine articles or re-created for the Silver Screen. Congress created the Medal of Honor to recognize our military heroes, members of the armed forces who "conspicuously distinguish themselves by gallantry and intrepidity at the risk of their lives above and beyond the call of duty."

Every firefighter, EMT worker, and police officer who responded in New York and Washington, D.C., on September 11, 2001, embodied the definition of hero: putting their lives on the line to save others. The untrained men and women who fought back that day on Flight 93 also lived up to the heroic ideal, sacrificing themselves to save

our capital. On the fifth anniversary of this event, President George W. Bush called them "ordinary citizens rising to the occasion, and responding with extraordinary acts of courage."

Heroism is around us every day. The returning war veteran who now endures countless hours of physical therapy to gain control over a prosthetic limb. The people who rush into the streets to direct traffic during a blackout. Those who fly around the world to deliver goods or services in the wake of a natural disaster. They are your friends and family, rising to answer the call to duty, and in one act, they become heroes.

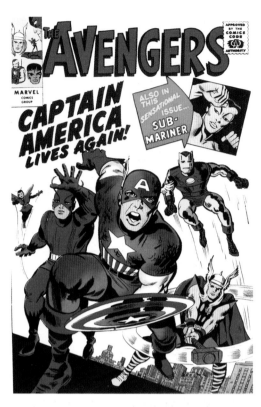

I created these other superheroes to be led by Captain America in the comic book The Avengers. *The team and these heroes were featured in a blockbuster motion picture.*

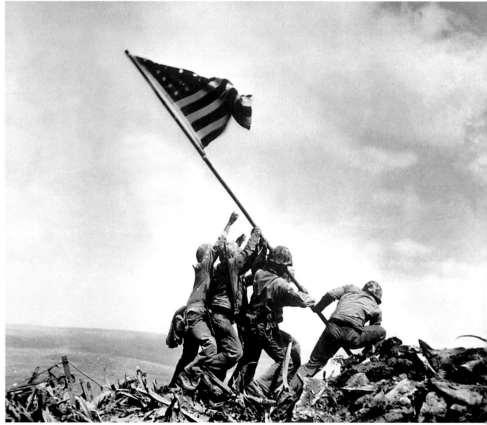

"Raising the Flag on Iwo Jima" is a historic photograph taken on February 23, 1945, by Joe Rosenthal. It depicts five U.S. Marines and a U.S. Navy corpsman raising the flag of the United States atop Mount Suribachi during the Battle of Iwo Jima in World War II.

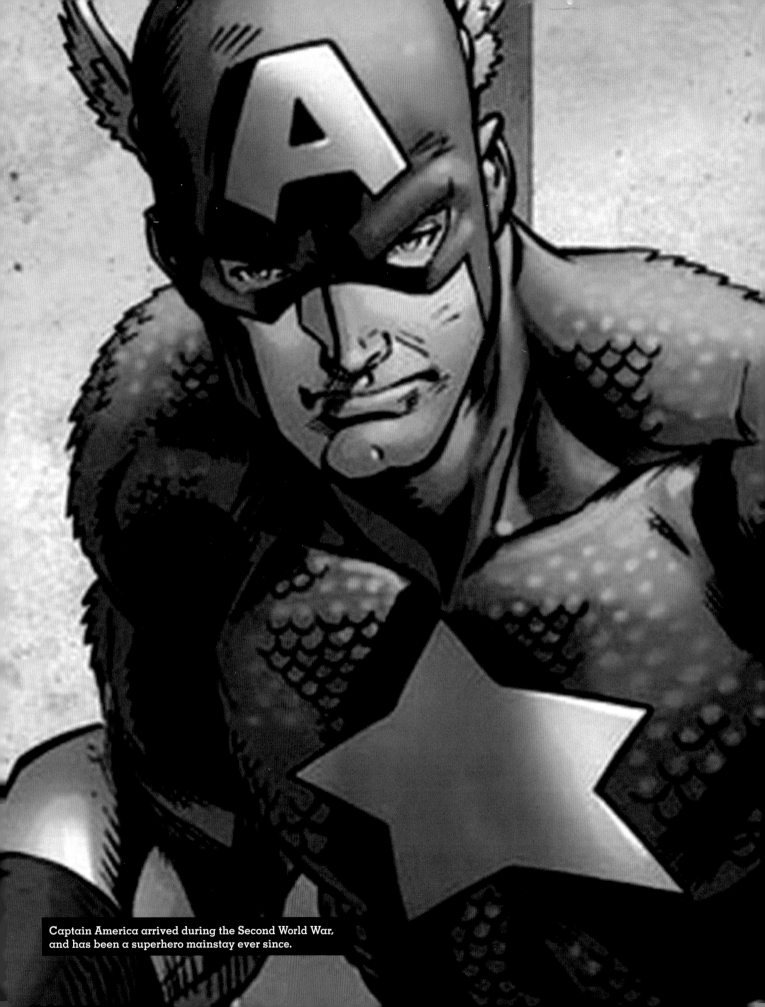

Captain America arrived during the Second World War, and has been a superhero mainstay ever since.

CREATING YOUR HERO

Okay, my creative cronies, the history lesson's over! Now—it's *action* time! Here's where you learn to craft the character and look of a superhero. Whether you want to render an established good guy or you have a brand new one of your own you want to unleash on an unsuspecting world, here's how you go about it . . .

BUILDING BLOCKS

Superheroes inhabit wild and weird worlds. However, they're visually composed of some basic building blocks. In this chapter I'll give you some pointers on how to draw superheroes based on the wild and wonderful world around us—as well as the world that's aching to burst free from your fevered imagination!

If you want the full course on how to draw comics, you'll have to go reread your copy of *Stan Lee's How to Draw Comics* by yours truly (of course). What? You don't have a copy? Well, to demonstrate just how bighearted I can be, I'll still show you the highlights you need to know to draw like a pro. But you might consider getting a copy of *Stan Lee's How to Draw Comics* soon. After all—your competition already has it memorized!

From the Legendary Co-creator of Spider-Man, The Incredible Hulk, Fantastic Four, X-Men, and Iron Man

STAN LEE'S
HOW TO DRAW COMICS

FEATURES THE WORK OF SUPERSTAR ARTISTS, including Jack Kirby; John Romita, Sr.; Neal Adams; Gil Kane; Mike Deodato, Jr.; Frank Cho; and Jonathan Lau

I wrote about creating art for comics in general (as opposed to superheroes in particular) in Stan Lee's How to Draw Comics. *In it, I go into detail on key aspects of drawing for, as my friend comics genius Will Eisner dubbed it, the sequential art medium.*

SHAPES

At the heart of even the most complex drawings are the three basic shapes of the *circle*, the *square*, and the *triangle*.

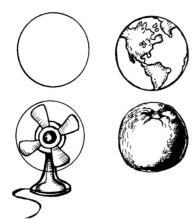

Anyone with a protractor or a quarter can draw a circle. But that's just the beginning. A circle becomes the building block for other objects. The world around us is filled with objects (and even people!) that are visually based on circles—for example, a globe, a fan, or an orange. Look around and you'll see what I mean.

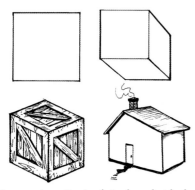

A square is pretty simple to draw, but look what you can do with that basic shape! Used in variations, it becomes any object you can think of. When you adjust measurements and add complex shapes, you can turn a square into a cube, a wooden crate, or a house.

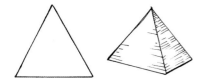

A triangle seen straight on is a simple three-sided shape. But using perspective, you can create a pyramid that has four sides.

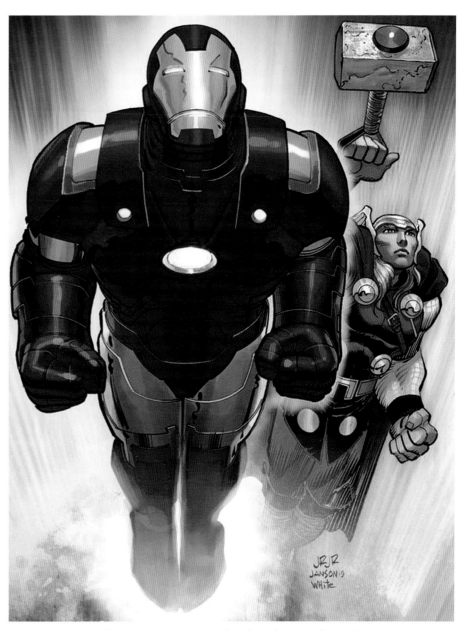

Here's Iron Man (and his Avengers teammate, Thor) from the cover of Marvel's 2009 Free Comic Book Day comic, as explosively drawn by John Romita Jr. and inked by Klaus Janson. How many circles, squares, and triangles can you find in the art?

COMBINING SHAPES—THE FOUNDATION

Your job as an artist drawing a human—or superhuman—is to use shapes like circles, squares, and triangles to build the figure. Remember that you're trying to give the illusion of depth to these shapes and their combinations. So the circle becomes a sphere, the square becomes a cube, and the triangle becomes a pyramid. And an oval—which is really a stretched out circle—can and does become the basis for the human head and face.

I know what you're thinking, "Ol' Smiley has finally lost his marbles! How can a few simple shapes become Iron Man?" Just take a look at the example above.

CREATING A HEROIC HERO

"Heroic hero"? Isn't that redundant (not to mention repetitive)? But think about it—how many times do you see drawings of superheroes who don't seem all that heroic? There are keys to making your heroes markedly heroic, which is easy as a concept, but challenging to execute. As with many things in the arts, one man's heroic is the next man's lackadaisical. But what follows are some basic characteristics and principles that almost all heroes possess.

THE PHYSICAL BUILD

Most superheroes are 9½ heads tall (approximately 6' 2"). Artists use the "heads" measurement as a unit of comparison. That way, no matter how small or large the figure they're drawing, they always know the proportion of the character's body as compared to his head.

Below is a shot of what a basic superhero's physical build looks like. The figure's done in as straightforward a manner as possible so you can see the basics. The character reminds us of someone at the peak of physical perfection, although, in reality, a guy who looked like this would be thought of as having a small head. But for classic superhero proportions, he's just right.

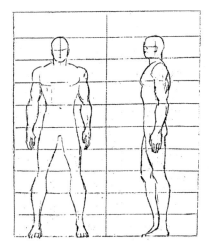

No, this isn't the vile and villainous Adaptoid. My longtime creative partner John Romita Sr. created this 9-heads-high grid as a figure base for artists to invent their own superhero (and super-villain) costumes. It's a powerful, heroic shape, in proper superhero proportion, ready and waiting for you to draw costume details, musculature, and facial features on it. But don't draw on this copy! You'll want to make many copies for yourself to practice on. You might even want to enlarge it to make working with it easier.

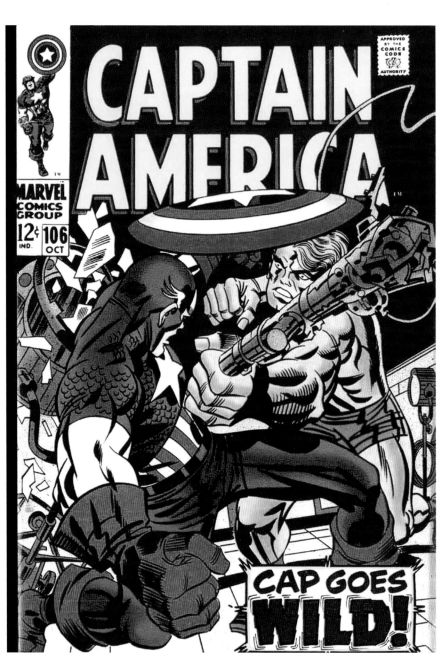

Drawings of superheroes don't get more dynamic than my old partner Jack Kirby's rendition of Captain America! How about this classic Kirby cover for sheer dynamic heroism? Everything is shown from an extreme angle and perspective, and the action is about to explode.

FACIAL FEATURES

What is it that makes the faces of the people you know different from one another? It's the shape of their heads (here our pals circle, square, and triangle come into play, again) and the person's features. Even with a character like Spider-Man, whose mask covers his entire face, you still have to imagine and account for the facial features underneath the mask when drawing him.

For superheroes whose faces are partially or completely exposed, you want, in general, to draw features that, when at rest, are what people would generally refer to as handsome, although that term is certainly subjective and depends on what you and your audience think of as handsome or attractive. In terms of classic superheroes, you generally can't go wrong if you think of whoever the male movie stars of the day are as the basis for your handsome superhero's features.

Side view of our hero! Notice how bold the physical build is with these lush colors.

BASIC HEIGHT PROPORTIONS

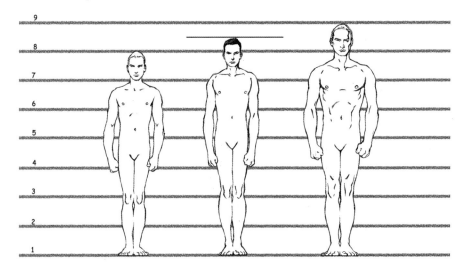

From left to right, this chart shows normal, ideal, and heroic proportions.

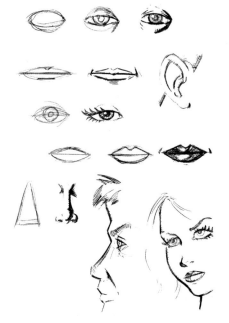

Here are some approaches to, and angles for, various versions of mouths, ears, noses, and eyes. Practice drawing them—but don't imitate from comics. Use photos or actual people, or study your own features in a mirror to understand how these facial elements are constructed.

THE SECRET INGREDIENT

Let's face it, the most perfectly proportioned superhero wouldn't last a second against a supervillain—or a day in the pop culture marketplace—if he didn't have *attitude!*

What do I mean by "attitude"? Well, it has two meanings. In general, it means the way people present themselves to the world. You see it every day. Someone comes into a room and you get an immediate impression. One person is bold, another shy. One is nervous, another confident. Someone is funny, another guy wouldn't know a good joke if it walked up and bit him on the behind.

Of course, the more colloquial meaning of attitude is slang for "assertiveness and confidence." For a hero, this means he may come across as self-assured and even hostile when confronting bad guys—but not when he's dealing with allies or with those he's protecting! For villains (as I'll show you later in this book), attitude is beyond just confidence—it's arrogance and contempt.

But good guys have—indeed they need—attitude. They're going up against some rough customers. They need to show that they're equal to the task. And, let's face it, some heroes have a little bit of the "bad boy" in them. That's part of what makes their stories so fun to read! Your superhero should be just that: super *and* heroic—always conveying an attitude of confidence and mastery, but not (unless it's a part of their character) arrogance.

So how do you convey attitude in a way that says "hero" but not "scary"? "Strong" but not "threatening" (unless the hero you're working on is more in the "tough guy" category)? One way is through *gestures.*

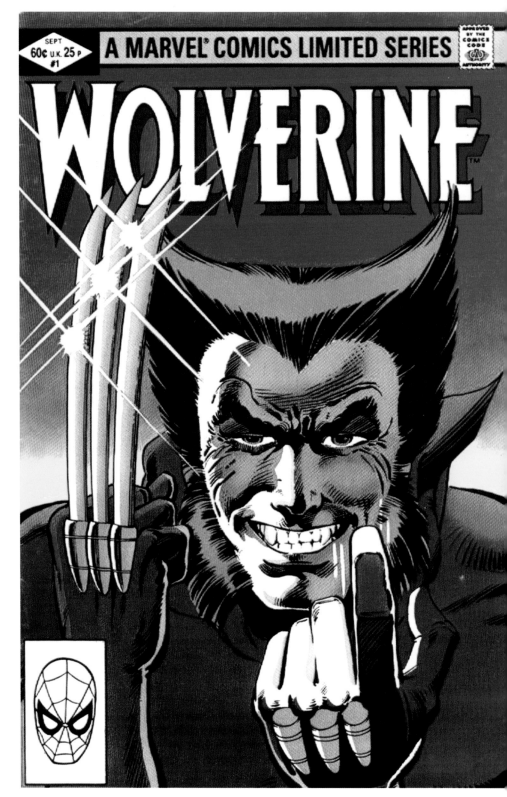

The captivating cover to the first issue of the Wolverine *limited series, penciled by Frank Miller and inked by Josef Rubinstein, should be in the dictionary as a visual definition of the word* attitude.

GESTURES

Much of a character's attitude is conveyed through *gestures* and body language. Your superhero doesn't approach a scared little girl the way he does an armed-to-the-teeth terrorist. He (and you, the artist) will adjust his attitude to be appropriate for the situation at hand.

Gestures become more delicate and gentle for the hero's approach to the little girl—like a father protecting a daughter. The terrorist doesn't get that kind of treatment from him. He gets the full "chest-heaved-out, sinews tensed, clenched fists, gritted teeth" attitude of the hero who's here to kick butt and take names!

To draw these extremes of attitude—and all the shades in between—you've got to imagine yourself as the hero in each situation. It helps to do this in front of a mirror or with live models. See what a change in their or your physical positioning and tension does to the attitude of the character you're drawing. A lot of attitude comes from gestures a character makes. These range from big, broad, bold gestures to small, timid, hesitant ones.

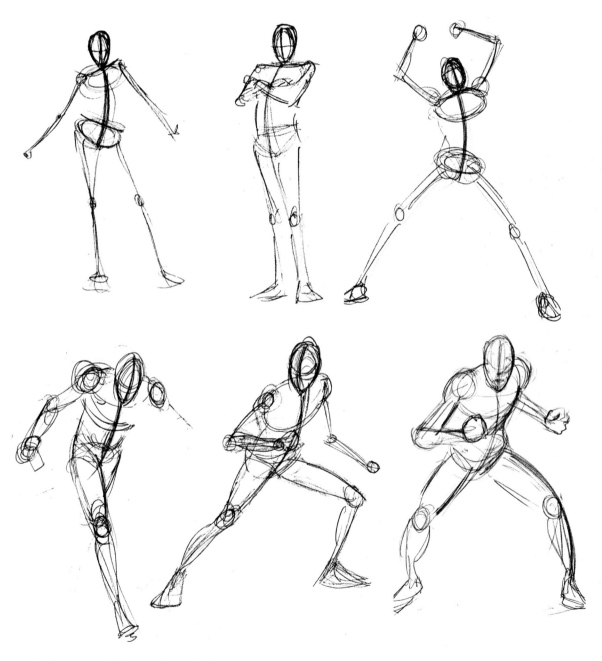

Gesture drawings are a quick way to determine the poses you want your characters to show.

COSTUMES

Even the most dramatically drawn character isn't a superhero without some kind of costume to wear.

Most superheroes have a distinctive costume that is identifiable only with them (or, in certain cases, with their team—like the Fantastic Four—or an organization—such as the superspy agents of SHIELD). Even those superheroes that don't have skintight uniforms with insignias on the front have some kind of "superhero look"—whether a clothing style, like a leather jacket or a cowboy hat, or physical characteristics that make them distinctive. Think of Wolverine's trademark sideburns and the hair combed upward on the sides. In or out of costume, we know it's Logan—especially once he *snikts* those adamantium claws out!

A superhero's costume should reflect the character's powers and *purpose*, even if only the readers (as opposed to the other characters in the story) will get the "insider" meaning. Sure, Batman dresses like a bat, Spider-Man's costume is arachnid-themed

The Phantom (created by Lee Falk in 1936) is arguably one of the first "costumed adventurers," or superheroes. He certainly has the distinctive uniform that would become the hallmark of the superhero.

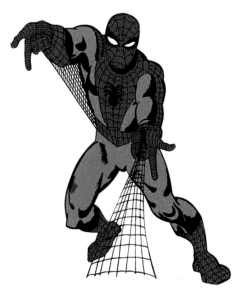

Even if you didn't know his name, this Steve Ditko drawing would tell you pretty quickly, from one look at the costume, that this fella has something to do with spiders, man!

(on the front and the back!), and the Fantastic Four have big "4"s on their chests. Those are all pretty obvious.

But Iron Man has a large ray blaster/floodlight in his armor's chest. You'd think people would constantly be asking him, "Hey. Why don't you call yourself 'Chest-Beam-Guy'?" But they don't, because the reader knows that device on his chest isn't a symbol of what the character is all about. And the *reader* trumps the supporting characters every time.

Superhero costumes are usually skintight, and they are often brightly colored. Darker hues are traditionally left for the supervillains. Capes are optional, as are decorative or utilitarian doohickeys and headgear of whatever sort. The more the costume reflects some aspect of the hero and his origin and overall mission, the better. There's a reason the Punisher has a skull on his shirt and not a fluffy bunny!

A cute bunny insignia is hardly likely to strike fear into the hearts of evildoers (at least evildoers who aren't carrots)!

No Costume? No Way!

Think your superhero doesn't need a costume? As I learned the hard way, fans have come to expect that a superhero will have a costume. The Fantastic Four didn't have costumes for the first two issues of their series. Jack Kirby and I wanted to break away from what, even fifty years ago, was something of a cliché. But the mountain of letters we got from fans told us they loved everything about our kooky quartet—except for the fact they didn't have costumes.

A deluge of letters from our readers told us in no uncertain terms that the Fantastic Four had to have costumes, and in issue #3, we gave the team its familiar blue outfits. The Thing may not technically be wearing one, but in his case, his rocky, orange skin serves as the equivalent of a costume, since it makes him instantly recognizable.

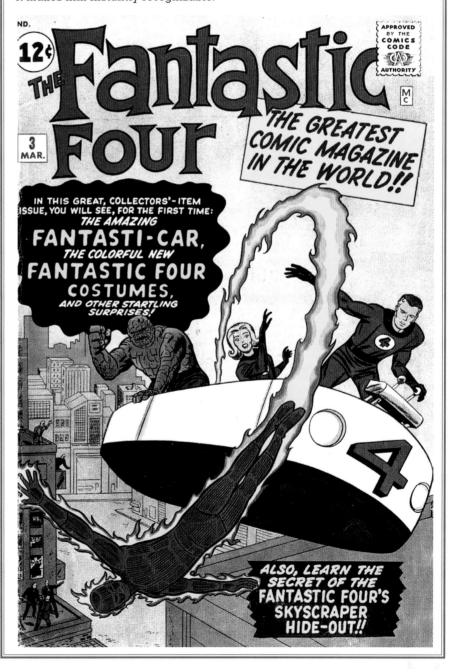

POWERS

"Well," I can hear you thinking (you sure think loud!), "it's about time we got to powers. After all, this is a book about superheroes."

To begin with, superheroes have superpowers—except those who *don't*.

I'll pause a moment while you let that seemingly self-contradicting statement sink in. But you know what I'm talking about: Lots of characters considered "superheroes" are no more super than you or I.

Those superheroes that don't have powers usually have some kind of edge or weapon or gimmick that gives them capabilities beyond that of regular people. So it's pretty clear why they'd be considered "super."

There are even some superheroes who have neither powers nor weapons nor gimmicks, but are just really good at something, have a nifty costume, and have some kind of "coolness" factor. They, too, get lumped in with "superheroes."

And it turns out that sometimes just hanging around with superheroes is enough for a character to be considered one, provided he has a distinctive costume, can do something special that most people can't, and has an attitude or belief that he is, indeed, a superhero.

It's kind of like those "real life superheroes" who have popped up in recent years, in the news or on my own *Who Wants to Be a Superhero?* TV show. The superhero club can be a pretty big tent. The line may be drawn at ear-wiggling, which didn't qualify the Fantastic Four's letter carrier, Willie Lumpkin, to become a member of the team. (And bonus points to anyone who can tell me what dashingly handsome thespian played Willie in the first FF movie? Here's a hint: His initials are S.L.!)

You may not know this, but there are entire books devoted to defining what a superhero is or isn't, and there are ongoing debates in fan and academic circles about what defines a superhero. My feeling is, I know a superhero when I see (or create) one, and I bet most of my readers will, too.

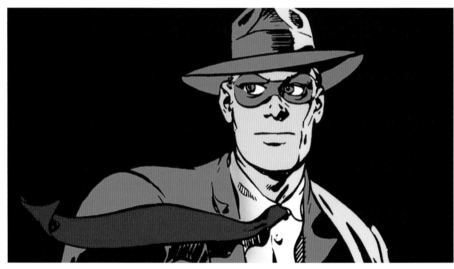

Will Eisner's classic character, the Spirit, has no superpowers. A tiny mask and a pair of gloves added to a business suit and fedora seem to be enough to constitute a costume and for the character to be considered a superhero. Ironic, since Will didn't really care much for superheroes.

Yours truly with some eager contestants from my hit Syfy show, Who Wants to Be a Superhero? *Apparently, a lot of people do.*

Peter Coogan takes a thoughtful look at costumed super-types in Superhero: The Secret Origin of a Genre. *Super-scribe Denny O'Neil himself provided the introduction.*

YOUR PERSONAL STAMP

In general, it's preferable to give your superhero powers or accoutrements that make him different from the average Joe. Now, here's where a lot of creators get stalled, making themselves crazy trying to come up with something that's never been done before. After seventy-five years of superheroes, not to mention thousands of years of myths and storytelling, just about every power has been thought of and used.

That shouldn't stop you from creating your own superheroes. Why not? Because what's important is *your* take on a power.

If a character shoots force-beams from his palms, do the beams have a look only *you* could give them? Does the psychological effect of being a guy who shoots beams from his hands impact his life in some way? Do the beams that shoot from his hands make him a menace? Does he get worried every time he shakes someone's hand or caresses his girlfriend? If

he scratches his nose wrong, will he disintegrate his own head?

See what I mean? The key is putting your own personal stamp on the character, and this includes his powers. So my advice is to pick a power or two, ideally powers that will resonate with the character's personality and origins and/or that are somehow topical. (Have you ever noticed that we used a lot of radiation-based origins in the 1960s, when everybody was anxious about radiation?)

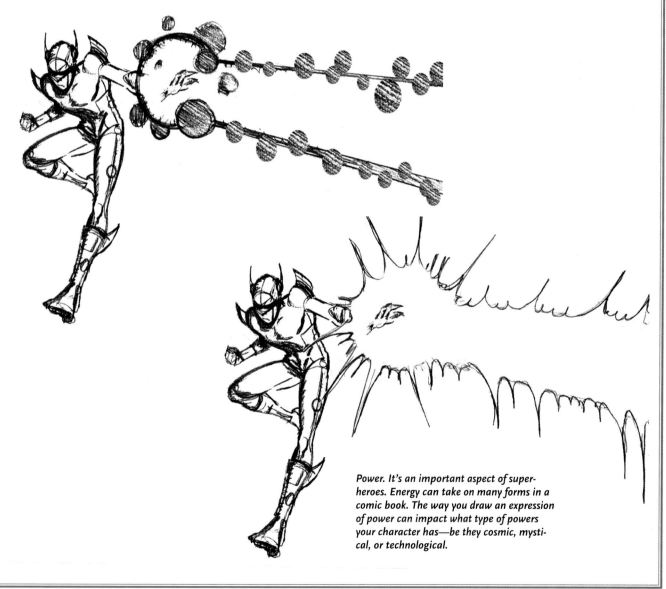

Power. It's an important aspect of super-heroes. Energy can take on many forms in a comic book. The way you draw an expression of power can impact what type of powers your character has—be they cosmic, mystical, or technological.

RULES AND REGULATIONS

Once you establish a superhero's powers, then you should also establish the *rules* for how those powers work. When he started out, Thor had to keep in physical contact with his hammer or else, after sixty seconds, he'd change back to his mortal identity of Don Blake, leaving him vulnerable to his adversaries and revealing his secret identity. That put a metaphorical ticking clock into his stories, and a writer could easily establish tension if a villain managed to get between Thor and his

uru mallet. Iron Man needed to have a ready source of power, or his armor—and his heart—would cease functioning. Spider-Man's webbing dissolves after an hour. Superman is vulnerable to Kryptonite and magic. (And I hear that Achilles guy in the Greek myths had some kind of foot problems.)

Play fair with your readers: Keep the rules about your character's powers simple and straightforward, and establish them early in the story you're telling.

The Heroic Flaw
The best heroes are flawed, not perfect, ones. Superman's problem was his home world, now radioactive chunks that can kill him, while Tony Stark has to confront his alcoholism and rise above it every day as Iron Man.

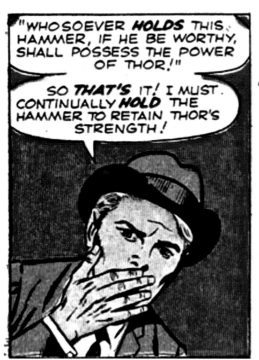 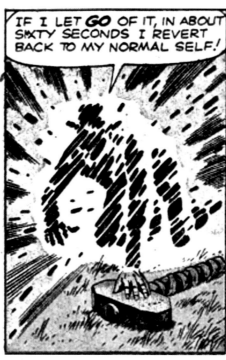 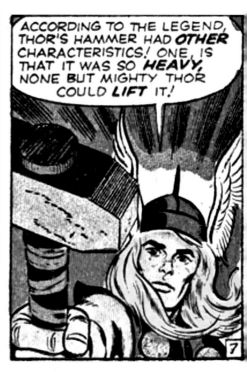

In Thor's first appearance, as written by me and Larry Lieber and drawn by Jack Kirby and Joe Sinnott, Don Blake learns the rules of his Thor powers—including that he has to stay in physical contact with his uru hammer to keep being the thunder god. These rules would change many times over the years of Thor's existence in the Marvel Universe.

MAKING MEMORABLE SUPERHEROES

Like movies and theater, comics are a combination—a hybrid—of many different skills, crafts, and arts. So when you're trying to come up with the look of your superhero, there are many different elements to consider. Is the hero intended to be someone who will *strike fear* into the hearts of his enemies? Or is he someone who is more about *inspiring* the people he's sworn to protect than about seeming fearsome? Who is the intended audience for the character? Men? Women? Children? Teenagers? Everybody?

Why do some superheroes' images resonate through the entire culture? Everybody has some idea in their mind of what Spider-Man, Iron Man, or Captain America look like and who they are. But there are other superheroes, with no less creativity put into them, who are only known by a few devoted fans.

For instance, despite a costume that takes a long time to draw (all those web lines), Spider-Man has been popular with comics readers—and everybody else in the whole world—for some fifty years now. (And drawing all those web lines has caused many a penciler and inker to nearly miss a deadline.) On the other hand, a Marvel character with an equally or even more detailed costume, the Jack of Hearts, never caught on in a

big way with the comics-reading public. (Comics artists the world over breathed a collective sigh of relief about that.)

SUPERHERO TYPES: UNIQUE BUT RECOGNIZABLE

For the moment, let's forget about the superheroes who don't fully adhere to the archetype (twenty-dollar word there)—offbeat characters like the Thing, who's as much monster as hero, and Spider-Man, who's slender, wiry, and agile and moves like a combination

gymnast/dancer/acrobat—one could even say, like a *spider!* Let's focus on the more traditional superhero types that you'll most likely want to, or be assigned to, create and draw.

Each superhero should, of course, be unique, while still staying within the bounds of the genre. Through the years, there have been essentially two archetypes (or just "types") of superheroes who have established the template—the model—on which scores of other heroes have been built.

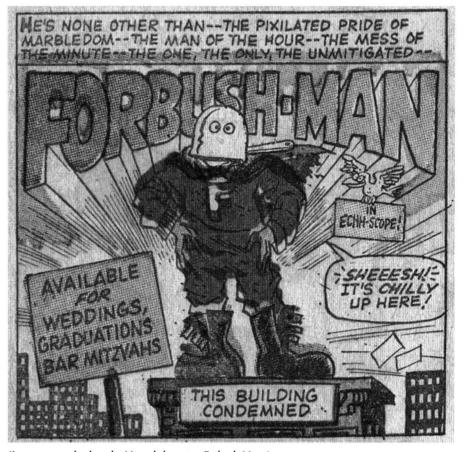

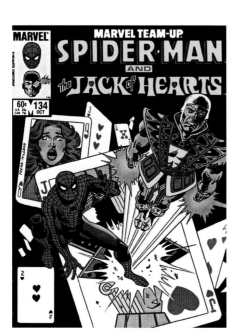

Spider-Man and the Jack of Hearts, here penciled by Ron Frenz and inked by Al Milgrom. The superheroes joined forces in Marvel Team-Up #134. *Both have distinctive costumes filled with details that take a lot of time to draw.*

I'm not sure why, but the Marvel character Forbush-Man (as rendered here by Jack Kirby and Tom Sutton) never caught on the way Spider-Man, Iron Man, and the Hulk did. Maybe ol' Forby was just too serious and brooding . . . ?

THE TWO SUPERHERO ARCHETYPES

The two superhero archetypes—or "types" for short—are Superman (the S-Type) and Batman (the B-Type). Much as folks the world over love Spider-Man, Captain America, the Fantastic Four, and the other magnificent Marvel characters, Supes and Bats established the visual vocabulary for superheroes just by being there first.

As the discussion continues throughout the book, I'll refer to S-Type (in the Superman mode) and B-Type (in the Batman mode) superheroes. And now—onward!

One other thing I want to point out is that S-Type and B-Type heroes are, in terms of body types, the exact same guy. They were both modeled on the movie stars of the 1930s, especially Clark Gable, as well as on circus and vaudeville strongmen and aerialists, boxers like Jack Dempsey, and other popular figures of the era.

If that's true, then what differentiates the two types of heroes? A lot, as it turns out …

 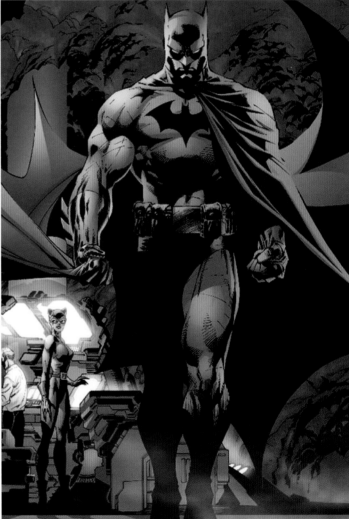

In these examples, you can see John Byrne's Superman (inked by Dick Giordano) and Jim Lee's Batman (inked by Scott Williams).

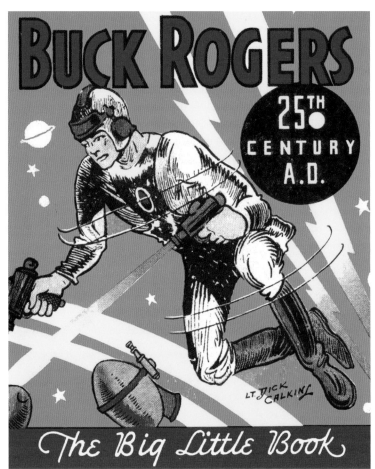

The S-Type "boy scout" superhero was inspired by a variety of predecessors, including the classic sci-fi hero Buck Rogers, drawn here by the great Dick Calkins. I used to love reading Rogers's adventures when I was a kid.

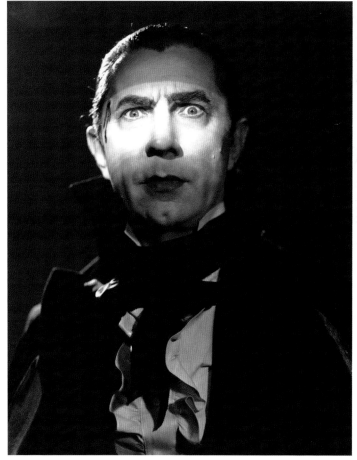

Bela Lugosi in the 1931 Dracula, directed by Tod Browning. Bram Stoker's vampire character was one of the visual inspirations for Batman and for any B-Type superhero—one whose MO is to strike fear into the hearts of his enemies. I know ol' Bela sure struck fear into my heart!

YOUR PERSONAL STAMP II

While the style these days is to draw "costumed adventurers" as if they spent all their spare time pumping iron, your own taste, or that of your editor and publisher, may lead you to draw a sleeker, less-pumped-up figure for your superhero. But with both the S-Type and the B-Type, their attitude and intentions—their "vibe," as the kids used to say—remain consistent with the templates set by the originals. (And, of course, these are generalizations, to which there are always exceptions.)

Since each superhero—S- or B-Type—is different, a good deal of how you draw yours will depend on *the reasons he has chosen to become a superhero* and his particular take on *why* he's doing what he's doing, even if it's a variant on the classic Spider-Man "with great power there must also come great responsibility" theme.

No two heroes interpret that responsibility in the exact same way. So if your hero suffered a great loss and is trying to make up for it, his body language may be slightly different from that of someone who found a big pile of money and decided to try to help the world, or a third guy who was in some kind of freak scientific accident and decided to devote himself to stopping people who would abuse science for evil ends.

Your superhero can have a sense of humor or always be deathly serious. He can think of himself as God's gift to women, or he can be married and settled down. All the different factors you give your character will make you think differently about him and will lead you to express the subtleties of who he is in his figure as you draw him.

Early superheroes were modeled on heroic movie stars of the 1930s, including Clark Gable (left). I can see the resemblance.

THE S-TYPE: CAPTAIN TITAN

A typical S-Type hero, Captain Titan is there to help and protect you. That's indicated most obviously by the fact that he's dressed in bright, friendly primary colors. His face is uncovered and his eyes are visible. If the eyes are the "windows to the soul," then you can know everything about Captain Titan because he looks you right in the eye—although not so intensely as to scare you, unless you're a supervillain he's hunting down. In that case, those piercing, sincere eyes can make you surrender by their sheer intensity. What you see is what you get. He says what he means and means what he says.

In terms of body language, Captain Titan stands erect, strides with determination, and moves smoothly and gracefully, with no furtive movements. He's like a presidential candidate. He wants you to feel you can trust what he says and does. Captain Titan would walk an old woman across the street, fly up to a tree to rescue a stray kitty, fly into space to correct the course of a satellite, and, if need be, throw his body between you and a hail of bullets. The fact that the bullets can't hurt him is beside the point. Captain Titan is who we all think we want to be. He's the friendly cop on the beat, the teacher who brings out your unrealized potential, the best friend we all wish we had.

PENCIL TO PAPER

On a practical level, you draw Captain Titan in bold, dramatic poses—legs spread to plant him firmly on the ground, fists clenched, and teeth gritted. There are very few shadows on his form. Like a classical Greek sculpture, Captain Titan is revealed for all the world to see. He fights like a boxer—no fancy karate moves for him (unless he's a martial-arts-based superhero like Iron Fist—see,

there's always an exception)—and is drawn from a straight-on perspective. His anatomy is like that of a well-developed athlete, one who's as muscular as regular weight training will allow him to be. Of course, your own style and preference (or the preference of your editor or publisher) may lead you to vary from these exact specifications, but for superheroes with superpowers, this is the basic arena in which you'll be playing.

Now that I've taken you through the theory and the thought behind drawing an S-Type superhero, like Captain Titan, it's time for you to actually do it. Using the sketches on pages 41–43 as inspiration, draw the following five "stages" for the character. Once you've done that, you'll have a final concept drawing. I'll step outside and check my Twitter feed while you're doing that.

Captain Titan should be standing straight at attention, his large chest poised forward in a confident, but not intimidating, way.

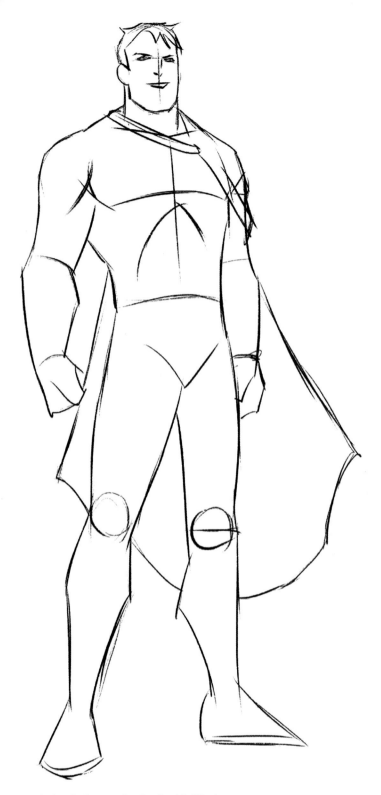

The head, chest, and waist should all be in alignment. The chest and abdominal muscles should be well-defined.

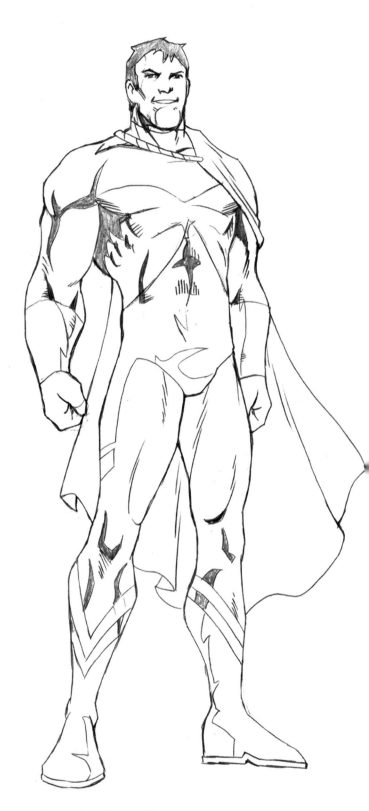

Although the uniform is skintight, there should still be folds and shadows in the material to indicate that he is indeed wearing clothing.

Captain Titan

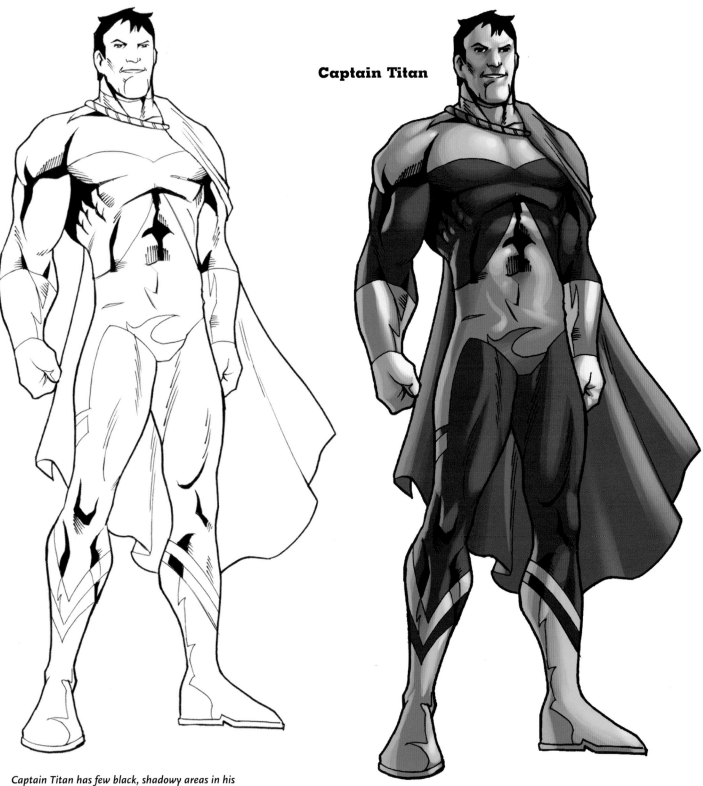

Captain Titan has few black, shadowy areas in his overall look. He's not dark and mysterious. He's friendly and inviting, in a strong, assured way.

CAPTAIN TITAN

Alter Ego: Carter Cross Jr.
Attributes: Possesses super strength, laser vision, heat breath, and super smarts.

THE B-TYPE: SEARCHLIGHT

Searchlight is a typical B-Type super-hero—well, he isn't even super! He's built (and constructed) like Captain Titan, but he doesn't have any powers that are "beyond those of mortal men." Bullets can and do hurt him. He's considered a superhero for a variety of reasons, but largely because he wears a costume and has adventures, and the term "costumed adventurer," while accurate, isn't as direct and impactful as "superhero."

So Searchlight isn't as simple as a guy who can juggle artillery shells and squeeze lumps of coal into diamonds. A B-Type has to have a gimmick or three. Iron Man has his armor. Without it, he's a regular guy, and one with a bum ticker at that. Hawkeye has lots of cool arrows. You get the idea.

But even with gimmicks and gad-gets galore, Searchlight is still a normal person, except perhaps for the fact that he actually uses his gym membership. (Or he would, if he didn't have his own state-of-the-art gym in his own private ultra-teched-out hideout.)

What I'm trying to say in my long-winded way (and I'm not even getting paid by the word!) is that Searchlight presents himself to the world 180 degrees from the way Captain Titan does. Like a classic vampire, Search-light stays close to the shadows. He uses his cape to camouflage himself and intimidate you. His eyes are cov-ered so you can never see what he's thinking. He crouches dramatically so you get the impression he could leap in any direction—maybe even at your throat! He looks like he will do what-ever he has to in order to get done what needs to be done.

Searchlight often wants you to think he's crazy. Which he just might be! Why? Because a crazy person is unpredict-able, and if you're a regular guy, even a regular guy with a tricked-out car and a belt full of miniaturized gadgets, then you're going to be outmatched when you take on superhuman people who actually are crazy. You need them to think you might do anything!

When you draw a B-Type superhero like Searchlight, he's almost never standing straight up. You don't see his full body. He's cloaked in shadow even in broad daylight. Although he can't fly, he somehow manages, through climbing and swinging from ropes and cables, to be above you, ready to drop down. Searchlight is often drawn from baroque angles. Artists often draw this character in an upshot. Searchlight's muscles are always taut and tense. He could pounce at any time. His attitude is: "You picked the wrong guy to mess with." Searchlight wants you to *think* he might kill you—though, in truth, he tries to avoid killing. But he'll use as much force as necessary short of that to stop a supervillain.

You're not always going to be drawing a full figure shot or a panel-filling facial close-up. Sometimes you'll want to bring the "camera" in closer to have what's called a medium shot. You have to imagine the rest of the body even if you can't see it, so you know how to position the part of the body we do see.

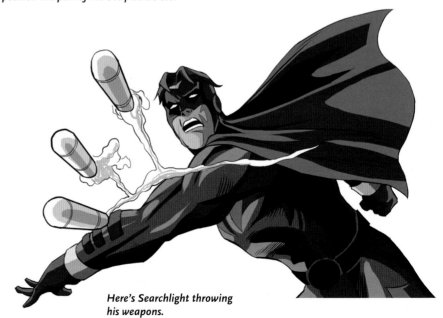

Here's Searchlight throwing his weapons.

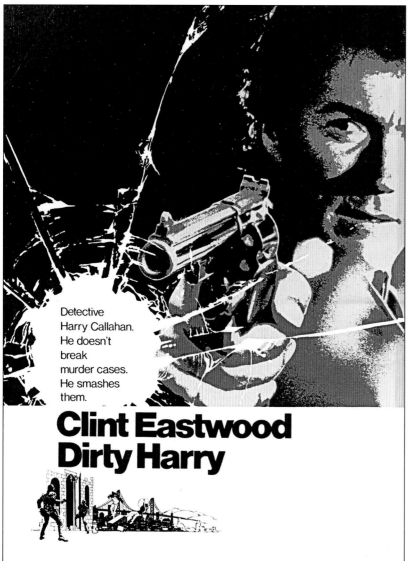

Detective Harry Callahan. He doesn't break murder cases. He smashes them.

Clint Eastwood
Dirty Harry

Suspension of Disbelief: Real Life vs. Comic Book Life

Let's be frank, frantic ones—most non-super-powered superheroes do seem to have the ability to emerge unscratched from hails of bullets fired at them, and both types of superheroes generally are able to not hurt any innocent bystanders in the course of their violent encounters with villains, super or not. In what is laughingly referred to as "real life," things wouldn't work that way. If the hero or an innocent bystander does get hurt in a comic, it usually becomes a major story point.

This state of affairs is what is referred to as "the suspension of disbelief," which is a fancy way of saying that when you partake of certain genres of entertainment, in whatever medium, you have to give yourself over to the premises laid out by the creators of said entertainment. For as long as it takes you to experience that story, you have to believe that "a man can fly" or walk up walls or teleport halfway across the world, or read minds, and so on. You get the idea.

Clint Eastwood created a movie icon with his portrayals of "Dirty Harry" Callahan. Is Harry crazy—or does he just want his adversaries to think he is? In this way, Harry resembles Batman and other B-Type superheroes.

The B-Type hero trains endlessly to develop his athletic skills. Me? I'm more of a brisk walk kind of guy. I leave the glamorous stuff to the pros—and the superheroes!

DRAWING TIME

Once again, as with Captain Titan, now that I've taken you through the thinking behind Searchlight, it's time to do some *drawing!*

The simplified skeleton of Searchlight wants you to feel he could do anything at any second. He doesn't care if you like or admire him. He wants you to be intimidated by his mere presence. Bullets don't bounce off him—so he's got to psych out his foes before they can even think about pulling the trigger.

Searchlight is no less muscular than Captain Titan, but he contorts and twists his body and keeps constantly in motion so as to not present an easy target.

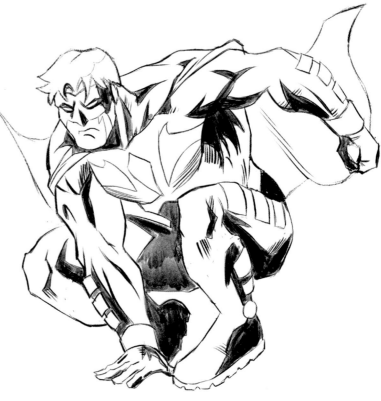

Make sure to indicate lots of shadows on Searchlight's figure to maintain his air of danger and mystery.

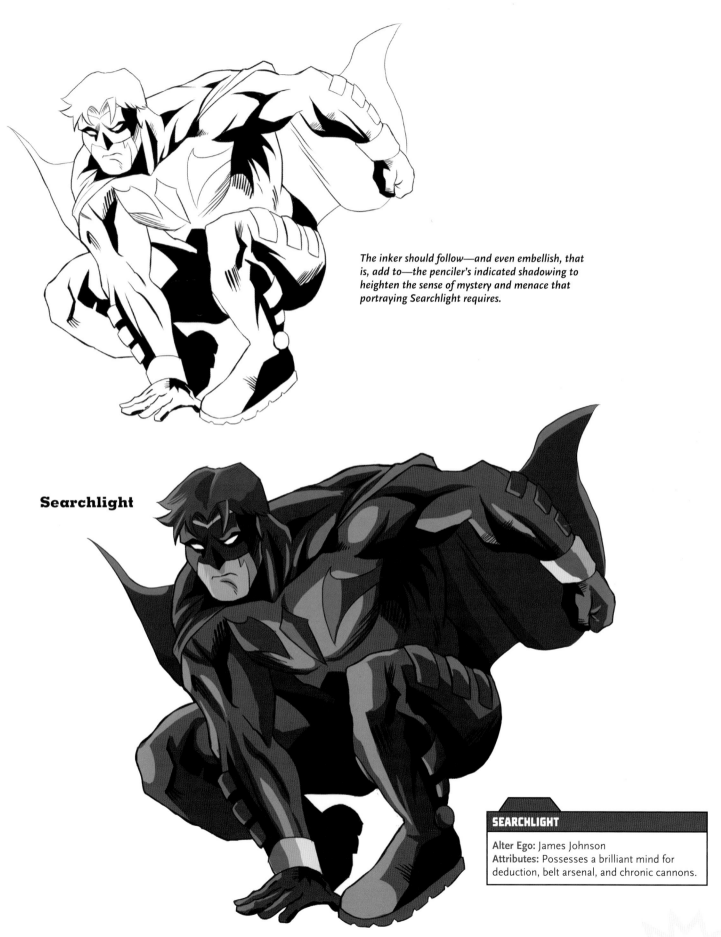

The inker should follow—and even embellish, that is, add to—the penciler's indicated shadowing to heighten the sense of mystery and menace that portraying Searchlight requires.

Searchlight

SEARCHLIGHT

Alter Ego: James Johnson
Attributes: Possesses a brilliant mind for deduction, belt arsenal, and chronic cannons.

BASICS FOR DRAWING SUPERHEROES

I've simplified superheroes into S-Types and B-Types, but of course, many fall somewhere on the spectrum between the two types or mix and match elements of both types. But no matter what individual physical or personality traits your superhero has, there are some basic elements you'll need to master to draw him convincingly.

FACIAL EXPRESSIONS

Okay, now take a person and show him in three different moods—*happy*, *sad*, and then *angry*—all while making sure the viewer can tell it's the same person in each drawing. Using a mirror or a live model is the way to go here—don't just copy from comics. You need to see and feel how real people express emotions before you can translate those expressions into cartooning or comics form.

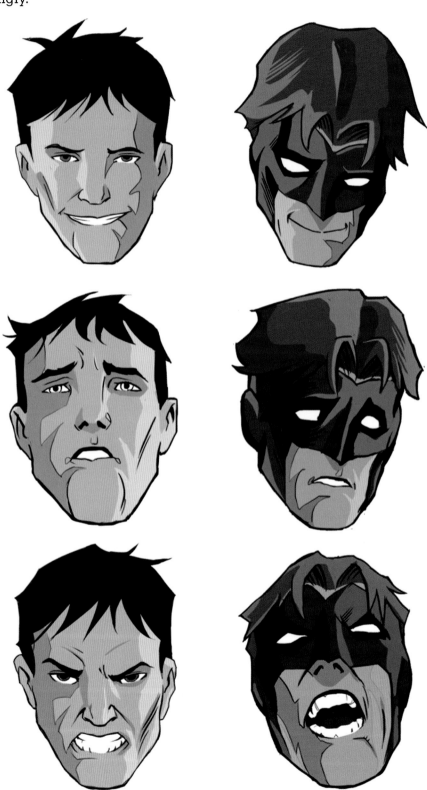

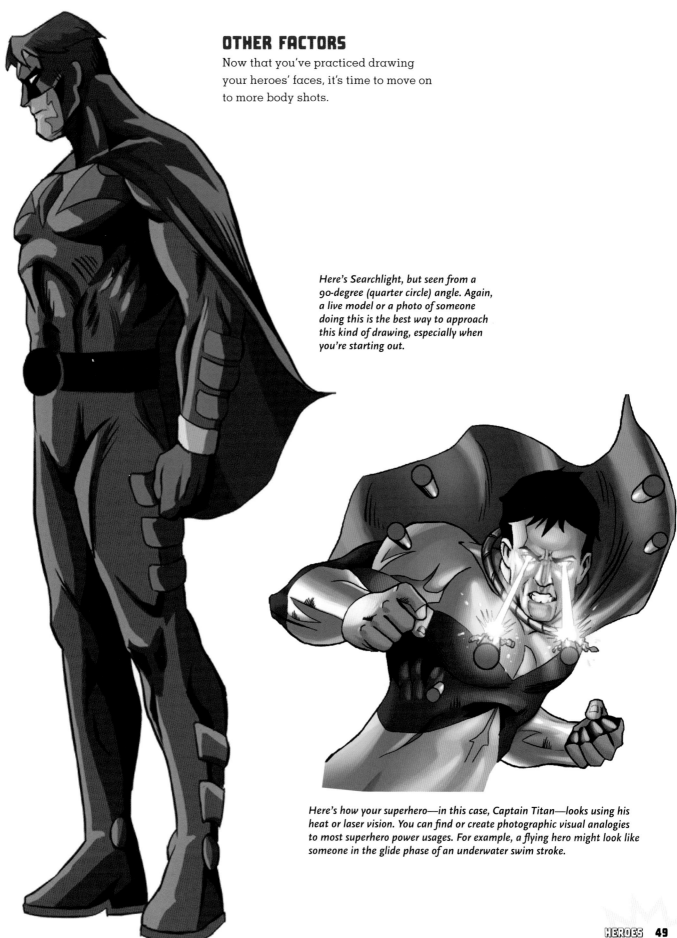

OTHER FACTORS

Now that you've practiced drawing
your heroes' faces, it's time to move on
to more body shots.

*Here's Searchlight, but seen from a
90-degree (quarter circle) angle. Again,
a live model or a photo of someone
doing this is the best way to approach
this kind of drawing, especially when
you're starting out.*

*Here's how your superhero—in this case, Captain Titan—looks using his
heat or laser vision. You can find or create photographic visual analogies
to most superhero power usages. For example, a flying hero might look like
someone in the glide phase of an underwater swim stroke.*

SECRET IDENTITY

Most superheroes have secret identities, or alter egos. The key to drawing a hero's secret identity is that the civilian identity in general shouldn't look as heroic as the costumed version of the character. You can literally make the character shorter and thinner and trust that the reader will not be jarred by the extra mass the character acquires when he's in superdude mode. Other tricks include having the civilian version slump or wear glasses or in some other way not exude the superhuman nature you want displayed while your superhero's on the job. This goes for superpowered as well as non-superpowered superheroes. Of course, for a masked or cowled superhero, sometimes just removing the mask and costume and changing into a suit or T-shirt and jeans is enough.

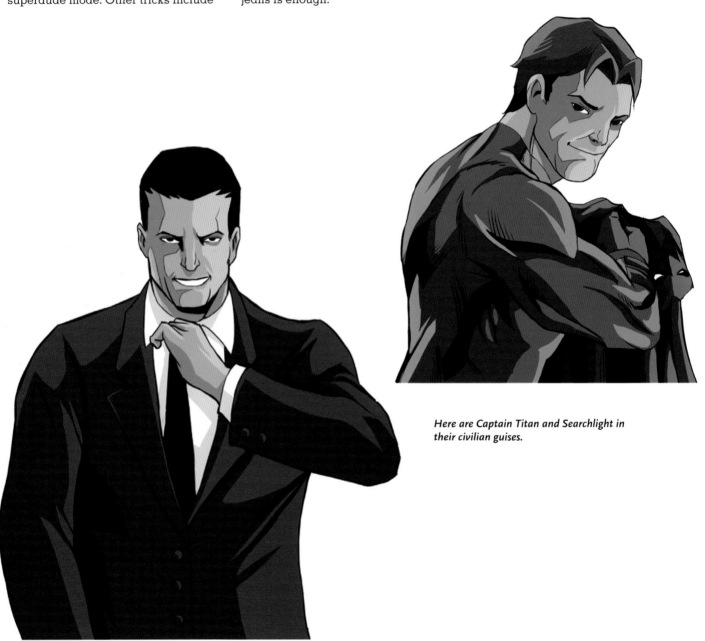

Here are Captain Titan and Searchlight in their civilian guises.

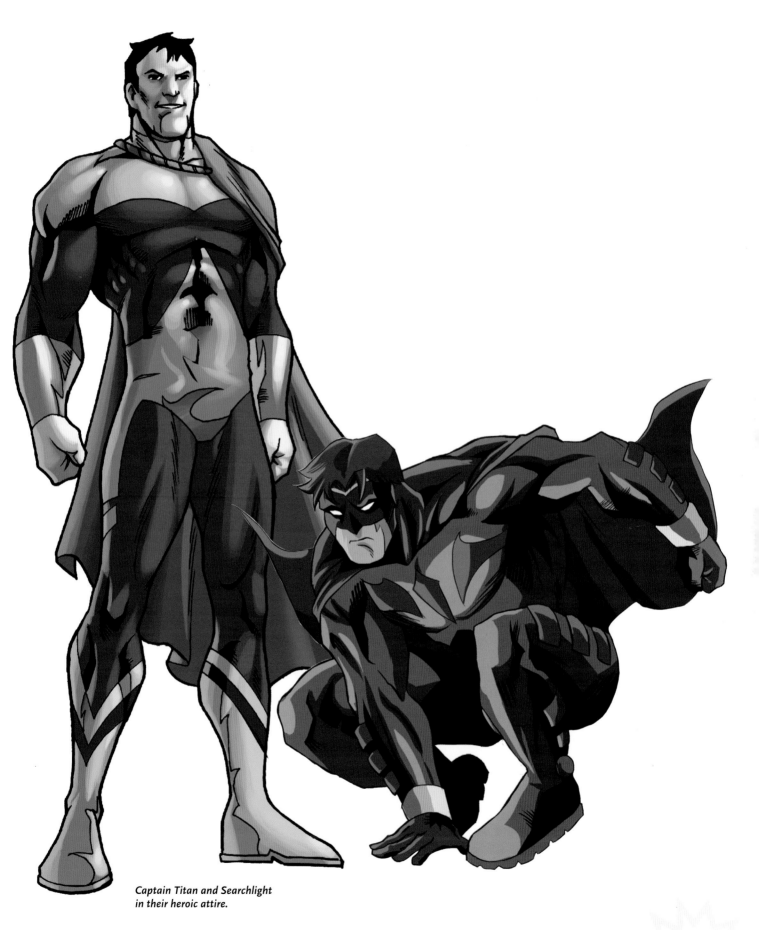

Captain Titan and Searchlight
in their heroic attire.

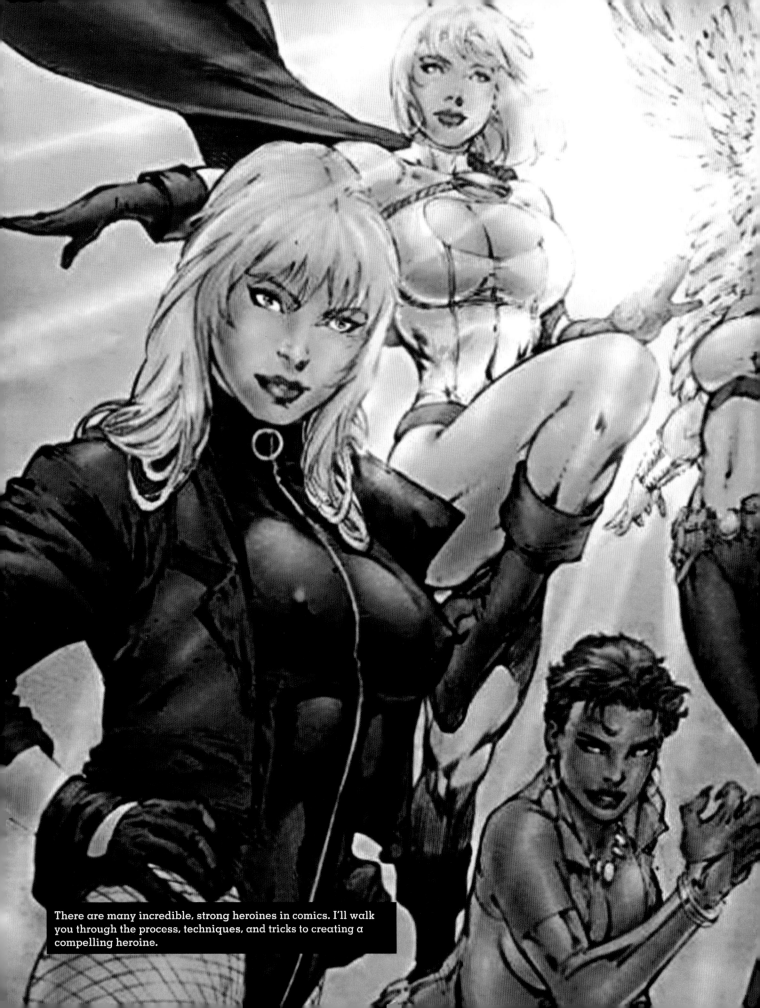

There are many incredible, strong heroines in comics. I'll walk you through the process, techniques, and tricks to creating a compelling heroine.

THOSE FANTASTIC FEMALES

I've heard it said that, "the female of the species is more deadly than the male." Now that I look back, I can't help but think that must have been in my mind when I was thinking up some of my superheroines. Because I certainly wouldn't want to tussle with gals like the Invisible Woman, the Black Widow, Medusa, She-Hulk, or the Wasp.

Strong female characters were a big part of the success of Marvel Comics stories back in the early years and today it's no different. Making sure that your superheroine is more than just a pretty face is going to be the secret to your own comic book success.

The Fantastic Four broke all the rules when they arrived on the scene. They weren't celebrities. They already knew one another. They all received their powers the same way—from cosmic rays. And, oddly enough, they didn't have secret identities. Next, and perhaps most importantly, they were real people. They talked to one another, fought with one another, loved one another, and acted just like real people with real problems. I guess, you could say they had human problems to go along with their super-human problems. And, when it came to Susan Storm, the Invisible Girl— well, one of the things that set her apart from other female comic book characters was the fact that she was every bit as powerful and brave as the rest of the Fantastic Four. (Maybe even a little bit more, but don't tell Reed and the boys I said that.) Not only can she turn herself invisible, but she can turn other people and objects invisible as well. She can create force blasts to knock down her opponents. And she makes force fields that can withstand the blows of even the Incredible Hulk.

Here you can see the Invisible Woman on the cover of Marvel Knights 4 #5 *as she holds back bullets with an invisible force field. Just one of the many ways this "fantastic" female can use her incredible powers.*

DARING, DANGEROUS, AND DEADLY, BUT NEVER IN DISTRESS!

What motivates these brave beauties? Keep in mind that your superheroine is not just battling to save the world, she's also fighting to keep her place up there on the front line. Why are these superheroines so brave? Maybe it's because they've had to fight that much harder to be considered heroes.

Think of all the times the Thing or Mister Fantastic stepped in to save the Invisible Girl when she could have just as easily taken care of herself with an invisible force field. These days, things are a little different for the cosmic quartet as the Invisible Girl is now the Invisible Woman, and not only can she take care of herself when Doctor Doom or the Skrulls attack, but she also does it while taking care of her kids, little Franklin and Valeria (not to mention Reed, Ben, and Johnny). She's a superheroine twenty-four hours a day.

Times change—and they've certainly changed since I began in the biz—and the female characters of today are leaps and bounds ahead of where they were in the beginning of the industry. Today, I don't think the Thing has any doubt that the Invisible Woman can take care of herself—and him, too!

So don't look for simple motivation when creating your superheroine. You have to ask yourself what makes this wonderful woman willing to risk her life to save the world? What does her bravery say to the world? Giving her the power is one thing, but giving her the drive is something entirely different. Is it just a desire to do the right thing or is she making an inspiring statement?

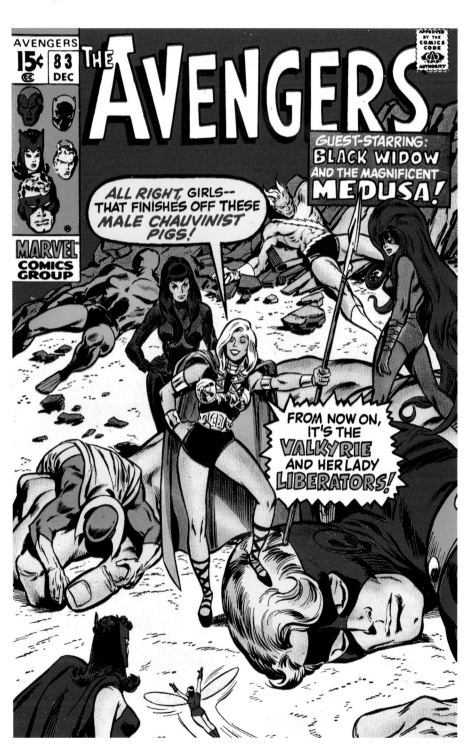

The Lady Liberators appeared in Avengers *#83. They were a team of Earth's Mightiest Heroines that included Valkyrie, the Black Widow, the Wasp, and others.*

TIME TO CREATE AND DRAW

Drawing a superheroine really isn't much different from drawing a superhero. Instead of using a collection of angles, you need to depict your mighty maiden of might with a softer, more rounded (if I may be so bold), more visually appealing form, while still displaying the strength of her stature. It is important to convey the astounding power of her physique, her facial features, her gestures, her costume, and her powers themselves, while keeping her clearly feminine and attractive. Now I'll walk you through the creative processes and techniques you'll need to know in order to illustrate a compelling heroine.

KEEPING THAT FEMININE FORM

As with the totally masculine heroes, heroines are taller than the average person. However, they are still slightly shorter than their male counterparts. So, if a male hero stands 9½ heads tall (as covered in chapter 2), a female heroine stands about 8½ heads tall, or just slightly shorter than her male counterpart.

As you have probably figured out by now, to illustrate superheroines you essentially follow the same basic rules for illustrating superheroes, only honing and tweaking the anatomy so that it isn't as bulky or massive as it is for the guys. From these same creative building blocks you will go through the five stages of creating a super-heroine, all of which will lead to the final piece—a fully realized four-color superheroine, ready to fight off the mighty minions of evil.

Now that I've cleared up any mis-conceptions you might have about what a superheroine looks like, let's move forward and create some.

Vampirella and Red Sonja are two of the best examples of what compelling heroines look like.

STUDYING THE FEMALE FIGURE

Essentially, there are two major body types for superheroines. There's the all-powerful, über-strong, "bench-press a Buick and bend an I-beam around your head" superwoman (for lack of a better name). Because Wonder Woman is probably the most recognizable of all the superwomen—let's call her the W-Type heroine. Then there's the lithe, slim, Olympic-class athlete who might not be able to leap buildings in a single bound or change the course of mighty rivers but who is certainly worth her weight in sumo wrestlers as she is quite capable of handling herself in an old-fashioned rumble. Let's call her the Elektra or the E-Type heroine.

The W-Type heroine's very presence commands your attention. This is the kind of superheroine who can stop a train. This doesn't mean that she needs to be as big as the Hulk, though. The W-Type heroine can be as strong as Superman, but still as graceful as a ballerina. The E-Type heroine's body type is more like a scrapper, a ninja, if you will. She's someone who is strong, but still has to train every day to stay in shape. Remember, where our W-Type heroine is more of a weight lifter, our E-Type heroine is more of a dancer—lithe and supple.

While it is obvious even to the untrained eye that both heroine types are very powerful and beautiful, they each adhere to different body types.

Beautiful Examples
Over the years I've worked with some of the finest artists in the business. While it is difficult to pick just one among them all (and you know I'm not going to), I always enjoyed collaborating with Jazzy Johnny Romita Sr., who rendered some of the most beautiful women to ever grace the pages of comic books. Both Gwen Stacy and Mary Jane Watson were introduced under the mighty pencils of Dashing Steve Ditko (even though we never got to really see MJ until Jazzy Johnny depicted her in *Amazing Spider-Man* #42) and were very attractive. Still, it wasn't until they appeared rendered by Jazzy John that they went from "merely" attractive to drop-dead gorgeous.

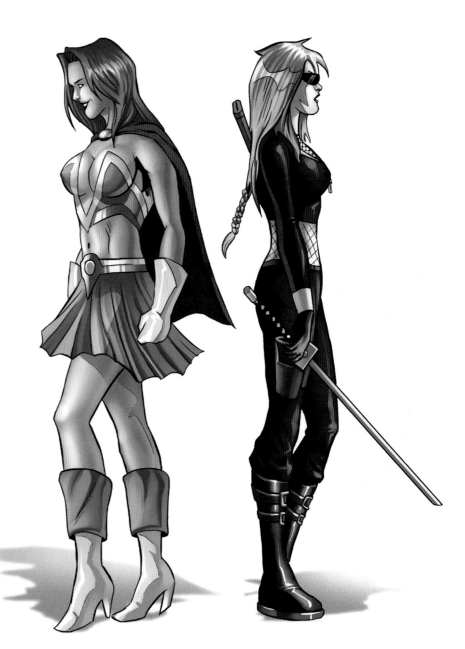

As you can see by these illustrations, our W-Type (Miss Mechanix) and E-Type (Lady Locke) heroines are clearly cut from different cloths.

THE W-TYPE: MISS MECHANIX

All right, down to business, let's start off by taking a look at Miss Mechanix. Truly she's a character of mythic proportions. She is someone who stepped out of the heroic legends of the distant past and into the modern world. This is one woman you don't want to mess with. Notice that she stands some 8¾ heads tall (nearly as tall as Captain Titan); this is mostly because of her legendary status. While it is typical to not display the same kind of rippling muscles on her that you would for a male hero, you still need to show that she is strong and powerful.

When illustrating Miss Mechanix, recall that she is very regal in nature and should stand upright with her head held high and her shoulders thrown back, as if commanding the very space around her. While it is perfectly clear that she has an ample bustline, she is still not overly endowed. It is always important when drawing superheroines to not overly accentuate their proportions.

Miss Mechanix's waist is narrower and her hips are wider in relation to her shoulders than they would be on a man. She is shown to be smooth, soft, and more rounded as opposed to the blocky, angular lines of a man. Traditionally, a woman's head is drawn slightly smaller than a man's. Again, generally speaking, you should always draw women slightly smaller than men—except of course for their busts. As a rule, when standing with their arms at their sides, a woman's arm (like that of a man's) should fall to her mid-thigh.

PENCIL TO PAPER

The first thing you should do when drawing something is to get an idea of what you're drawing, and then loosely sketch it out. Also, it is always useful to have some sort of an idea of who your character is, not just what she looks like. When I was creating characters on a regular basis, I always tried to imagine who that person was, what caused him or her to become a hero or turn to crime. I felt that knowing the character's motivation always helped me to better visualize him or her. Since Miss Mechanix is a W-Type heroine, let's imagine that she has been empowered by ancient gods.

Using circles, triangles, and lines, sketch out the beginnings of a dramatic pose for your W-Type heroine. Once that's done, take a look at what you've done. You've created a simplified skeleton. If this is your first attempt at drawing, you should draw a number of stick figures until you get the hang of posing a figure. When that's done, you can move on to more advanced forms of figure composition.

Once you've defined the pose you want to illustrate, it's time to flesh it out by adding cylinders to the frame. All the artists I've worked with insist that you "draw through" the figure. That is to say, not only should you draw the back, or hidden, side of the figure, you should also draw any part that is behind another part. This way you make sure you get all the anatomy in its proper place. When you've fully fleshed out your figure, you'll want to erase all your "draw through" construction lines to fully render your figure.

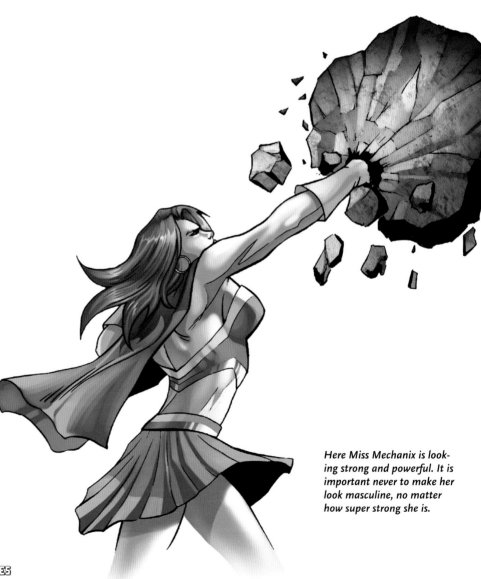

Here Miss Mechanix is looking strong and powerful. It is important never to make her look masculine, no matter how super strong she is.

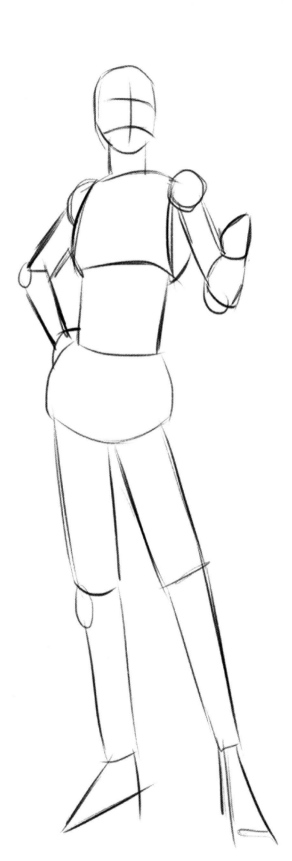

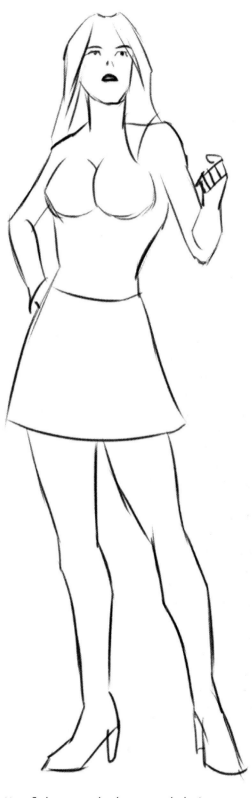

Next, flesh out your sketch to create the basic form of Miss Mechanix.

Using what you learned drawing superheroes, sketch out Miss Mechanix. First you need a simplified skeleton to provide direction.

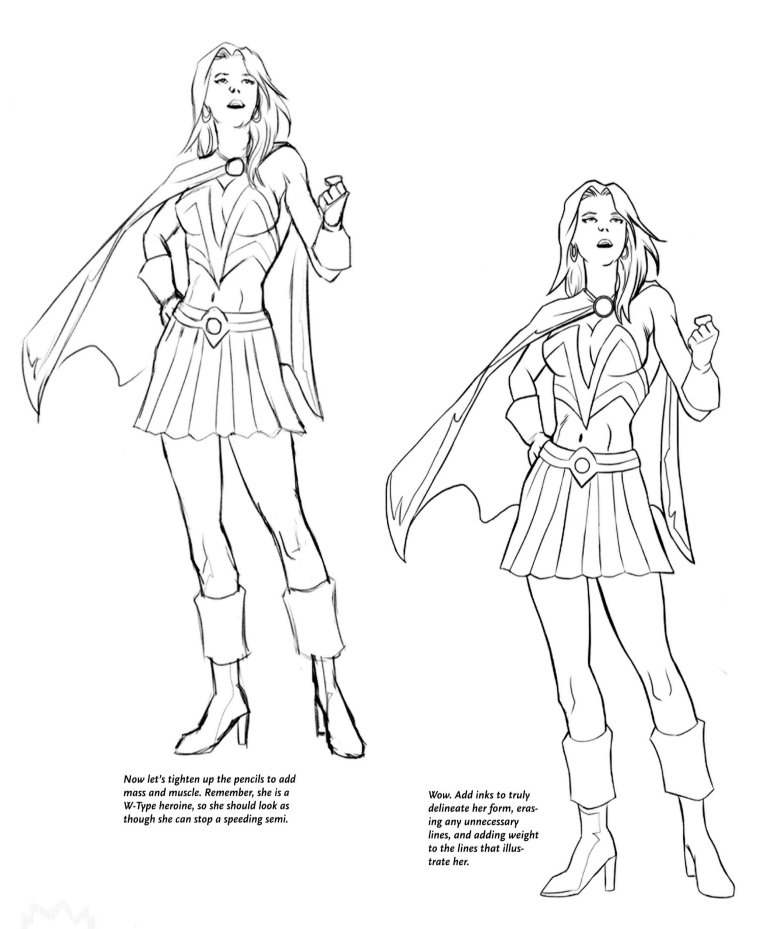

Now let's tighten up the pencils to add mass and muscle. Remember, she is a W-Type heroine, so she should look as though she can stop a speeding semi.

Wow. Add inks to truly delineate her form, erasing any unnecessary lines, and adding weight to the lines that illustrate her.

Miss Mechanix

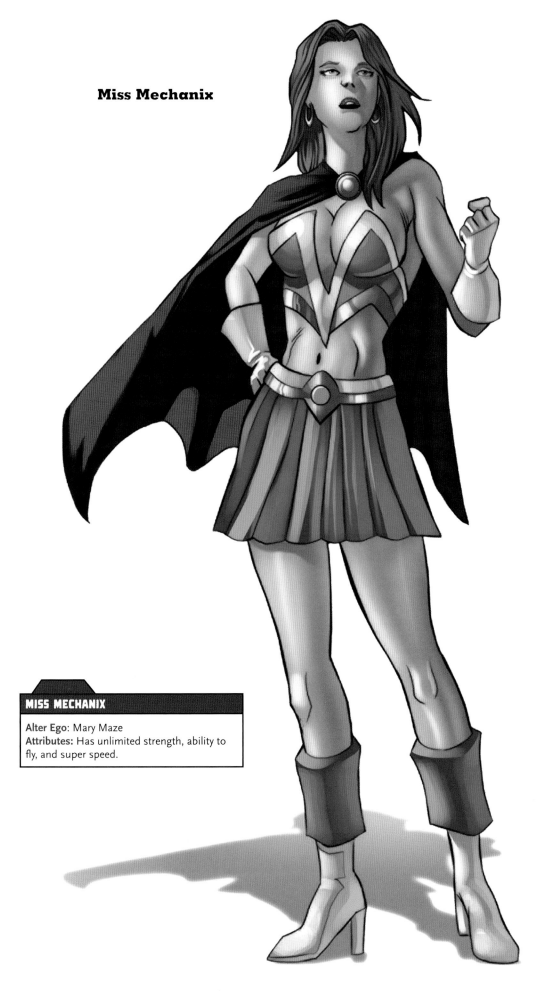

MISS MECHANIX

Alter Ego: Mary Maze
Attributes: Has unlimited strength, ability to fly, and super speed.

THE E-TYPE: LADY LOCKE

Okay, now it's time to sharpen your pencil and begin creating Lady Locke, an E-Type heroine. Remember, this heroic lass can often walk the fine line between right and wrong, and in order for her to do that (and stay on the side of the good guys), she needs to be nimble, graceful, and dangerous. What she may lack in super-strength and cosmic powers she more than makes up for with her fighting skills and prowess. Her muscles are fine-tuned, sleek, and designed to strike hard and strike fast. I'd say you should avoid meeting this girl in a dark alley, but chances are you will never see her coming.

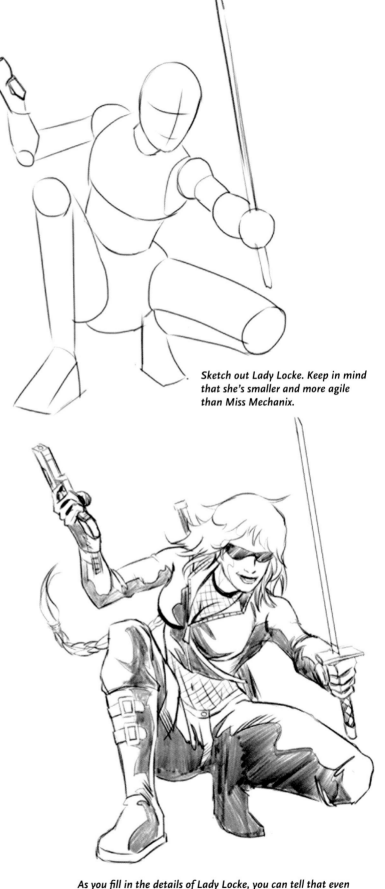

Sketch out Lady Locke. Keep in mind that she's smaller and more agile than Miss Mechanix.

As you begin to add depth and roundness to Lady Locke, notice how much slimmer she is than Miss Mechanix. If you compare the two of them to cars, Miss Mechanix is a Humvee, and Lady Locke is a Porsche.

As you fill in the details of Lady Locke, you can tell that even though she may not be able to knock down a skyscraper, she is still a formidable opponent.

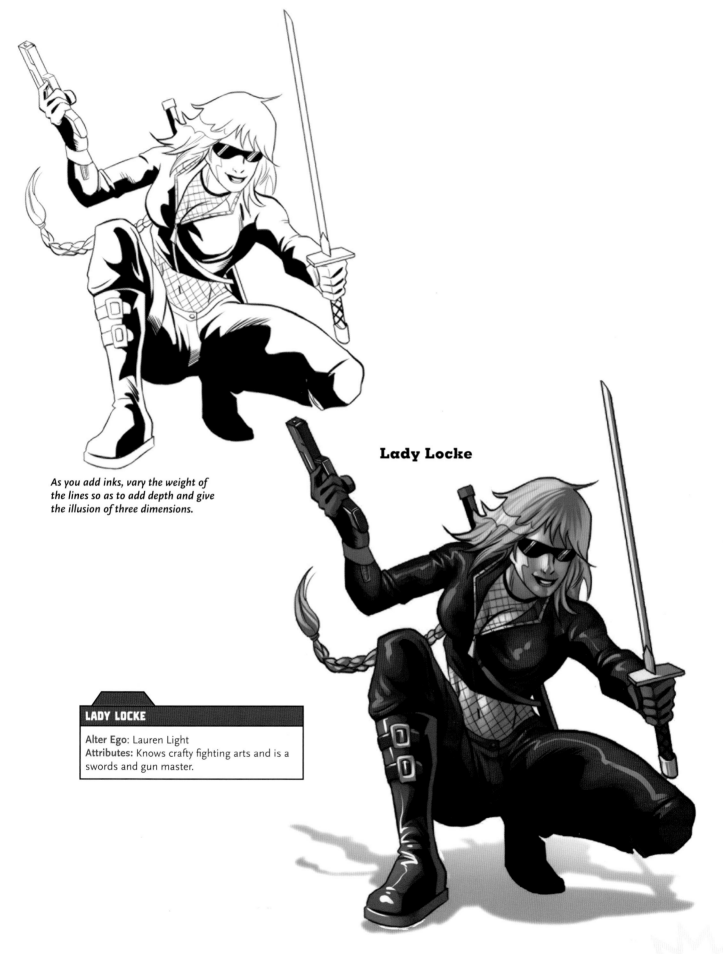

As you add inks, vary the weight of the lines so as to add depth and give the illusion of three dimensions.

Lady Locke

LADY LOCKE

Alter Ego: Lauren Light
Attributes: Knows crafty fighting arts and is a swords and gun master.

BODY TYPES

In spite of what I wrote on page 57, physical strength and beauty alone do not make a superheroine. It's also about her heart and strength of character. Superheroines come in all shapes and sizes, as can be witnessed by Miss Mechanix and Lady Locke, each of whom displays a very distinctive body type. But don't stop there! Take Ashley Crawford, for instance, also known as Big Bertha of the Great Lakes Avengers. Although Ashley works as a fashion model, when she uses her mutant power, she gains incredible mass to make herself super-strong and extraordinarily durable (even bulletproof). Or the Avenger's Squirrel Girl, who not only has a fluffy tail but a less muscular, more nimble physique. While it is clear that these women appear very different, no one can dispute the fact that they are all heroines.

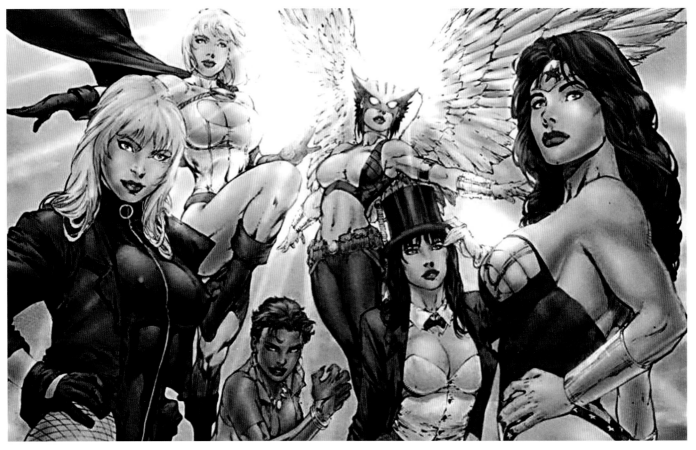

As you can see by this line-up of DC superhero-ines, there are indeed numerous body types for the superwomen.

Fashion model Ashley Crawford represents two body types rolled into one by splitting her time between walking the runway and as Big Bertha, a member of Marvel's Great Lakes Avengers.

FACIAL EXPRESSIONS

Needless to say, drawing your heroine is only the first step; you'll also need to illustrate your heroine's various expressions. I mean, you can't have her look exactly the same in every panel. So you'll need to range through the full emotional spectrum from love to hate, fear to shock, surprise, tenderness, etc. These alterations can be made by tweaking the various elements that you've just layered on your heroine's face—the eyes, nose, mouth, eyebrows, and lips. When doing this, you shouldn't use a lot of lines. Remember to make her appear smooth and attractive.

Obviously, each female face you draw has to be distinguishable from all others so as to allow the reader to tell one from the other. As already discussed, one of the primary differences between the two types of heroines is that Miss Mechanix has a fuller face, more rounded and with wider eyes, and Lady Locke, because she often works on the other side of the law (and has lived a harsher life than a superpowered princess), has a more angular face.

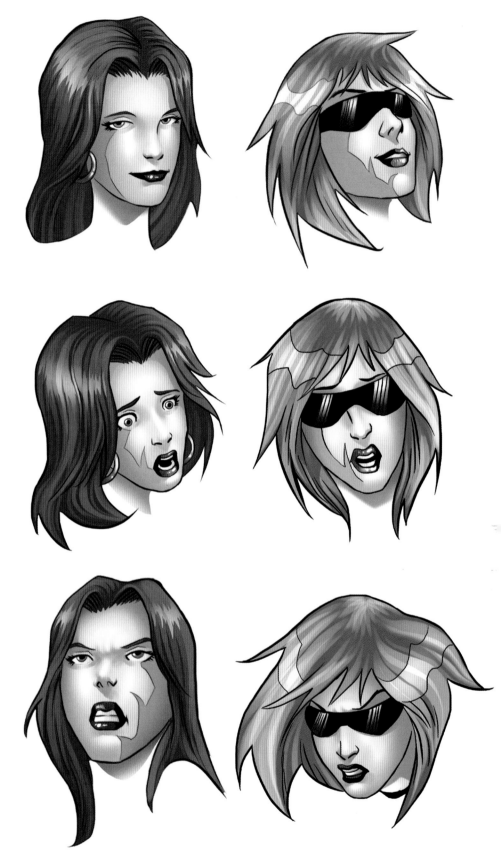

When drawing a woman's face, you need to be aware of her age, race, and numerous other aspects, thus ensuring that your reader can distinguish her from other characters panel-to-panel.

THE BODY OF A WOMAN

Now that you have a handle on faces, let's move on to upper-body shots.

Unlike a man's torso (which has more of a "V shape") women tend to have more of an hourglass shape. As before, the fewer lines you use to illustrate her form, the better your heroine will appear. It's always important to keep your lines smooth, rounded, and simple. Again, notice the different body types of women—not all of them are big and busty; some are slim and lithe. Needless to say, Miss Mechanix is of the former variety while Lady Locke, being a bit slighter, still strikes an imposing figure.

It should be clear by looking at these two images that they feature very different individuals. Masquerade is regal and statuesque, while the Damsel princesses have more of an iconic feel.

AND WHO DISGUISED AS . . .

Even the most dedicated of all heroines has some downtime, so you are going to need to know how to draw your heroine in her civilian identity. To be sure, while Wonder Woman is also Diana Prince and has a separate life in her civilian identity, Elektra (aka Elektra Natchios) doesn't really have a civilian life per se. However, you still should be able to illustrate the E-Type heroine like Lady Locke outside of her ninja garb.

Furthermore, you might want to make some sort of visual distinction in the character's posture while in costume and in street clothes to somehow differentiate her in and out of costume (this way other characters don't guess her secret identity). For someone like Sue Storm this might not be necessary—as Sue doesn't really have a secret identity—but for someone like Wonder Woman, this could be a big deal.

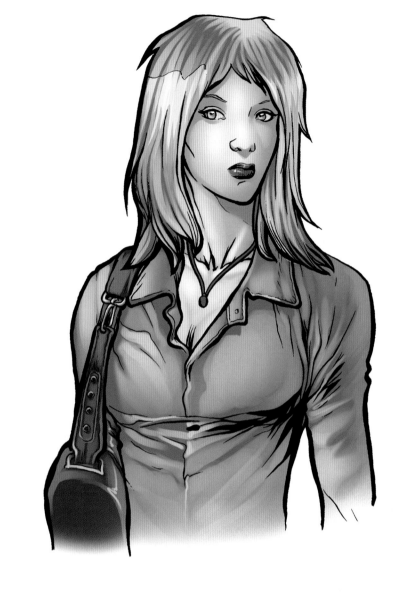

Every superheroine has downtime, so it is important that you know how to draw her both in and out of costume.

BRING ON THE ACTION!

That's right, action fans, now for the really fun part. You've drawn your superheroines. You've put them in costumes and in civilian clothes. You've posed them and looked at them from every angle. Now you need to unleash them on the dastardly criminal element that threatens the world.

Everyone knows that a comic book is comprised of static pages, but you can give your images the appearance of fluid movement by doing more than adding speed lines. You have to give your figures the illusion of movement. You need to animate them and put them into action. Just being able to illustrate a magnificent pose is one thing, and if you can do that, you can most assuredly become a terrific cover artist. But comic books are about movement and action. So you'll also need to know how to make your figures look as though they are moving—whether that means throwing a punch or a kick, flying through the air, swimming, running, or falling. You need to make them move.

The best way to start is by going back to stick figures and posing them in various positions. You need to draw and redraw them, keeping balanced proportions and positioning in mind as you add mass and muscle to them. Try this: Take a character through a series of sequential movements from one position to another. Let's have her throwing a punch. First, using only rough pencils, start with your figure's arm pulled back. Then continue drawing the follow-through as if you were drawing the in-between panels of an old-style animated cel cartoon. The images should all overlay one another as you move your figure through the punch, giving you between six or eight images when you are done and your character delivers the coup de grâce.

Black Widow in action, showing why she is one of the toughest hero- ines around!

Your superheroine should look like she's ready for battle and knows how to take care of business.

WEAPONS

Yep, most heroes and villains have weapons and gadgets that are part and parcel of their accoutrements. Captain America has his shield, Daredevil his billy club, and Batman carries an entire warehouse worth of equipment in that handy-dandy utility belt of his. (Seriously, how cool is that?) The same is true for both W- and E-Type heroines.

Wonder Woman has her Lasso of Truth. Elektra carries those very deadly Sais. Thus you are going to learn how to not only draw the weapons of choice, but you are going to need to know how that gadget, weapon, or item is held. Using a photo or artistic reference is recommended, but it would also help you to actually get your hands on the item in question and hold it yourself. (However, if you happen to get your hands on an Ultimate Nullifier or the Cosmic Cube be very careful, and I'd suggest putting a call in to the Fantastic Four, the Avengers, and quite possibly Damage Control for safe measure.)

So there you have it. You've created your very own superheroine. She's bold and daring and ready to kick villainy's collective butt. She's her own hero on her own journey. And if you call her a sidekick—look out!

When drawing your character fighting with weapons, you really need to know how they are held.

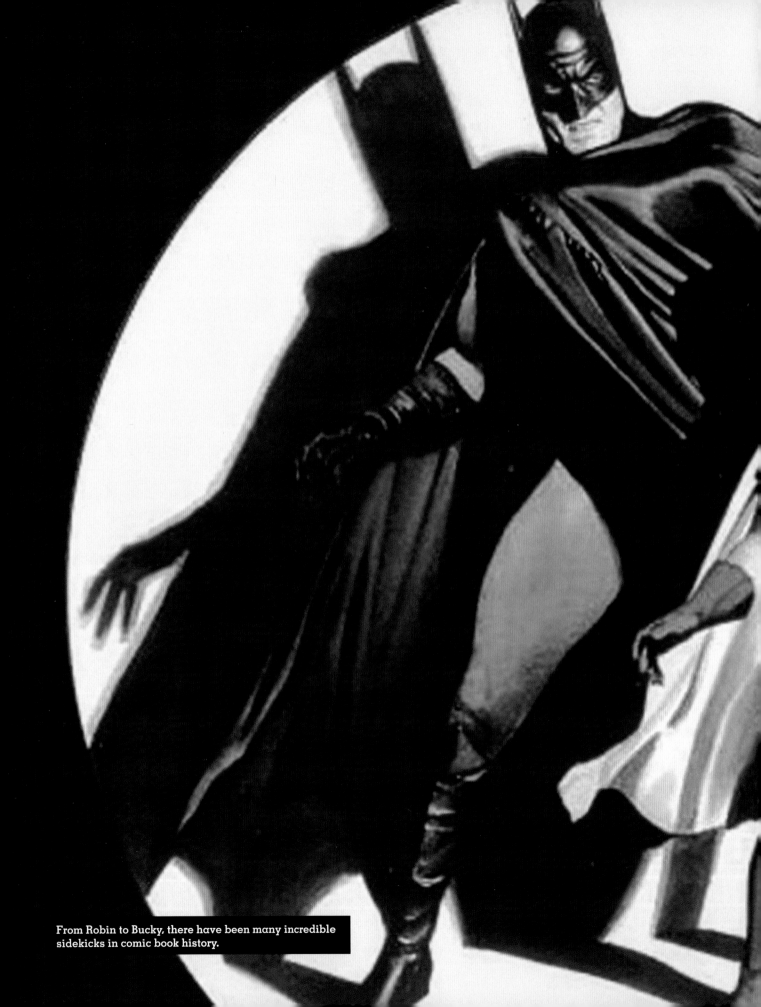

From Robin to Bucky, there have been many incredible sidekicks in comic book history.

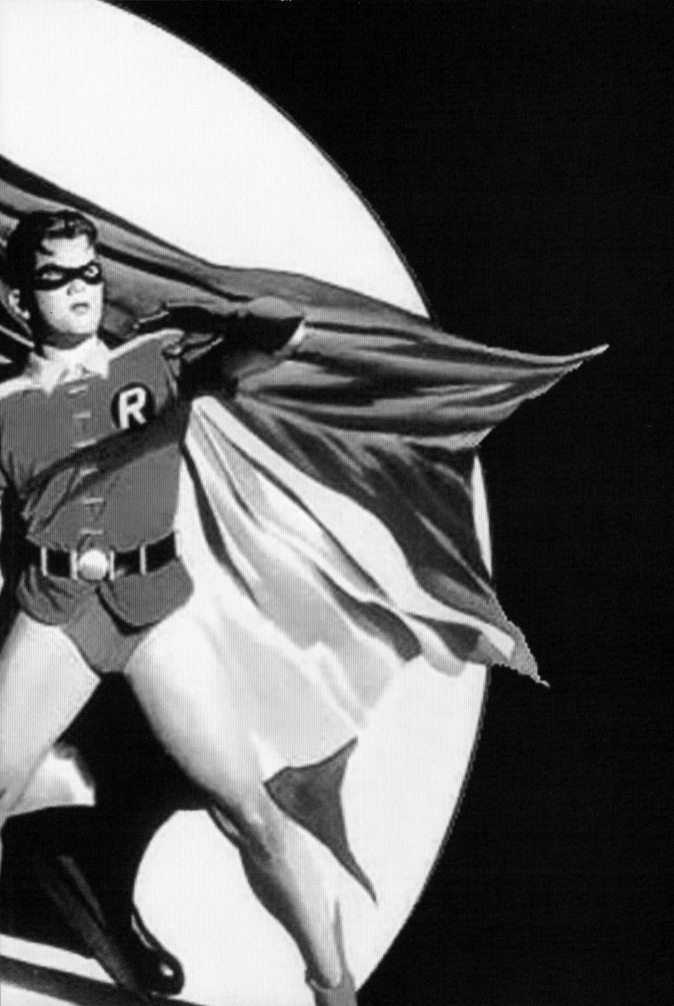

NOT ALL HEROES ARE GROWN-UPS

Okay, gang, we're really moving along now. And if you're getting tired, then have no fear because you're about to get some help—well, your heroes are, anyway.

You've learned the history of heroes—how they put on colorful tights and evolved into superheroes. You've learned how to develop your very own superheroes. Next, because superheroes can't go it alone, I showed you how to create superheroines to fight alongside your male heroes. But hold on, because just when you think it's time to start saving the world—there's still more. While they aren't for everybody, there was a time in the not-so-distant past of this meshuggeneh industry that almost every self-respecting hero had a teen sidekick.

PAST, PRESENT, AND FUTURE

Of course, sidekicks and teen heroes aren't just found in comics. Beowulf, the hero from the epic poem, had a sidekick, a distant cousin named Wiglaf who helped him defeat a mighty dragon. How about the Greek hero Odysseus? Not only did he have a whole crew of sidekicks to help him battle gods and monsters, but he also had a son named Telemachus who helped him win the day upon his return to Ithaca. Later, King Arthur's knights of the Round Table had squires to help them on their quests. Even today, I would consider the bat boy at a baseball game as a sort of sidekick. And speaking of "bat boys"…

When I say it's time to create a teen hero or a sidekick, I bet one colorfully clad lad jumps to mind—Robin, the Boy Wonder. Over at DC Comics they loved sidekicks. Aquaman had Aqualad. Wonder Woman had Wonder Girl. Green Arrow had Speedy. In fact, DC had such great success with sidekicks that they actually had them for their own team—the Teen Titans. And as for teen heroes—well, they created a whole legion of them to battle evil in the thirty-first century.

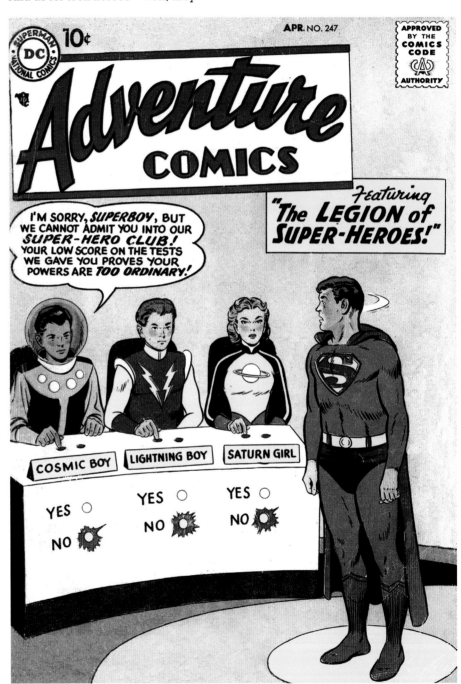

In the 31st century, teen heroes join together to form the Legion of Super-Heroes. Even Superboy was invited to try out, as you can see on the cover of Adventure Comics #247.

THOSE TREMENDOUS TEENS

At Marvel, we took a different approach to sidekicks by making them their own heroes. At the time, teenagers were becoming a culture all their own, and I decided to create a hero who would be a part of this culture. Yes, I am talking about Peter Parker, your friendly neighborhood Spider-Man. Poor Peter wasn't just subjected to all the typical hardships of youth; he also had to fight off the likes of the Green Goblin, the Sandman, the Vulture, and others in his spare time. In fact, I sometimes wonder if the lesson of Spider-Man shouldn't be that with great power come great *problems*.

Having a teen hero was quite a daring move in those early days. In fact, I once got into an argument with my then publisher, Martin Goodman, about sidekicks. I not only wanted Spider-Man to be a teenager, but also the star of his own book. Martin said three things that I will never forget. First he said, "People hate spiders, so you can't call a hero Spider-Man." He then went on to say, "A teenager can't be a hero, but only a sidekick." Finally, when I told him that I wanted Spidey to have problems, he said, "Don't you understand what a hero is?"

Later, the X-Men, who were "the strangest teens of all," came along, and once again you had heroic young people fighting villains while dealing with matters of relationships, acceptance, prejudice, and other difficulties. Of course, putting teen heroes in the spotlight didn't mean we were against sidekicks at Marvel. Look at Rick Jones. He didn't even have superpowers, and yet he became a sidekick for none other than the Incredible Hulk and later, for a short time, he fought alongside the sentinel of liberty himself, Captain America, as the new Bucky.

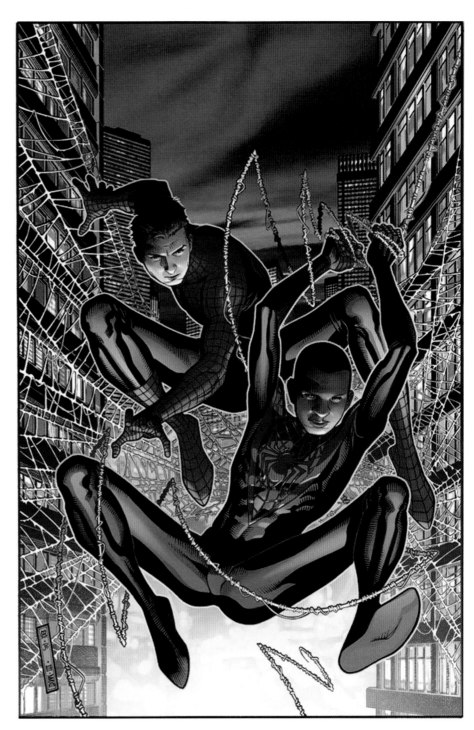

When Peter Parker became Spider-Man he found himself facing more than the usual difficulties of being a teenager. Likewise, Miles Morales demonstrates similar difficulties but in a different time. The two meet in Spider-Men *from Marvel Comics.*

LITTLE HEROES, BIG PICTURE

As you begin thinking up your teen hero or sidekick, it's important to remember that little heroes should get the big picture. Don't just think about the fun stuff—like how they received their powers or how colorful their costumes are—but think about where they come from and what they deal with every day. You need to have the human before you can have the superhuman—or if you want it in fancier terms, you need to "humanize" your hero.

Sure, Captain America has to fight the Red Skull, but he doesn't have to worry about homework or finding a date for the prom, too. Think about how you differ from your teachers, coaches, and mentors. Or consider what your students, players, or younger siblings and friends go through as they try to find their place in the world. Many of the life difficulties that Peter Parker and Scott Summers faced in their rookie years still challenge the youths of today, just in different ways. You see, a sidekick isn't just an accessory, but a hero on a journey of his or her own. Your teen hero should be someone relatable and understandable to young and adult readers alike. Your teen hero should be someone for young

readers to identify with, as well as someone for adult readers to learn from. Now, as you begin to see "the big picture," fighting the Green Goblin seems the easy part of being a teen hero.

One of the most important parts of creating a sidekick for your hero is figuring out their differences and similarities. The two may share an origin or a power source, but that doesn't mean they always have to have the same point of view. While you may want your teen hero to dress like and fight valiantly alongside your superhero, he or she may not always get along with or agree with his or her mentor. Sure, your hero is trying to fight for truth, justice, and the American way, but maybe your sidekick comes from

a different generation and isn't always going to be too happy with those ideals. Maybe he or she has an extreme sense of justice that exceeds that of your hero. In this case your teen hero represents a change—and in some cases a need for change. There can be a conflict within the hero/sidekick dynamic that is every bit as valuable as the teamwork. Keep in mind, your sidekick has more to offer than just an extra "Bam!" and "Pow!" in a fight. Teen heroes aren't just a Batman or Captain America in training. Consider how the X-Men went from being "the strangest teens of all" to instructors at Professor X's school. Sidekicks and teen heroes are teachers, mentors, coaches, and parents in training as well.

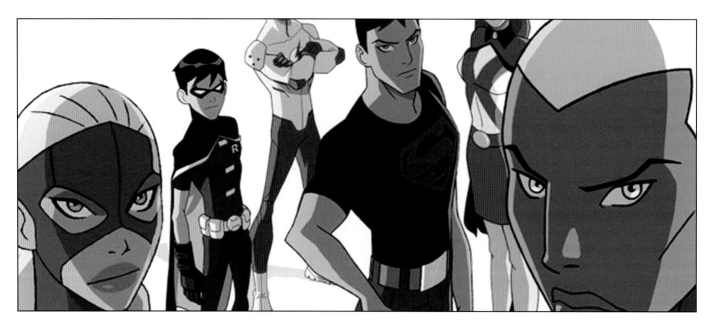

DC Teen Heroes graduated from comics to TV in the Cartoon Network's animated TV show, Young Justice.

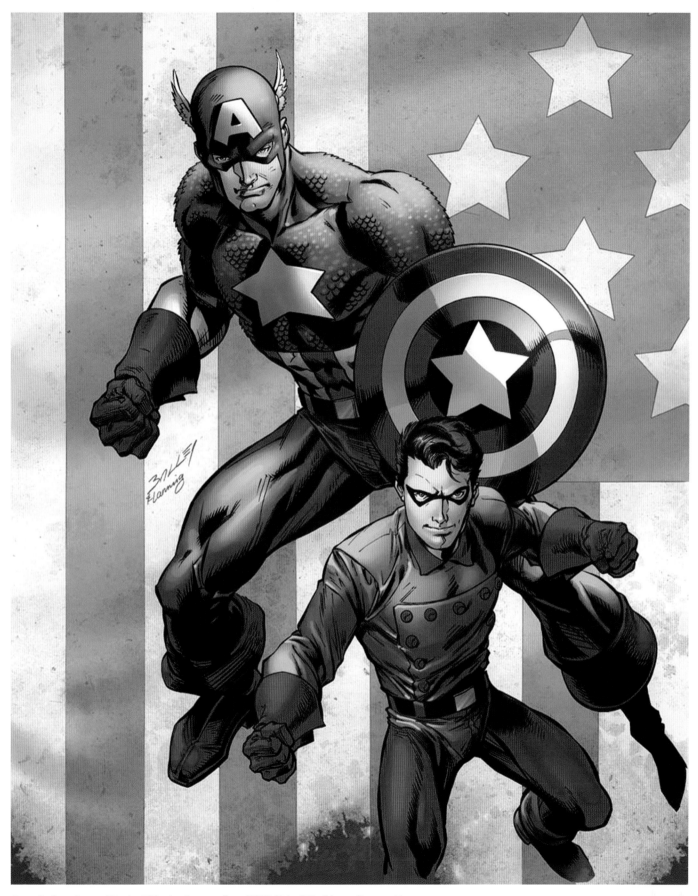

Captain America and Bucky: This classic team from WWII kicked Nazi butt all across Europe.

LET'S GET SIDEKICKING

Having covered the basics of teen heroes and sidekicks, it's time you learned how to create your very own, personalized superhero sidekicks. So if you are considering adding a sidekick to your hero or heroine, I'll show you what you need to consider when creating one.

Much like their adult counterparts, teen heroes are essentially just a collection of geometric shapes, piled upon one another with muscle tone, shading, and "sculpting" added.

Since sidekicks are traditionally teens, it is important that they are drawn not only smaller than their adult counterparts, but less-muscled as well.

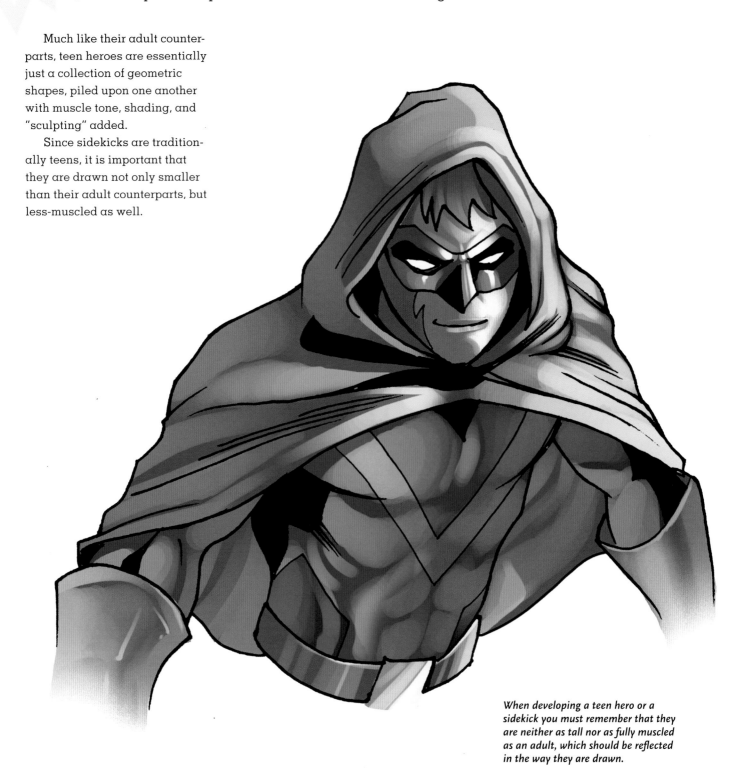

When developing a teen hero or a sidekick you must remember that they are neither as tall nor as fully muscled as an adult, which should be reflected in the way they are drawn.

OTHER FACTORS

Another thing that's important to consider when designing a superhero sidekick is that the sidekick's powers, costume design, and even his or her name should reflect and complement the powers, costume design, and name of the team's senior partner. While this might be a little bit obvious, it wouldn't make any sense to have someone with, say, Hulk's powers as Daredevil's sidekick. It has also been traditional to have the sidekick and superhero be the same sex, although even that isn't entirely necessary anymore. In Frank Miller's *Batman: The Dark Knight Returns* graphic novel, Frank introduced a female Robin who was paired up with the male Batman, forever breaking that particular superhero rule.

Another "rule" for heroes and sidekicks is that they both should have similarly themed costumes and/or superhero names. Still the rule on costumes isn't hard and fast either. For, as you can plainly see, while Batman dresses in dark hues of blues, grays, and blacks, his young partner Robin wears brightly colored red and green. What you should keep in mind is that these two heroes are linked by more than being named after winged creatures—they share similar origins.

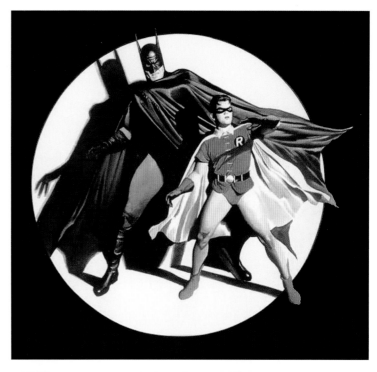

The Dynamic Duo is an example of a super-team whose costumes are very different in nature. However, their origins and abilities are quite similar.

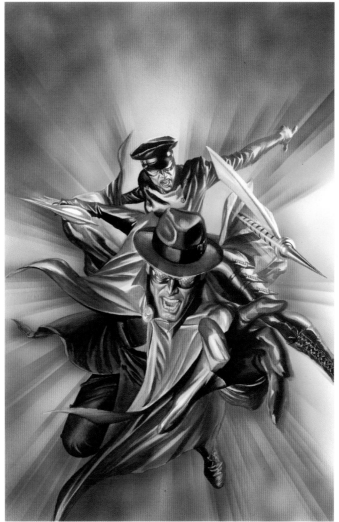

Interestingly enough, while the Green Hornet and Kato have traditionally been two adult men (one Caucasian and one Asian), Dynamite has mixed that up, giving us not only different ethnic backgrounds, but opposite genders as well.

BACK TO BASICS

Okay, let's go back to the drawing board for some more practice. Begin by sketching out a few action poses so you can get into the groove of illustrating your new junior heroes. Try not to draw a static image, because as I've been saying for the past three chapters, comic books are all about movement.

See how easy it is to indicate your figure? Notice that in the illustration, there are balls inserted where elbows and knees go to show the joints that exist there.

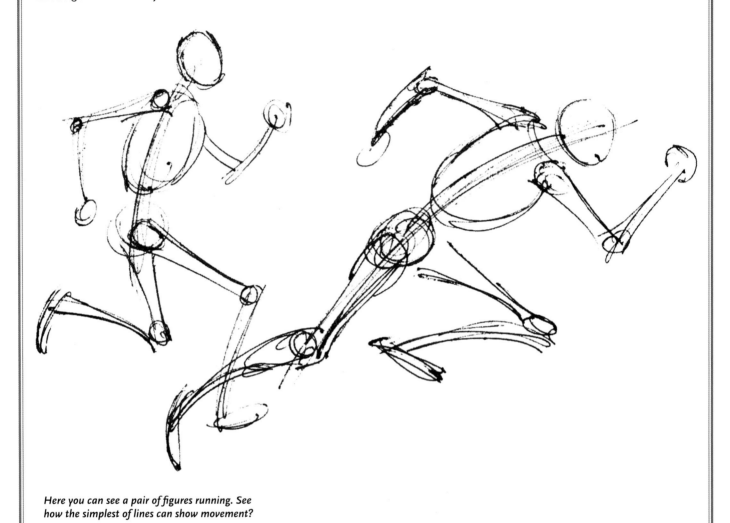

Here you can see a pair of figures running. See how the simplest of lines can show movement?

ARCHETYPAL TEEN HEROES

Now that I've shown you some examples of a few different superhero sidekicks, it is time that you design your own. The important thing about your sidekick is that his or her look should complement the hero's (who is, after all, the primary character of the comic). So again, you have a couple of different archetypes for these characters.

THE S-TYPE SIDEKICK: BIG BOY

Remember, you're not just creating a smaller version of Captain Titan—you are creating a *teen* hero and there's a lot that goes along with that. Sure, this eager lad gets his lead and inspiration from his valiant mentor, but he should also have a style and attitude all his own. Maybe he wears his collar turned up. Maybe capes just aren't cool. Maybe he wears a mask, maybe not. Whatever the case, from his mussed hair to his rockin' kicks, subtle differences will tell us who this heroic youngster really is—and who he is likely to become.

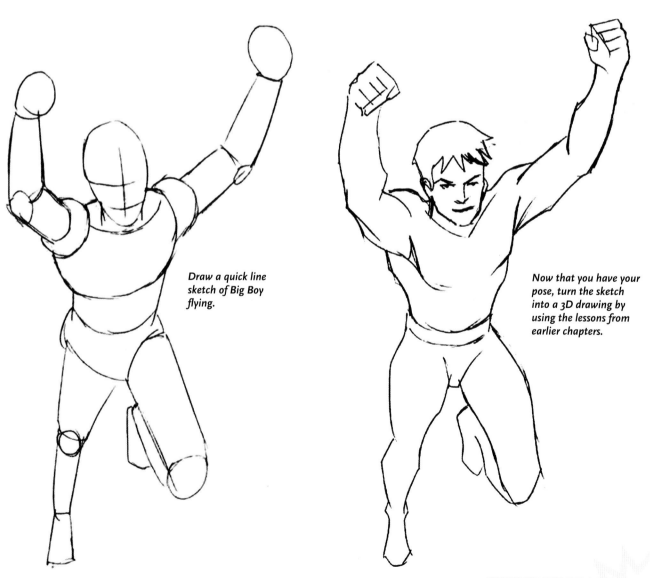

Draw a quick line sketch of Big Boy flying.

Now that you have your pose, turn the sketch into a 3D drawing by using the lessons from earlier chapters.

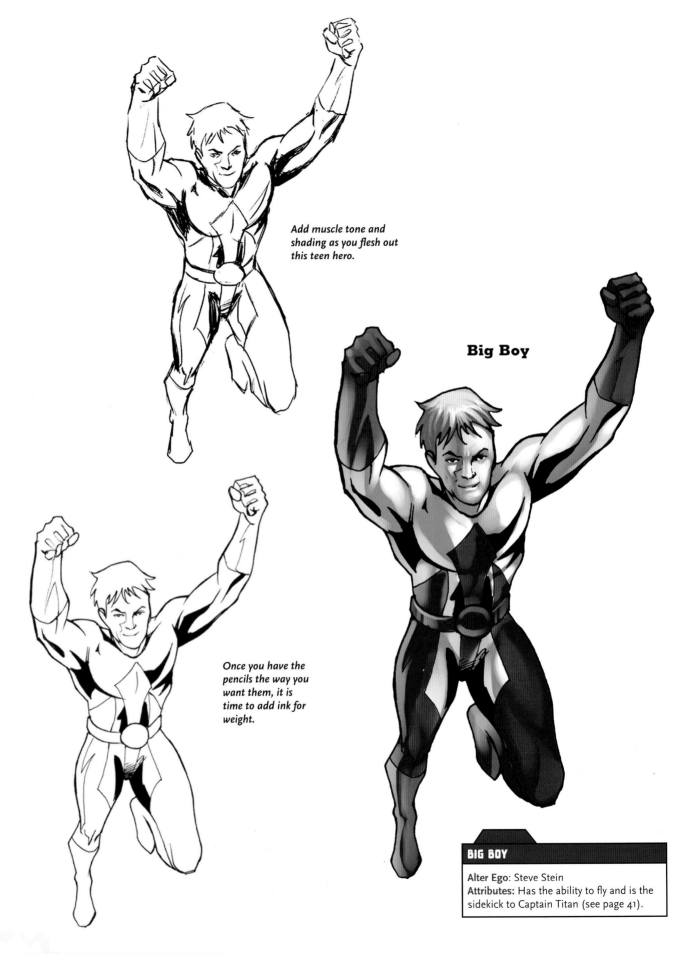

Add muscle tone and shading as you flesh out this teen hero.

Once you have the pencils the way you want them, it is time to add ink for weight.

Big Boy

BIG BOY

Alter Ego: Steve Stein
Attributes: Has the ability to fly and is the sidekick to Captain Titan (see page 41).

THE B-TYPE SIDEKICK: THE DARK HOOD

Okay, that worked out pretty well, now let's do it again, only this time based on a B-Type hero, like Searchlight. Keep in mind what I said about Searchlight—he's considered a superhero for a variety of reasons, but largely because he wears a costume and has adventures. Now, before you start handing out the grappling hooks and boomerangs, imagine the responsibility of bringing a young partner along on these adventures. What kind of gadgets and gizmos will this daring dude be trusted to wield? What kind of gear will he require? Think about what kind of fighting techniques will fit his physique and style. It's a dangerous world for our B-type team-up, so let's make sure our teen hero is ready for the challenge.

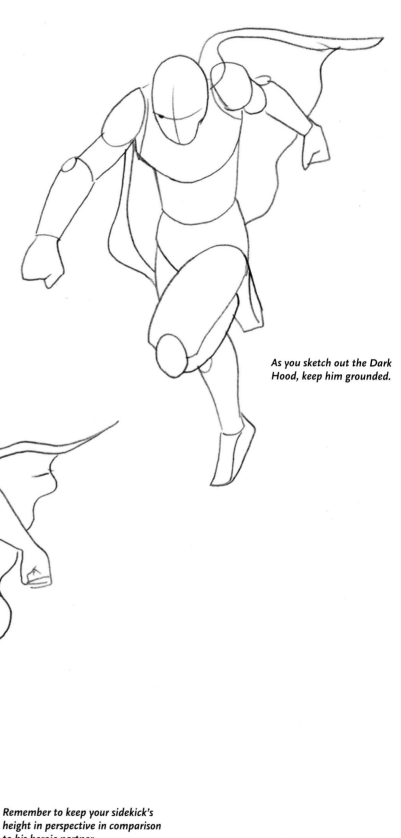

As you sketch out the Dark Hood, keep him grounded.

Remember to keep your sidekick's height in perspective in comparison to his heroic partner.

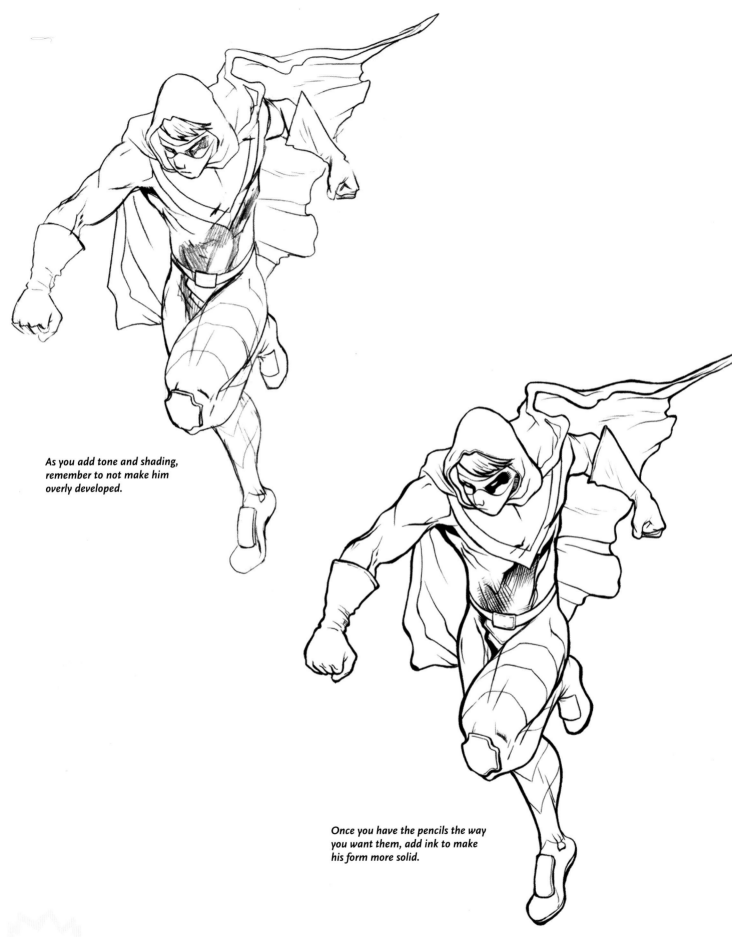

As you add tone and shading, remember to not make him overly developed.

Once you have the pencils the way you want them, add ink to make his form more solid.

The Dark Hood

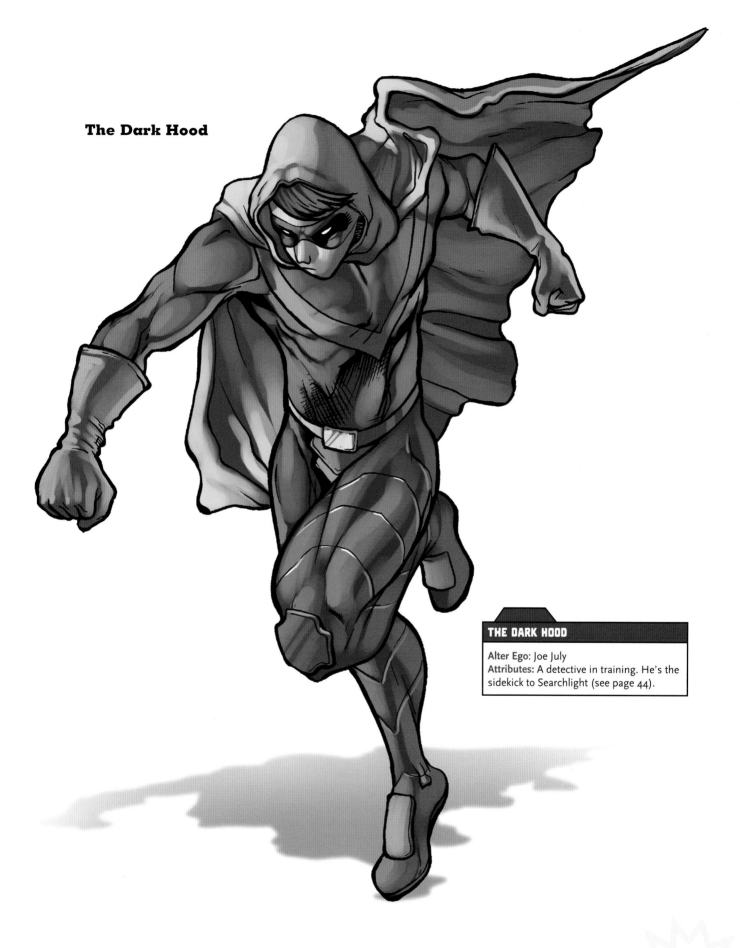

THE DARK HOOD

Alter Ego: Joe July
Attributes: A detective in training. He's the sidekick to Searchlight (see page 44).

SIDEKICK SECRET IDENTITIES

Once again, part and parcel of the hero motif is the secret identity. As with the superhero and superheroine, the teen hero needs a civilian alias. When heroes are in costume, they are always easily recognizable by the reader; but it is not so easy to make your heroes recognizable when they are out of costume and in their street clothes. First of all, they are supposed to blend in. In costume, they are designed to attract attention to themselves; in street clothes, not so much. They don't want to be noticed; however, we, the readers, should always be able to easily identify our heroes when they are not in costume. With young Clark Kent, that is easy, as he is sporting those glasses and has Supe's signature cowlick. For someone like Dick Grayson or Bucky Barnes, that may not be so easy without the mask. It is important to make your sidekick look not so impressive when out of costume.

To be sure, if you were to put images of a sidekick in costume next to a similarly posed image of the sidekick in civvies, you would (or at the very least you should) notice some very substantial differences. The character as hero should be bold, visually arresting, and powerful. On the other hand, that same character out of costume should be quiet and unassuming, someone who would not be especially noticeable in a group. The reason for this is that, as a civilian, the sidekick doesn't really want to be the center of attention, but rather part of the crowd. As the hero/sidekick, he or she needs to be bold, and, yes, even somewhat garish in his or her appearance.

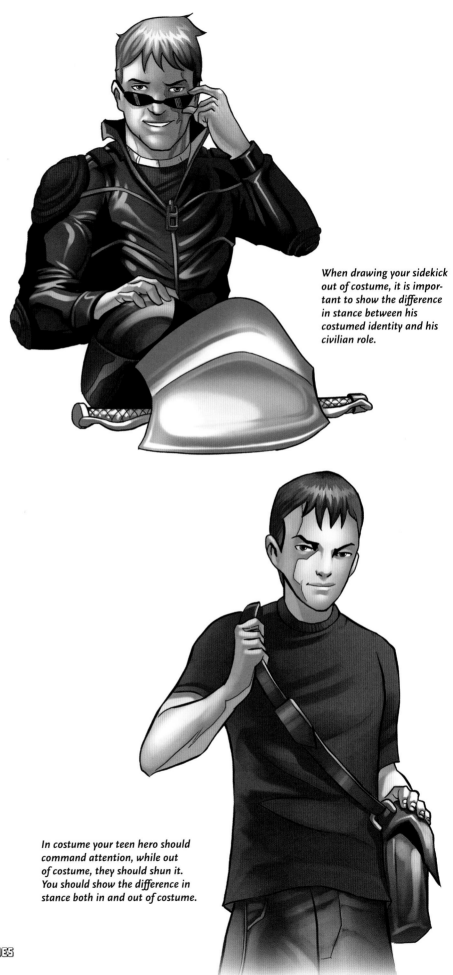

When drawing your sidekick out of costume, it is important to show the difference in stance between his costumed identity and his civilian role.

In costume your teen hero should command attention, while out of costume, they should shun it. You should show the difference in stance both in and out of costume.

IT'S ALL ABOUT HAVING THE RIGHT TOOL

As a rule, an S-Type sidekick, like Big Boy (and also an S-Type hero, like Captain Titan), doesn't use any special tools, gadgets, and/or weapons, but there are other hero sidekicks who do. As such, designing gadgets is an important part of creating sidekicks. You should practice drawing your sidekicks using whatever weapons or items you've decided they should carry. Like his mentor, Batman, Robin has a utility belt that contains all sorts of gadgets and doodads. Even though Captain America carries a shield, Bucky really doesn't have any weapon (although the World War II–era Bucky is sometimes shown carrying a gun). Knowing how to draw these types of weapons/tools is very valuable.

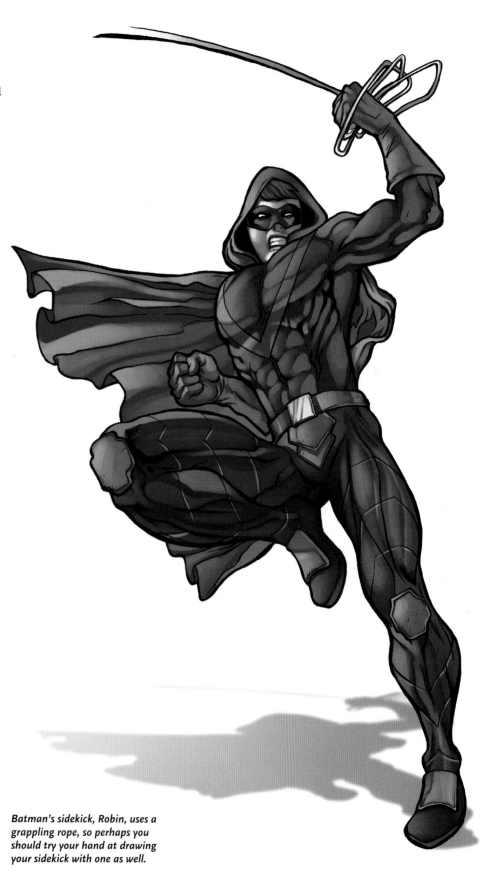

Batman's sidekick, Robin, uses a grappling rope, so perhaps you should try your hand at drawing your sidekick with one as well.

Heroes can often be defined by their villains.

THE TRUTH ABOUT VILLAINS

Get ready to be shocked, gentle and not-so-gentle readers alike. I'm going to let you in on yet another scribing secret. Despite the title of this chapter, I'm here to tell you: *There's no such thing as a villain.*

That's right. You heard me. Let that sink in for a few seconds.

"But, Stan," I hear you furiously asking, "how can you say there's no such thing as a villain? What about the corrupt, conniving characters whose creation you yourself have been party to? What about Drs. Doom and Octopus? What about Magneto and the Mole Man? What about Googam and his pernicious pappy, Goom?"

Well, you know what, friends? Those nefarious nudniks may be viewed by you, me, and the general populace of the worlds they inhabit as dirty, rotten scoundrels and vile villains. But—and here's the takeaway—*they don't see themselves as villains.*

Each and every villain in comics, in movies, in novels—and especially in real life—thinks of him- or herself as the good guy. The hero. The one noble spirit who stands between civilization and chaos, between salvation and doom—between good and evil!

Even the Brotherhood of Evil Mutants didn't think of itself as evil. That name, of course, was coined at a time when comics were aimed more at kids than many of them are today, so a name like that was not a problem. When you're writing stories for young children, having characters refer to themselves as "evil" is fine. Plus, "The Brotherhood of Evil Mutants" is just a cool-sounding name. But even the Brotherhood's

founder, the multifaceted Magneto, never thinks of himself as evil. Like all of us, he is *the hero of his own story.*

In other words, the goal of every villain worth his or her salt is to do the right thing according to his or her personal values. No one ever thinks, "I'm about to do an evil thing, even if I have another option." We humans are champions at rationalization, at convincing ourselves that we're doing the right thing, no matter how we must twist logic to get to that conclusion. We need to believe that what we are doing is somehow good, or at least the lesser of two (or a hundred) evils.

The best villains think they're heroes. Redhand, from Dynamite's Green Hornet, *is no exception.*

Doctor Doom may be a dastardly villain, but to Doc Doom himself, he's a great hero. Maybe he's got a point—he even starred in issue #20 of Marvel Super-Heroes, *with art by Larry Lieber and Vince Colletta.*

WHAT YOU AND DOC DOOM HAVE IN COMMON

Every villain thinks he's a hero. Dr. Doom wants to control the world so the planet can be a more harmonious and orderly place. Magneto wants to subjugate all non-mutants so that mutants can be safe. The school bully wants your lunch money because he feels like he's misunderstood and picked-on himself and he's fighting for all the picked-on people in the world. (Besides, he's hungry. Sort of like Galactus on a smaller scale.)

This doesn't make people who do bad, evil, nasty things *right* or *good*. It doesn't mean that everything is relative and that we can never know what's right and wrong. But as someone creating superheroes and supervillains, the first thing you need to "get" before you create evildoers is that villains believe—maybe even more than some heroes do—that *they and only they* know what's right and that they and only they have the guts to do what needs to be done.

Now that I've shocked you into stunned silence with my philosophical rant, let's get on with talking about how to create supervillains. That's right: Now that I've told you why there's no such thing as a villain . . . I'm going to show you how to create villains. (Makes sense to me . . .)

THE IMPORTANCE OF A "GOOD" BAD GUY

I know you'll be flabbergasted to discover that I'm about to quote myself, from the prologue I wrote for my *Bring on the Bad Guys* book. What did I say that was so peerlessly profound? It was this:

Once we've invented a hero, that's it. He's pretty much the same, issue after issue. He's predictable. And that's only natural, because we've had time to get to know him, to learn to anticipate his reactions. . . . Our villain has to be unique, clever, inventive, and full of fiendish surprises. . . . Most of our Bullpen story conferences are concerned with the selection of the right villain for the right hero, and, most important of all, with ways of making you care about the villain. For, make no mistake about it, you've got to be as interested in the scoundrel as you are in the stalwart in order for the story to work.

Hey, that was pretty insightful of me, wasn't it? You'd think I do this kind of thing for a living or something.

In 1976's Bring on the Bad Guys, *I did some deep thinking about what makes for a great villain. But it's here in this book you're reading that I divulge the secrets of how to go about creating indelible evildoers.*

A BELIEVABLE CHALLENGE

As writing and editing legend Denny O'Neil likes to say, a hero is only as good as the villain he faces. In other words, you can't know how heroic or resourceful your hero is unless he goes up against someone who is not just his equal in power or determination or intellect—but up against someone faster, stronger, smarter—*and* more ruthless!

So you could even say that—in a different way, for sure, than my old pal Spider-Man—villains have a great responsibility that comes with their great power. They have the responsibility to make you, the reader, believe that the hero doesn't stand a chance against them. As a creator, that makes your job creating villains in some ways harder than creating heroes. You have to make your reader believe that, despite the fact that your hero triumphs over virtually every villain he or she faces—or else said hero would be long deceased—that this time, *this time*, he just may have run out of luck and the bad guy—whether a new or old creation—is going to defeat our valiant hero once and for all.

In other words, just like you had to create "heroic heroes" back in chapter 2, now I'm giving you an equally redundant—and equally important—job: creating truly *villainous villains!*

Dagon was just one of the ruthless villains who would menace the world in Dynamite's Meet the Bad Guys.

Villainous Attitude

Most villains have that "attitude" we attributed to superheroes in chapter 2, except they have it in spades. Villains are less concerned that people like them than they are in having people fear and respect them, or if not them, at least their willingness to use whatever means are necessary to achieve their goals. For bad guys, attitude goes beyond being merely confident and assertive. For them, attitude means arrogance and contempt.

SUPERVILLAIN ARCHETYPES

To start, I'm going to show and tell you about villains who use the most lethal weapon of all: the human brain. With a combination of genius and greenbacks, these smarties can buy, or have made for them, all kinds of sinister gadgets.

THE L-TYPE: MARIO MANS

Supervillains can and do come in all sizes and shapes. But the ones I want to focus on here are built just like regular people. They may or may not work out regularly. Their aim is to intimidate you by putting on a display of eerie calm and confident power—think here of someone like Superman's classic nemesis, Lex Luthor. Moving forward, I'll call this the L-Type villain, or Mario Mans.

Another example is billionaire bad-boy industrialist Obadiah Stane, who went up against the invincible Iron Man in comics, cartoons, and in the acclaimed first *Iron Man* movie. (Yes, I know that, technically, Stane is dead—but what villain worth his sodium chloride has ever let a little thing like that keep him down for long?)

Mario Mans clearly works out—or else he has his tailor pad out his suits. In the modern world, a villain, especially an L-Type, doesn't have to have a bizarre physical form.

Modern society fears villains who aren't so obviously evil. We're media-savvy enough to know that the image people present isn't always who they really are. Think of a scientist or an industrialist—someone who seems like a pillar of the community. Someone with those credentials can be a hero, in the mold of Anthony (Iron Man) Stark or Bruce (Batman) Wayne. But that same sort of person—well-dressed, well-groomed, well-spoken—can also serve as a façade for someone whose ambitions go well beyond plain old greed, into a zone where nothing short of world domination will suffice for their egos.

THE COSTUME OF THE L-TYPE VILLAIN

Like heroes, some L-Type villains wear a consistent style of civilian clothes that gives them a recurring look that can be thought of as a costume. For the L-Type, like Mario Mans, the costume-equivalent is his all-black business suit that seems as if he were wearing garments made out of the deepest shadows. Perhaps he'll even add a black tie to match.

The idea is that he wants to look like the meanest, most ruthless businessman he can. He looks like he might even be going to a funeral—*yours!* Let's face it, people are divided in their feelings about businessmen, especially

Little Orphan Annie's *Daddy Warbucks helped establish the visual shorthand for a wealthy businessman. He was even bald before Lex Luthor!*

ones who wear expensive, tailored suits. They might admire and respect them, but they can also excite jealousy, envy, and distrust. What did that guy do to deserve being so rich when I work just as hard as he does and I'm *not* rich? (Historical note: While the modern version of the L-Type seems to have come into vogue in the 1980s, the look does seem to owe something to the imagery of Daddy Warbucks in Harold Gray's classic *Little Orphan Annie* syndicated comic strip.)

PENCIL TO PAPER

Of course, the villain you think of when I describe a character like that is bound to be (aside from your school's principal) someone like Obadiah Stane. He may be a tad shy of the 9 heads tall that our superhero types are, but only a tad. There's always a strong hint of tension in his posture and his walk. He's always waiting for something to happen, hypervigilant—he's seeking out a victim—someone he can torture with a cruel word or a condescending glance. He's also concerned with anything or anybody that might threaten him. He's certainly not concerned with protecting anyone else.

You want to convey the feeling that this character fears and respects nothing and no one. You want to give the impression that he knows enough martial arts to kill you with his bare hands—but that he's also capable of snapping his fingers and having a legion of assassins do you in while he stands coolly by.

The head, chest, and waist should all be in alignment. The business suit hints at a well-developed physique, but doesn't overstate it. He's not trying to look like a body-builder. That's what he has hired muscle for.

Mario Mans

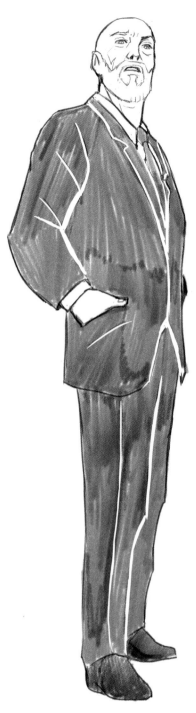

Although the suit should be dark and sleek, there should still be a hint of folds and shadows in the material to indicate that he is indeed wearing a cloth suit, not a skintight outfit.

Mario Mans is suave and sophisticated. His clothes should reflect that. The inking should emphasize the expensive material and expert tailoring of his clothes. Everything is sharp and exact, with no ambiguity of line.

MARIO MANS

Attributes: The startling archenemy to Captain Titan and Big Boy (see pages 41 and 79). Possesses genius business acumen and a smooth style.

THE J-TYPE: CHEEX

The other type of villain here—and maybe you know someone like this—is one who wants you to think he's insane and capable of anything. In this way, this archetype has some similarity to the B-Type hero. Remember, since B-Type heroes like Searchlight don't have superhuman powers, one thing they need is for their enemies to think they might do anything at any time—even if it meant they'd do themselves in at the same time that they blew their foes to smithereens. Thematically, the most extreme version of this type of villain is Batman's nemesis, the Joker. So in his "honor," we'll call this second type of supervillain the J-Type.

This bombastic badman isn't your school principal or your boss. He's not after the authority-figure-to-the-max look. Our J-Type villain, Cheex, is the derelict with the crazy eyes who looks like he won't take no—or even yes—for an answer.

The Clown, from Dynamite's Project Superpowers, is a terrifying villain who, like the Joker, turns a benign figure into a terrifying one.

Cheex embodies exactly what we find scary about madness: its unpredictable nature and the threat of violence that hangs like a cloud around those possessed by it.

An L-Type villain like Obadiah Stane may be scary and intimidating, but at least you sense that if he gets what he wants, he'll move on and leave you alone.

With Cheex you're thrown off-balance. Is he crazy? Only he knows for sure—and maybe even *he doesn't!*

PENCIL TO PAPER

When you're creating a J-Type villain, like Cheex, he can be 9 heads tall or average height. However, you want

This is the guy you move away from on the subway—except, before you can reach the door, he's there standing right next to you. He's rubber-limbed but tense. He could be harmless—but he could also be lethal. And you won't know which until he acts!

to always invoke a sense that he is a super-extreme version of Mario Mans or Searchlight. Cheex should always have the air of a coiled snake, ready to attack at any moment, whether he's personally threatened or not, even if he's asleep. He's a master showman, always on, which means his enemies (heck—even his friends) can't really tell what he's thinking or what he'll do next.

It's hard to tell if Cheex works out or not. He nonetheless gives off a manic kind of energy. He should give the impression that even if he can't sprint 100 yards, he's unhinged enough to still be lethal!

Nothing lines up on this figure. He's loose like a dancer doing warm-up exercises.

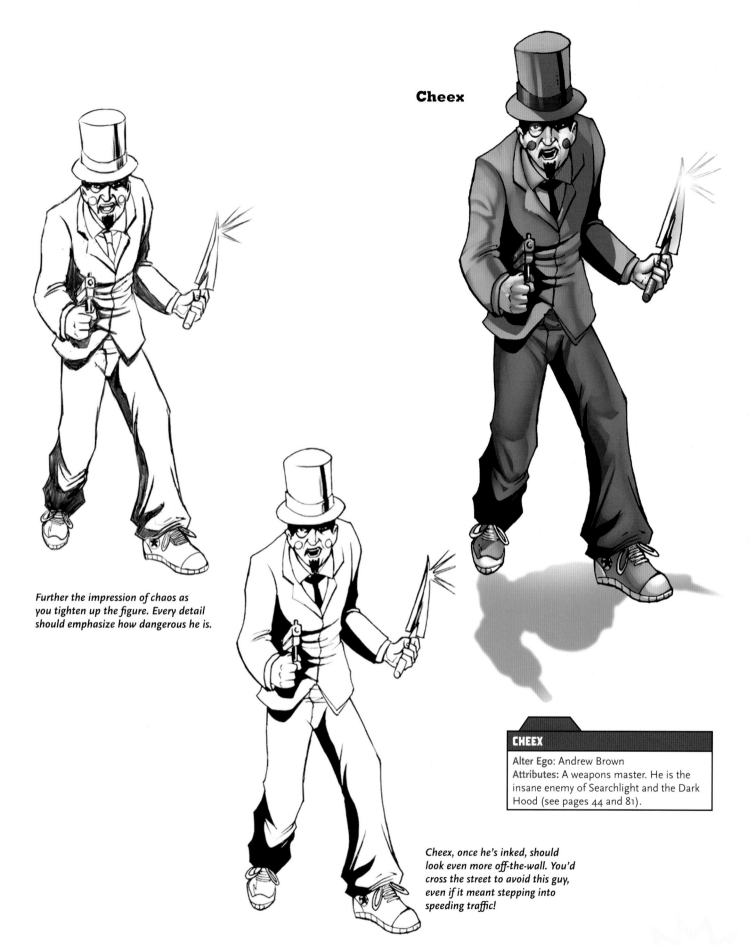

Cheex

Further the impression of chaos as you tighten up the figure. Every detail should emphasize how dangerous he is.

CHEEX

Alter Ego: Andrew Brown
Attributes: A weapons master. He is the insane enemy of Searchlight and the Dark Hood (see pages 44 and 81).

Cheex, once he's inked, should look even more off-the-wall. You'd cross the street to avoid this guy, even if it meant stepping into speeding traffic!

DRAWING BASICS FOR BAD GUYS

As with the superhero types, many villains fall somewhere on the spectrum between the two types covered here, or mix and match elements of both. Still, whatever the individual physical or personality traits of your malevolent masters of misanthropy, there are some drawing elements that come into play with just about all of them.

FACIAL FEATURES

Mario Mans may look sane (compared to Cheex), but in some ways, he's also crazy as the proverbial bedbug, because not only (like all villains) does he not think he's evil, he also thinks he's perfectly rational. In fact, that rationality is a thin veneer over deep but, usually, well-controlled madness. This insanity is mainly seen in his face.

In the case of an L-Type villain whose face is completely or partially covered by a mask, these same attitudes can be conveyed through subtle shifts to the parts of the face you do see—sneering lips, for example. If you can't see any features, then subtle shifts to eyeholes and any other facial-feature analogues are how mood and attitude are conveyed in this character. You always know how, say, Spider-Man is feeling, through body language and small but significant changes to his eyelets, the angle of his head, etc. Same with a fully masked supervillain.

Okay, now take a person and show him in three different moods—happy, sad, and then angry—all while making sure we know that this is a *villain*. Do it for Mario Mans first. Then do the same for Cheex.

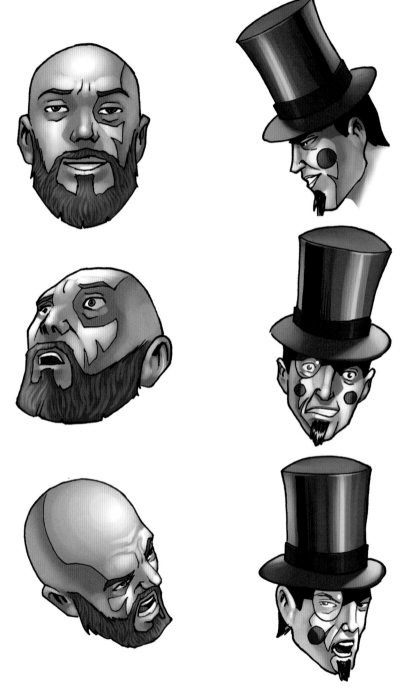

The facial expressions of Mario Mans are similar to that of a superhero. The difference is that Mans, while handsome, should always give the sense that he feels superior to everyone else. He should always look as if he's smelling something offensive, even when he's smiling. Think of a boss or teacher you've had for whom nothing is ever good enough. As for Cheex—well, he's crazy! (Or he wants you to think he is.) His expression should be full of menace and unpredictability.

FRONT UPPER TORSO

Now let's take a closer look—literally—at the villains. You're not always going to be drawing their full figures or facial close-ups. Very often, you'll be drawing them in a medium shot where we see the upper half of their bodies.

This should feel familiar. It's not that much different from how you drew the medium shot of Captain Titan—especially his civilian, non-costumed identity.

This take differs from what applies to either the heroes or the L-Type villains. The same thinking used for the general attitude of Cheex applies here. He's crazy as a—well, whatever you think of as crazy, double that for this miscreant.

SIDE ANGLE

Another skill you need to develop is drawing villains from a side angle. (Once you learn how, no one will ever be able say to your characters are two-dimensional.)

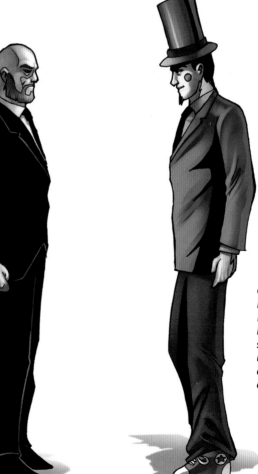

Here's a different point of view on this rotten-to-the-core rapscallion. A photo or a live model is the best way to assure you have everything about the figure moving just right.

Cheex is as focused in his way as Mario Mans. But his body language—even in a sideways view—should make you feel as if he could go ballistic at any moment.

ACTION SHOTS

Now here's what you've been waiting for! The chance to draw the villains in action against the heroes. I know it took awhile, but there were a lot of things you had to learn so you could do your best at it. So what are you waiting for? Let's draw some superhero vs. supervillain action!

The tricky thing about drawing a superpowered hero going up against a non-powered villain is convincing the reader that it's any kind of challenge at all for the hero. If the non-powered villain's mind and gadgets are powerful enough, then it becomes believable that this villain could be a threat to the hero.

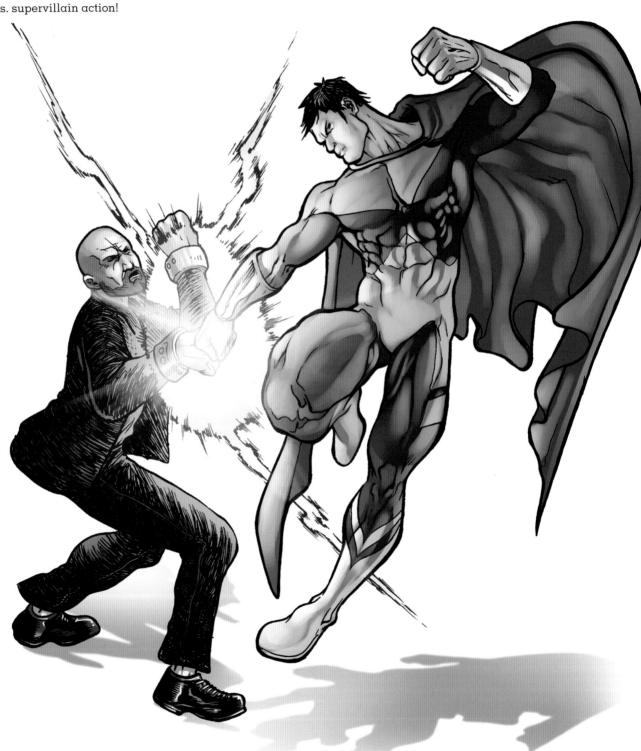

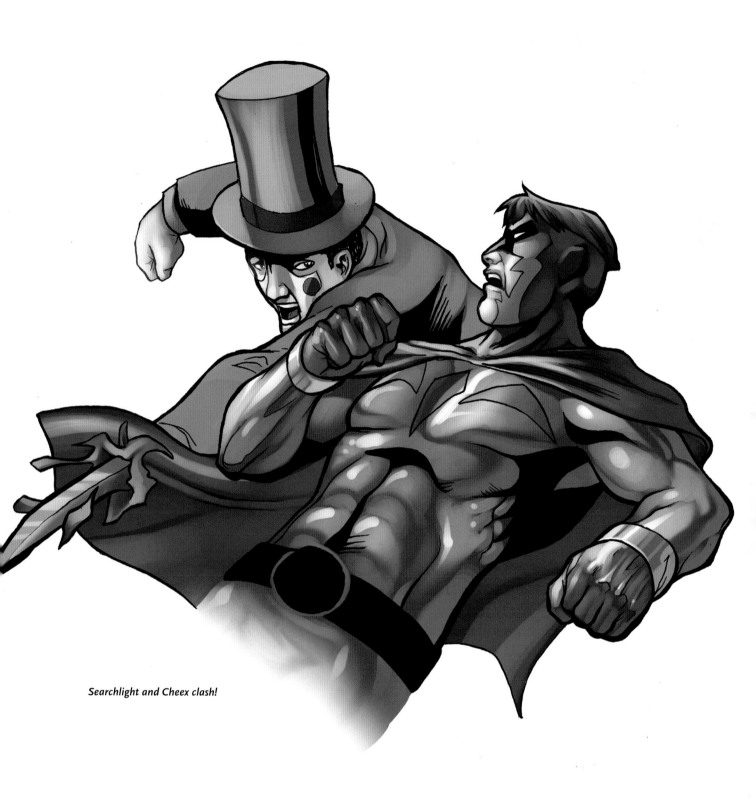

Searchlight and Cheex clash!

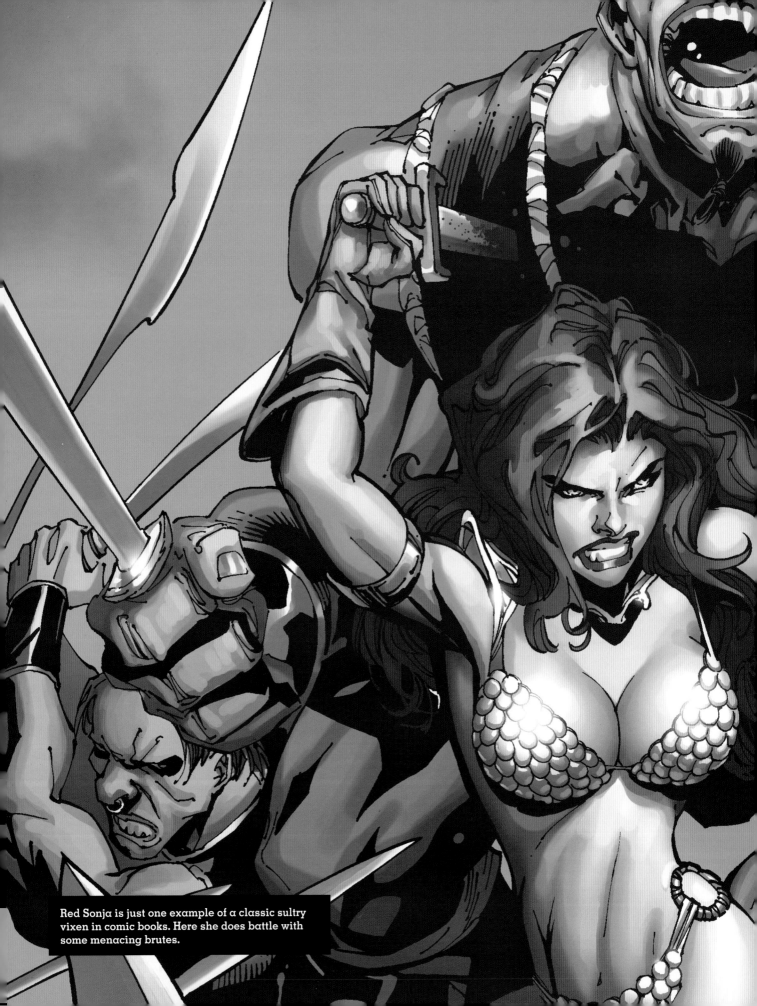

Red Sonja is just one example of a classic sultry vixen in comic books. Here she does battle with some menacing brutes.

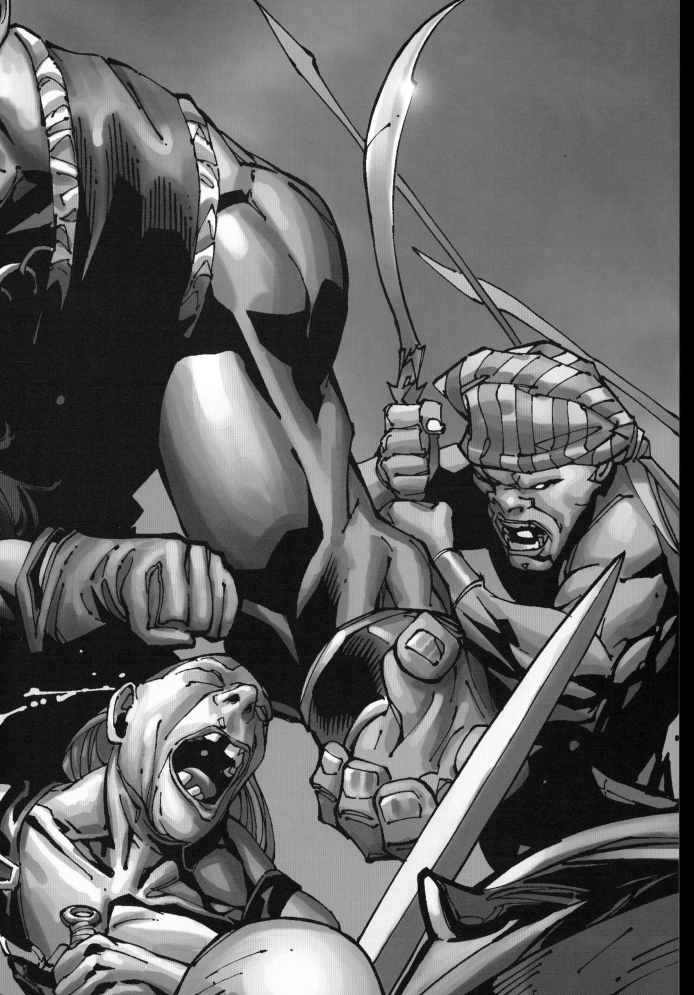

POWERFUL BRUTES AND SEXY VIXENS

Alrighty then, folks, it's time to turn our attention to a couple of interesting character types that truly make our crazy, madcap industry just out-of-this-world fun. Of course it's quite possible that I'm more than a bit prejudiced about them. You see, I sort of got my start in this wacky industry of ours writing about brutes and vixens (only in my day we referred to vixens as Mata Hari types).

On the brute side, I worked on stories featuring characters with memorable names like Droom, Grogg, Goom, Rombuu, Grattu, Monstrollo, Manoo, Bombu, and of course (a personal favorite of mine), Fin Fang Foom. We called these big fellas BEMs or Bug-Eyed Monsters. For a time they were all the rage in comics. In fact a couple of Marvel's biggest stars today (Hulk and the Thing) are the spiritual grandsons of those original monstrous creatures.

Dejah Thoris and the White Ape of Mars qualify as a vixen and a brute.

THE DIFFERENT ROLES OF BRUTES

A brute can be either a villain (or a villain's stooge), a random misunderstood BEM, or the actual hero of the story. You simply can't judge a book by its cover.

Now that I've gotten that out of the way, it's time to get down to how you go about creating your brutes. How do they differ from standard portrayals of superheroes and villains, and what are their physical attributes? Well, you're about to find out.

Defining "Brute"
- A nonhuman creature; a beast.
- A brutal, insensitive, or crude person.
- The animal qualities, desires, etc., of humankind: Father felt that rough games brought out the brute in us.

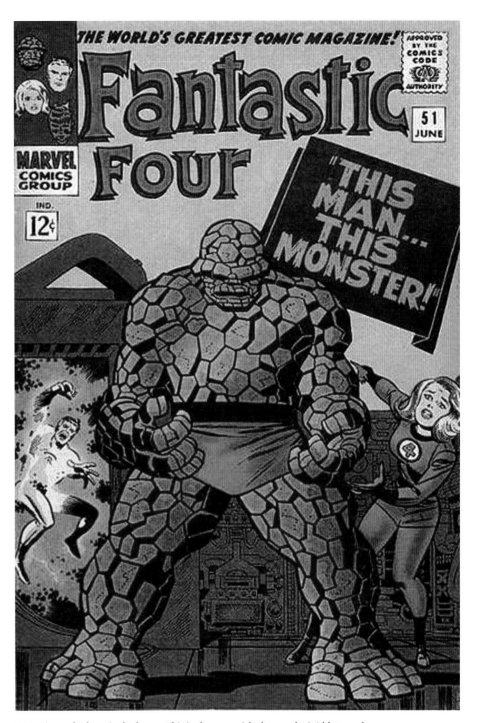

Sometimes the hero is the brute. This is the case with the ever-lovin' blue-eyed Thing of the the Fantastic Four.

BUILDING A BETTER BRUTE

Let's take a look at how to build a brute of truly monstrous proportions. First you need to get the perspective right. So if a standard hero is 9½ heads tall, make your brute 12 to 15 heads tall, so that he truly towers over your hero.

Just like other characters, the brute needs to be fully proportioned and able to express himself visually. That is to say, he should have more than one facial expression. Sure, you can have the brute always be a growling monster, but that is so two-dimensional and, well, trite (in movies when a character has only one way to express themselves that character is called a cartoon cutout). So let's not give the critics any more ammunition, and create characters that have depth, characterization, and motivation, eh?

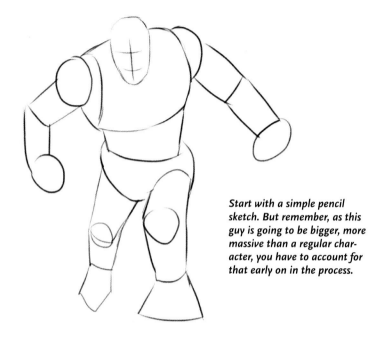

Start with a simple pencil sketch. But remember, as this guy is going to be bigger, more massive than a regular character, you have to account for that early on in the process.

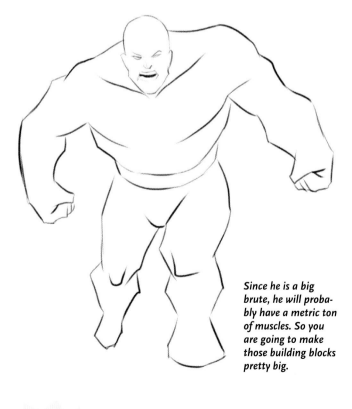

Since he is a big brute, he will probably have a metric ton of muscles. So you are going to make those building blocks pretty big.

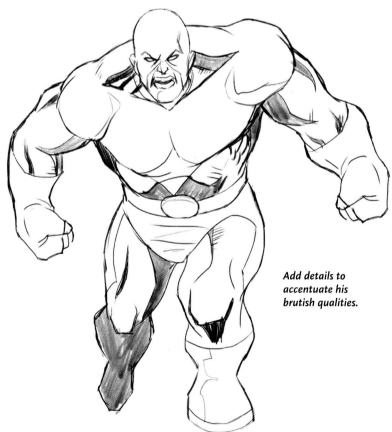

Add details to accentuate his brutish qualities.

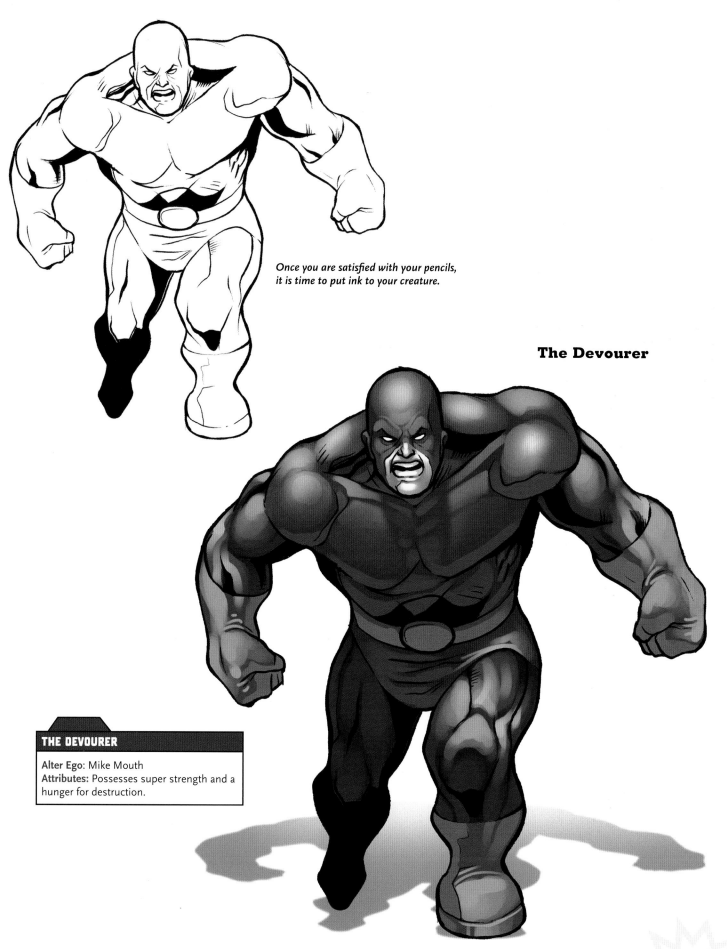

*Once you are satisfied with your pencils,
it is time to put ink to your creature.*

The Devourer

THE DEVOURER

Alter Ego: Mike Mouth
Attributes: Possesses super strength and a hunger for destruction.

BRUTISH EXPRESSIONS

Brutes are often characters of big actions but very few words. As such, you need to pay special attention to their facial expressions, which can be made to speak volumes. The Incredible Hulk, for instance, isn't likely to come out and tell you that he's having a bad day. Heck, sometimes he doesn't even know how he is feeling. However, you can figure out how the big green guy is feeling by reading his facial expressions. A furrowed brow, a pair of pursed lips, or a downward stare can let you know that he is confused, concerned, or sad. With a brute, these expressions are exaggerated due to his massive form. They are very important if there is an inability to communicate. Check out an old-timey silent film some time, and you will find that actors such as the great Lon Chaney had to "show not tell" what they were feeling. This is what is called melodrama, and it is really quite an art form.

ALIEN BRUTES

One of the most interesting and popular brute types is the otherworldy brute (like Tars Tarkas from Edgar Rice Burroughs's John Carter of Mars stories). Yep, you can really go to town when designing an E.T. Let me tell you that designing aliens and otherworldy creatures is some of the most fun that artists can have in this business. That's when they really get to cut loose and have themselves a good time. So take a look at the sizes and shapes (and colors) of some of the brutes in this chapter, then go to town and pull out all the stops. Only you can put limits on yourself (and the characters you create) when drawing.

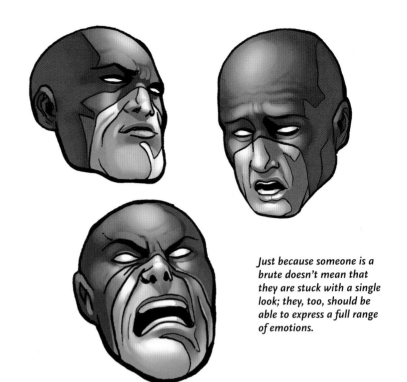

Just because someone is a brute doesn't mean that they are stuck with a single look; they, too, should be able to express a full range of emotions.

IF YOU'RE HUNGRY-- TRY EATING ME.

From Dynamite's Warlord of Mars, Tars Tarkas of Mars isn't just a double-threat because of his four arms. He's an alien and a brute rolled into one. An "out of this world" brute, you could say.

HUMAN BRUTES

To be sure, you are a touch more constrained in your creative design when you are building a human brute. Obviously they have to be . . . well, human, but even here, you get to have some leeway in your character design. Take, for instance, the Kingpin!

With all of previous figure drawings, I've been telling you to pay close attention to life models, toning, and the body's natural musculature. With someone like the Kingpin, you can pretty much toss all of that out the window. (Hey, rules are made to be broken, effendi!) As you can plainly see, Kingpin appears to be a massive mound of blubber. Only he isn't; he is every bit as strong as any other brute. So the trick with Kingpin is to make him appear to be a terrifying figure, even though he looks like a big pile of Jell-O. This can be done by using a lot of upward-angle shots. Have him towering over his underlings and use light and shadows to add to his menacing appearance. Of course you can also employ dialogue to demonstrate how dangerous a brute like the Kingpin really is.

Kingpin is one of the most unique Spider-Man villains of all time!

Gorillas Gone Wild

During the 1960s it was very trendy to put gorillas on the covers of comics; in fact, the talented crew over at DC Comics tended to do this quite a bit. As the story goes, whenever a gorilla appeared on the cover, sales went up. So, needless to say, for that period of time, gorillas proved to be very lucrative brutes for DC. This trend actually continued into the 1970s, quite possibly because of the popularity of the *Planet of the Apes* movies. Whatever the reason, gorillas kept showing up on covers—even though they tended to be more on the covers of comics like *Tarzan* instead of *Superboy*.

During the 1960s and '70s gorillas were very popular over at DC Comics.

THE BRUTE IN ACTION

Okay, now it's time to let our brute smash, crash, and rampage. Remember, brutes come in all shapes and sizes, so they won't all act and react the same way. Think about how your brute's physique and character work with his action. If he is a hulking hulk, then he may fight with pulse-pounding punches. If he is a four-armed goliath of Mars, then he may have quick reflexes to go along with his great strength, enabling him to pull off some senses-shattering moves. Whatever you do . . . make your brute *BIG!*

As I've already shown, just because you look like Frankenstein's monster, that doesn't mean that you are a bad guy.

Sometimes the brute can be a monstrous BEM who is rampaging through a city attacking innocents and who needs to be stopped by a powerful superhero.

TIME FOR THE VIXENS

Let's talk about these sultry women of ambiguous morals who want to not only knock over a bank, but also seduce the hero and (quite possibly) rule the world all at the same time.

In the world of comics, there are plenty of vixens to go around, and virtually every hero has at least one sexy Sadie who would just as soon kiss our hero as bean him with a Buick. This relationship is seen over and over again with Catwoman and Batman; Black Cat and Spider-Man; Iron Maiden and Dynamo; Elektra and Daredevil. All of these women are beautiful beyond belief. And yet even though they all usually walk on the wrong side of the law, they all find themselves attracted to the super-heroes who pursue them.

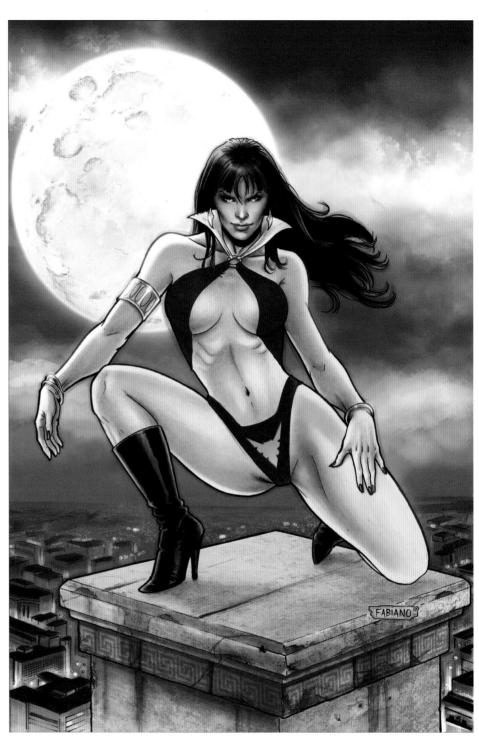

One of the most beautiful vixens in the comic world is Vampirella.

DRAWING THE VIXENS

When drawing vixens, there really isn't much difference between them and the superheroines from chapter 3. The vixens are just as sexy and alluring as superheroines (perhaps even more so). Their costumes are every bit as revealing (again, perhaps even more so). Perhaps the major difference between heroines and vixens is that the vixens know what they want—which can be anything from justice to jewels—and they are willing to do whatever it takes to get it.

More than once you have probably seen these attractive bad girls turn our heroes' heads only to then turn on them and make off with whatever prize they had set their eyes on at the beginning of the tale. You would think that our heroes would catch on eventually, but perhaps they keep holding out for the vixen's better nature to take hold and for her to walk down the righteous path to goodness and light. That probably isn't going to happen anytime soon! (Besides, if it did, we would lose some of the best story ideas, eh?)

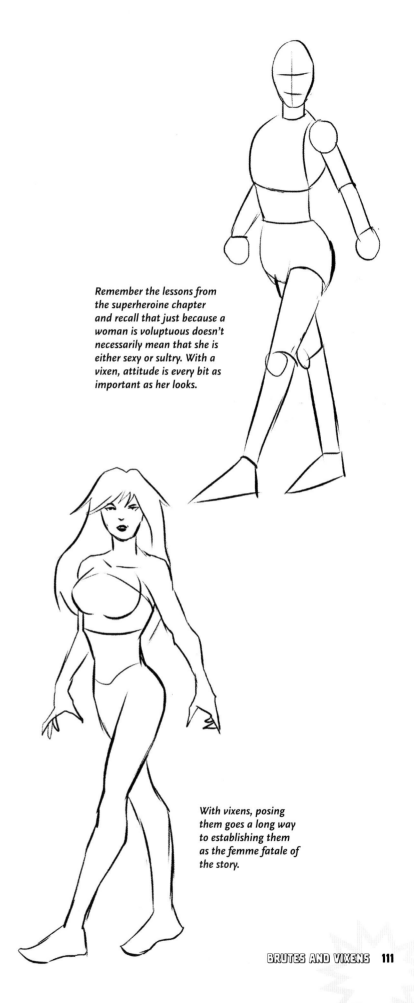

Remember the lessons from the superheroine chapter and recall that just because a woman is voluptuous doesn't necessarily mean that she is either sexy or sultry. With a vixen, attitude is every bit as important as her looks.

When drawing your vixen, you need to remember that sexy is more than tight clothing and a large bustline. It is the way a woman presents herself, the look in her eyes, the pout of her lips. In fact, her whole look needs to be considered.

With vixens, posing them goes a long way to establishing them as the femme fatale of the story.

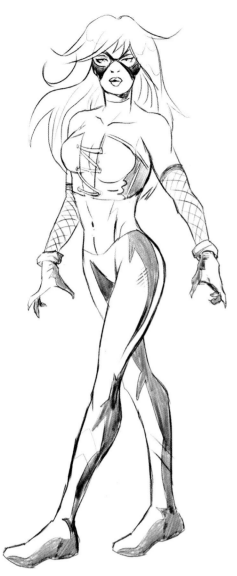

As you tighten your pencils, make sure to dress her in very alluring clothing. (Hey, clothes can make the woman as well as the man, if you know what I mean.)

As you add your inks, you want to refine her figure, making sure to pay attention to not just her body, but her face and her eyes as well, for it is with her eyes that a woman truly seduces a man.

Scandalous

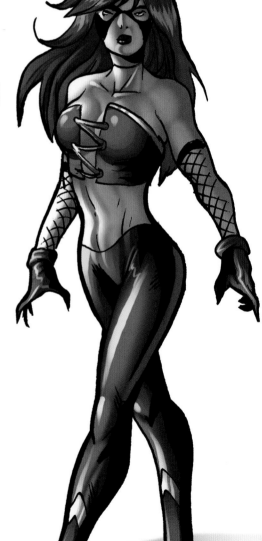

SCANDALOUS

Alter Ego: Ashley Smash
Attributes: An enemy of but also romantic love interest for Searchlight (see page 44). Possesses fighting skills.

FACES AND EXPRESSIONS UP-CLOSE

Look at the softness of the vixens' expressions, the glint in their eyes, the tilt of their heads as they give you that come-hither look that you just know will be followed by them confusing you all to heck and then making off with whatever booty was on the table before you let down your guard. Don't believe me? Then take a look at these images and tell us if you can remember what you were thinking about before you looked at them.

Being able to render top-flight bad-girl art is not something that every artist can do, but you should be able to successfully render the female form. Women are curves and soft lines, even these vixens who most assuredly could hand you your own head in a knock-down, drag-out fight. You want to make them both sexy and ferocious, sultry and alluring. You want your vixen strong enough to stand up to your hero in a fair fight, yet sexy enough to hold his attention while they aren't duking it out. She needs to be sweet with an air of innocence, yet experienced enough to be a master criminal.

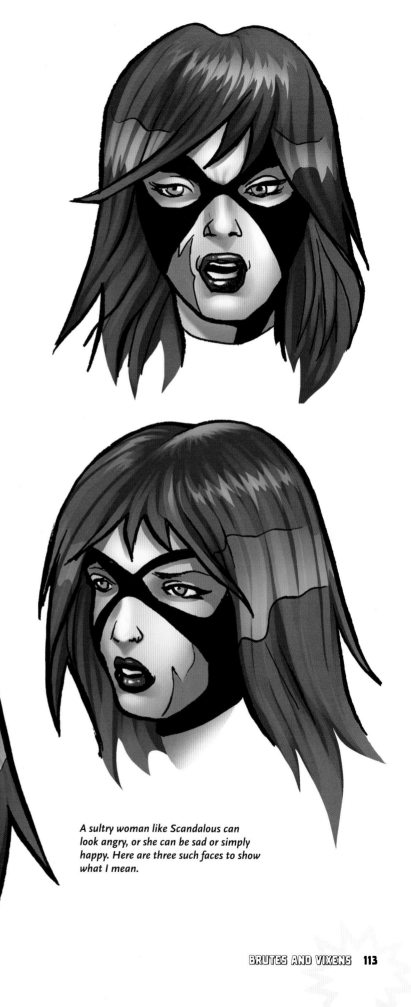

A sultry woman like Scandalous can look angry, or she can be sad or simply happy. Here are three such faces to show what I mean.

THE DUALITY OF THE BAD GIRL

You've probably heard of the classic bad girl with the heart of gold. It is this duality of nature that makes the vixen the ideal foil for your hero. She isn't truly evil like the Red Skull, but she walks a fine line between good and bad. It is this nature (and of course a skimpy, skintight costume) that keeps your audience clamoring for her return visits.

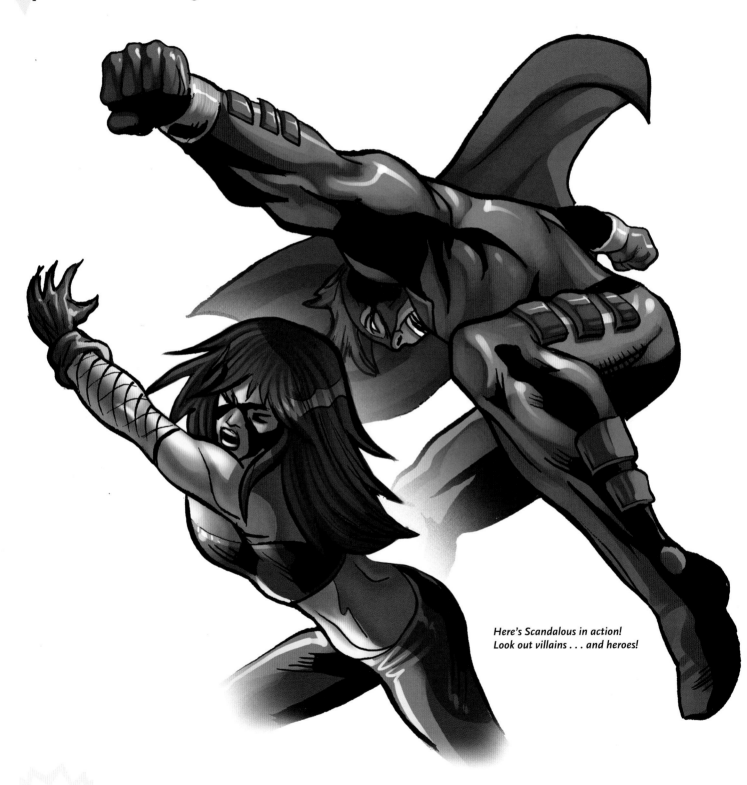

*Here's Scandalous in action!
Look out villains . . . and heroes!*

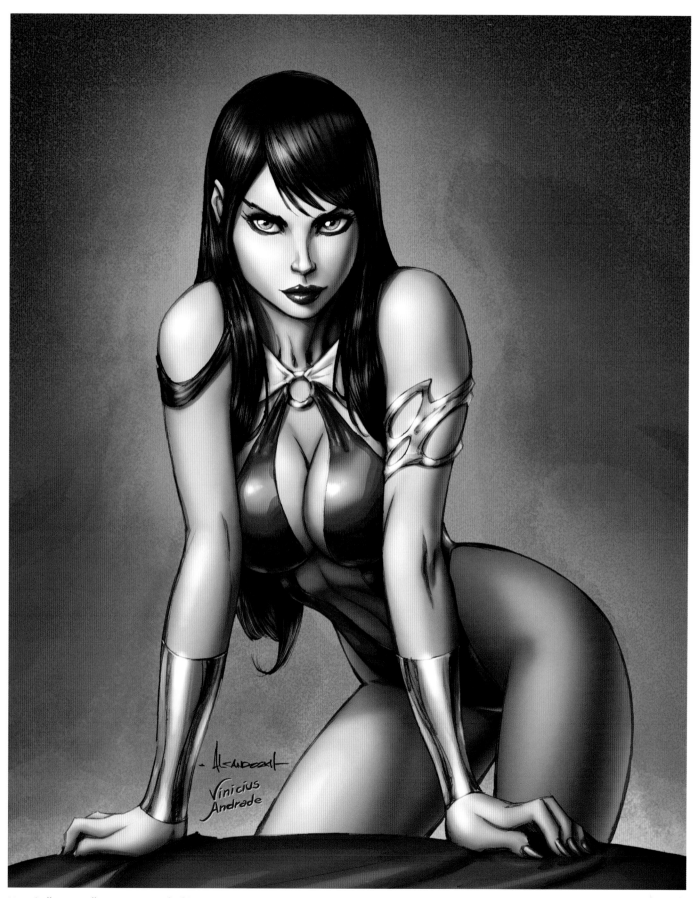

Vampirella so totally wants to put the bite on you.

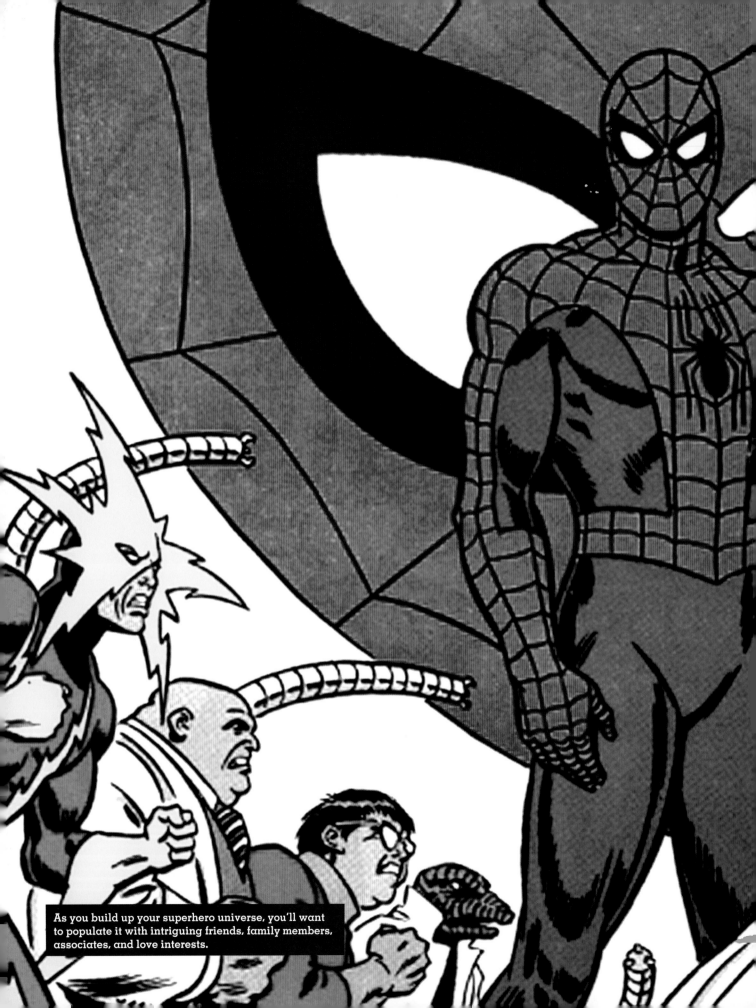

As you build up your superhero universe, you'll want to populate it with intriguing friends, family members, associates, and love interests.

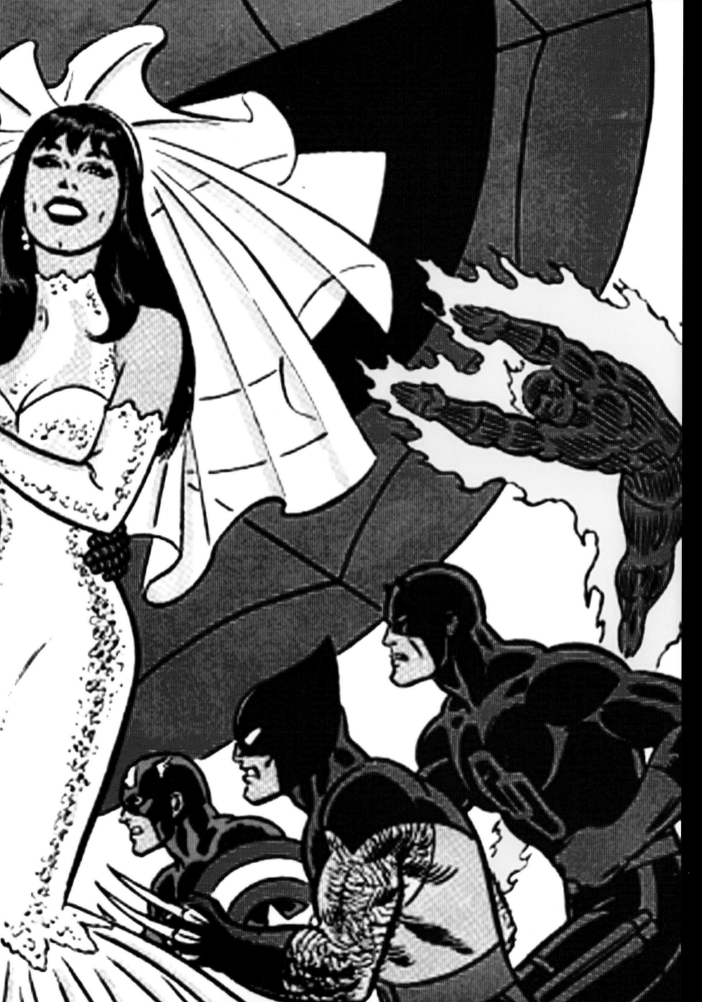

CREATING SENSATIONAL SUPPORTING CHARACTERS

Okay, all the supporting characters in the room—raise your hands!

Hmmm. I don't see any hands. Do you all have vibranium in your ears or something?

What's that you say? *You're not a supporting character. You're the main character in your own life story.*

Hey, me, too!

Everybody is the star of his or her own life.

Just as we saw in the Villains chapter, where no one thinks of himself as a villain—well, no one thinks of himself as a supporting character either. Nonetheless, in fiction, there are supporting characters. Otherwise, our superheroes would get pretty lonely. Who would they talk to? Who would they work with? Who would they fall in love with? Who would they rescue from dastardly supervillains?

SUPPORTING CHARACTERS DEFINED

The most important role of a supporting cast member is to reflect some aspect of the main character or characters. If they don't do that, they probably don't belong in your story or series.

As an example of a supporting cast I'm really proud of, let's take the case of the ever-amazing Spider-Man. In the "classic" version of Spidey, who's his best friend? Well, depending on the era, it's Harry Osborn or Flash Thompson. Who's Spider-Man's closest family member? Gotta be Aunt May, although for the married version of Peter Parker, Mary Jane would be a right answer too. MJ would also qualify as his love interest. (More on that later.)

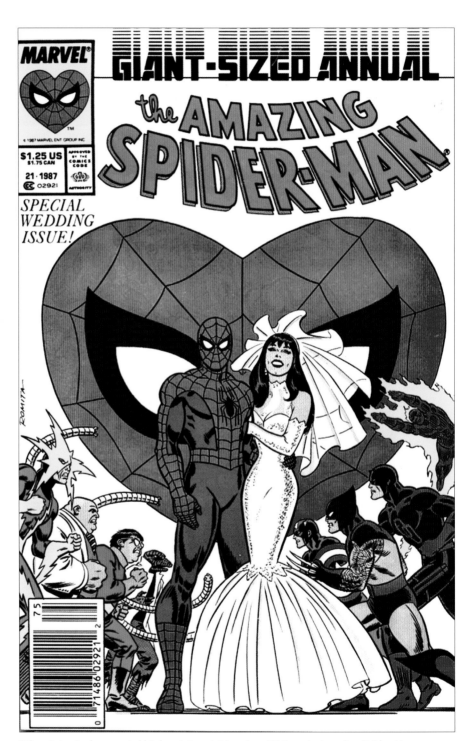

When Peter Parker married his love interest, Mary Jane Watson, in Amazing Spider-Man *Annual #21 in 1987, his entire supporting cast showed up. Although they're not currently married in the comics (long story . . .), she's still one of his love interests.*

INTRODUCING THE NON-STARS OF THE SHOW

Okay, so you have your superhero or heroine ready. You have the archenemy supervillain ready. You probably even have ideas, general or specific, for what kind of supporting cast will work best with your hero or heroine. But how and when do you introduce them to your eager readers?

Well, there are no hard and fast rules, but the odds are that, in most cases, you'll be introducing them to the reader in the first or possibly second appearance of your hero or heroine. Usually the first.

Just about every superhero or heroine has at least one or two supporting characters in his or her life from the get-go. After all, the introductory story of a superhero—whether it be the hero's actual origin or a first appearance with the hero already having

embarked on a career as a daring do-gooder—almost always needs someone for the protagonist to interact with. I suppose it's possible that a character could be alone—trapped in a cave, for instance (as Dr. Don Blake was when he first became the mighty Thor)—or locked in an intense fight with a villain or villains. But those are rare situations.

Still, even a character without a supporting cast nearby is understood to have one somewhere. After

all, "no man is an island," as John Donne so famously said.

In the first Batman adventure, in 1939's *Detective Comics #27*, we meet Commissioner James Gordon. In *Action Comics #1*, we meet not only Superman (and Clark Kent) but Lois Lane as well. In Spider-Man's debut in *Amazing Fantasy #15*, we meet Aunt May and Uncle Ben, as well as foe/friend Flash Thompson and sometime love interest Liz Allen.

In Thor's first appearance in Journey into Mystery #83, *Larry Lieber, Jack Kirby, Joe Sinnott, and I had Don Blake become Thor on a solo trip to Norway. We didn't establish any supporting characters until the next issue.*

LOVE INTEREST

The key role that any superhero's love interest plays is that of the person closest to the hero. She's his sounding board and, more than any other member of his supporting cast, is the point-of-view character for the audience.

For instance, Superman's love interest, Lois Lane, grounds him in his humanity, and yet always reminds the reader, subliminally, that Superman is a superpowered being from another planet.

Marvel mainstay Spider-Man went through several relationships—not bad for "nerdy" Peter Parker—including those with characters Betty Brant and Liz Allen, before he finally met Mary Jane Watson. The two would proceed to be an item and then break up and get together time and again. It was only when MJ told Peter she had known pretty much all along of his secret life as Spider-Man that they could come to terms with what that meant to their relationship and move forward.

Even after the murder, by the Green Goblin, of Peter's first true love, Gwen Stacy, it would take Spidey a long while before he would realize how deep his feelings were for Mary Jane, and hers for him.

Whether as girlfriend or wife, Mary Jane is Spider-Man's grounding in the real world. Because she secretly knew of his career as Spider-Man from early on, Mary Jane is the one person Spider-Man trusts with his feelings, be they joy or sorrow, ecstasy or insecurity.

Great Moments in Supporting Cast History #1: Superman first met Lois Lane in 1938's historic Action Comics #1.
She's been an essential part of the Superman mythos from the very beginning.

FAMILY SUPPORT

A superhero's family members are often important members of the supporting cast. From the Bible to Shakespeare, to the most current novels, movies, TV series, and comics, fathers, mothers, and siblings play key roles in heroes' and heroines' lives, from starting them on the road to herodom, to making their lives richer and more well rounded. Everyone has a family of some kind, even if they've never met them, and much of what we do is because of—or in spite of—our upbringing.

Superman had *two* families, in each of which he was a beloved only child. His Kryptonian family—dad Jor-El, mom Lara—only knew him a short time before they launched him into space in that famous mini-rocket to save him from the fate of their doomed planet. Equally, or perhaps more importantly, Superman's adoptive parents, Jonathan and Martha Kent, were key to providing Kal-El/Clark with positive values and served as moral guides as his powers developed.

In the mighty Marvel mythos, Spider-Man had two sets of parental figures as well. His actual parents, Richard and Mary Parker, gave their lives for their country, leaving four-year-old Peter in the care of his father's brother Ben and his wife, May. Without any children of their own, the pair raised Peter as if he was their son, showering him with love and attention. They also imbued him with a strong sense of values, including the concept that, "With great power there must also come great responsibility." This, of course, is the theme that would guide Peter's behavior for the rest of his life.

Shakespeare's King Lear and his daughters. Lear is the center of attention, of course.

In this classic painting by Raphael, Moses is adopted by the Pharaoh's daughter after he was sent floating down the river to safety by his birth-mother, not unlike how Superman's Kryptonian parents rocketed him to Earth.

BEST FRIEND

While the love interest may be the superhero's closest confidante, another supporting cast member who is key to a hero's story is his best friend. A superhero and/or his alter ego needs to have one person, who is not a romantic interest or relative, who he can confide in and lean on in times of crisis. That's Jimmy Olsen's role regarding Superman, and Harry Osborn's with Spider-Man (although this part is sometimes taken by Peter's former high school tormentor, Flash Thompson). The best friend shows us how the world sees the superhero and is in a way the eyes and ears of the audience, without the complications a romantic relationship entails.

The best friend is capable of heroic acts, but usually only when there's no other option. After all, he doesn't have superpowers or fancy gadgetry. But when the hero's back is to the wall—or when the best friend is the only one who can hold off the bad guys until the hero gets there—then the BF shows that there's more to him than even he, himself, is aware of.

(As you no doubt know, there are stories where the best friend gets some kind of superpower, and it's in these stories that we see why the hero—and not the best friend—is the hero. Generally, when a best friend gets powers or gadgetry, he does what you or I might do—he screws up!)

Supporting Cast Members Gone Wild

If you're a superhero's supporting cast member long enough, the odds are you'll end up with some kind of superpowers at various points in the relationship. I don't know if anybody's kept count of how many bizarre incarnations Jimmy Olsen has gone through. And now that I think of it, Peter Parker's pal Harry Osborn has taken on his dad Norman's mantle of the Green Goblin more than once! Readers (and writers) love to see how the relationship between the hero and his cast is affected when the supporting players become superhumans, too. And why not? Those stories are fun, and, at their best, can offer us insights into the hero and the best friend.

THE ASSOCIATE YOU ASSOCIATE WITH

Finally, there's the associate type of supporting cast member. *Daily Bugle* editor-in-chief Joe "Robbie" Robertson is an example of that in the Spider-Man mythos. Joe admires and respects Spider-Man and has high regard for Peter's photojournalism skills, but doesn't hang out with either incarnation. His function is, largely, to give Peter photography assignments that often turn into missions for Spider-Man. As Peter Parker's boss, he also plays the role of authority figure, in some ways a parental stand-in. Robbie is the "good father," in contrast to *Bugle* publisher J. Jonah Jameson's "bad father."

Secrets

One hallmark of best friends—and of romantic couples, for that matter—is that they share secrets. So it's interesting that, in different eras and incarnations of the classic superheroes, sometimes the hero's best friend and/or his love interest know his secret identity and sometimes they don't. I don't know about you, but it'd be hard for me to suddenly start shooting laser-blasts from my eyes without my wife finding out about it. But maybe you're better at keeping secrets than I am!

INCIDENTALLY . . . DON'T FORGET ABOUT INCIDENTAL CHARACTERS

Besides supporting characters, there are incidental characters who serve the narrowest of support-style functions in a story—say the person who sells the hero a package of gum and wishes him a nice day.

If the plot requires the hero chew gum or the reader see how he interacts with someone who sells him gum, then you need a gum-seller, who likely won't be seen again in that story. Heck, you may never see the guy again, period!

On the other hand, if the hero strikes up a conversation with the gum vendor, and every issue or episode he has an interaction with the vendor, who then becomes a part of the comic's cast—then gum-guy has graduated from incidental to supporting character.

People who just walk by in the street to indicate that the city is just that—a metropolis filled with people hurrying to and fro—well, those people are beyond incidental. You might even call them what they're called by movie producers: extras.

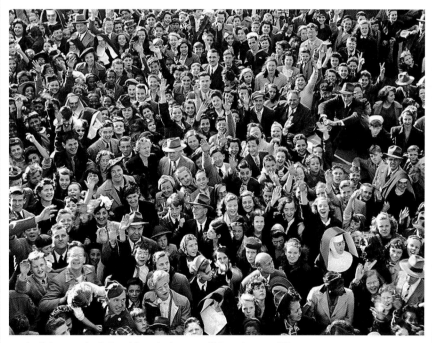

Each of the people dipicted here is the star of his or her own life.

SUPPORTING ARCHETYPES

Supporting cast archetypes are not as straightforward as hero and villain archetypes, but there are some distinctive features that they are said to have. The most common is a sympathetic quality.

In other words, a typical supporting cast member is someone who the reader or viewer likes and wants to spend time with. They're people who the reader should enjoy watching the superhero interact with. In many ways, they're idealized versions of the people the reader would like to have in his or her life: the tough but fair boss, the devoted best friend, the loving girlfriend or spouse, the caring (but not overinvolved) family member.

Physically, there's more room for variation in some of these characters than there is for the hero or heroine. That said, since superhero stories are fantasies of the way we'd like things to be, the odds are that the hero's girlfriend/wife will be classically beautiful, depending on the standards for beauty—usually embodied in movie stars—of a given era. The same holds true for the classic handsomeness of the superheroine's boyfriend or husband.

So with that theory behind us, let's get started on how we'd go about drawing Captain Titan's (see page 41) supporting cast.

Your biggest challenge in designing supporting cast members will be to make them visually interesting and distinctive—without them overshadowing the hero or the villain, but also without relegating them to the realm of "incidental characters." Sounds tricky, doesn't it? It is—but you're up to the task.

THE BEST FRIEND

Let's start developing the supporting cast with the best friend of Captain Titan's alter ego. As in movies or a TV series, the best friend is interesting, but not more interesting than the hero. He's good-looking, but not better-looking than the hero. He might be the closest thing to a "regular guy" in the superhero's inner circle. And like other regular guys, he sometimes saves the day and sometimes makes boneheaded mistakes. He should convey the sense of always giving everything his best effort—and succeeding more than 50 percent of the time.

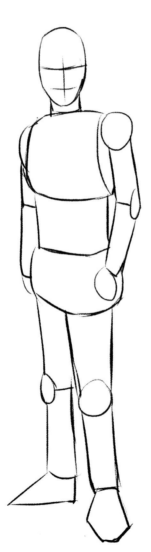

With the best friend, you want to convey, through body language, a sense of someone competent, but a little lacking in confidence.

The head, chest, and waist should be in alignment, but the body should have the sense of someone waiting for a bus. He's the average guy, with potential to one day rise above that.

Eric Racher

The best friend's clothes should be neat but casual. No tie and jacket—but no torn jeans, either.

The best friend's look should be open for color, not a lot of moody shadows.

ERIC RACHER

Attributes: Trustworthy and likeable. Means well. Unaware that Captain Titan's alter ego is his best friend, Carter Cross Jr. (see page 43).

THE FAMILY: CAPTAIN TITAN'S FATHER

An S-Type hero like Captain Titan can have a small tight-knit family or a large, sprawling one with dozens of cousins. It's up to you and how you envision your hero and his world. Right now, let's draw his father. Eventually you'll have to learn to draw other members as they become important to the stories. But since sons are bound to be notable for how similar to—or how different from—their fathers they are, people are likely to be interested in who Captain Titan's father is and what he's like.

As with the hero himself, the dad should have his head, chest, and waist in alignment.

Captain Titan's father is a hardworking guy, always ready to lend an ear and offer wisdom. He spends a lot of time at the office, and maybe not as much as he should at the gym. He's serious, but not humorless, and has a bit of a middle-aged paunch.

Carter Cross Sr.

Everything about Dad says "sensible," which is exactly what a son dealing with a crazy world full of weird menaces needs!

Captain Titan's dad is inked open for color, without many shadows. Like his son, he has nothing to hide. What you see is what you get.

CARTER CROSS SR.

Attributes: A hardworking father, provides Carter Cross Jr. (see page 43) with sensible advice, and serves as his son's role model for good morals.

THE BOSS

An important figure in most people's lives, the hero's boss is the one who, by definition, sets his or her employee's agenda. The boss is generally a good guy, although stress may make him explode in anger once in a while, especially if the hero's civilian side messes up in his assigned task (probably because he was out saving the world).

In any case, the boss—and I'm not talking about Bruce Springsteen here—is competent and responsible, but he's got too much to do and not enough time to do it. He may be well paid—but he has no time to enjoy that salary and expense account. His job is the main thing in his life. He's good at it, but it takes a toll on him.

Now all you have to do is translate that into your drawing.

Not Everyone's a Fan
In most cases, the supporting cast members are all folks who feel positively toward the hero. They like the guy. But remember—there can also be supporting cast members who *don't* dig the hero. One such naysayer is lovable ol' J. Jonah Jameson, the newspaper publisher Spider-Man loves to loathe—and vice versa.

Jonah hates Spidey with a passion, and yet isn't a villain. He's got his own point of view on who's a hero and who's not. Even though he's not supportive of the web-slinger, he's a very important supporting cast member who enriches Spider-Man's world.

The boss is an important supporting player to an S-Type hero like Captain Titan. He's an associate, someone the hero deals with regularly but isn't as close with as his best friend. He wears a vest and a loosened tie, but no jacket. His sleeves are rolled up.

The boss's posture isn't great. He slouches a bit and has an ample gut. But there's still a fire that burns in his eyes.

Josh Greenville

The boss's clothes were freshly pressed yesterday. Unfortunately, he spent the night sleeping at his desk because he was waiting for a reporter to submit a story.

As with the tight pencils, the inks on the boss should give the feel of a guy stretched beyond his limits. He's irritable, but still on the hero's side.

JOSH GREENVILLE

Attributes: The gruff boss at the office of Carter Cross Jr. (see page 43). Sometimes his personality may clash with Carter's, but he is ultimately supportive.

THE LOVE INTEREST: DORIS DELILAH

With all the villains and crises and secret identities, it'd still be a pretty lonely world for Captain Titan without a love interest—wife, girlfriend, friend who's more than a friend—you get the idea. But it takes a special kind of woman to be a superhero's love. The good news: Her male-pal is probably an admirable, dependable guy. The bad news: He risks his (and sometimes her) life on a daily basis.

So be kind as you draw Doris Delilah, Captain Titan's love interest. Despite her enviable role, she's got a lot to worry about, too.

For the love interest of Captain Titan, you need to draw someone who stands tall and proud. There's none of the indecision of the best friend.

Sleek is the word for Doris Delilah. Whether all black or open for color, her clothes fit her in a flattering manner. They need a crisp, hard line.

Doris Delilah

Doris Delilah wears a basic black dress. Depending on the need, she should look at home at a White House meeting or at a country-western saloon.

The inks accentuate the feeling established in the pencils. The elegant but strong ink-lines define her as beautiful and forceful.

DORIS DELILAH

Attributes: A confident and capable nurse, the attractive love interest to Captain Titan (see page 41).

PUTTING THE CAST TOGETHER

Now that you've drawn each scintillating supporting cast member, it's time to put them all together in one sensational shot with their Herculean hero.

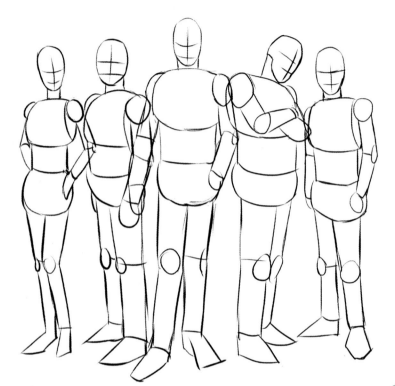

Draw the individual characters as established earlier in this chapter, two on either side of the hero, who's in his civilian identity. The trick here is to combine all five figures—the hero flanked by his father, his boss, his best friend, and his love interest—in a dramatic manner. Also, have the hero stand a bit in front of the others. He's the star after all.

Duplicate what you did with each individual figure before. Adjust anything that may seem awkward or off-balance about the way they stand together.

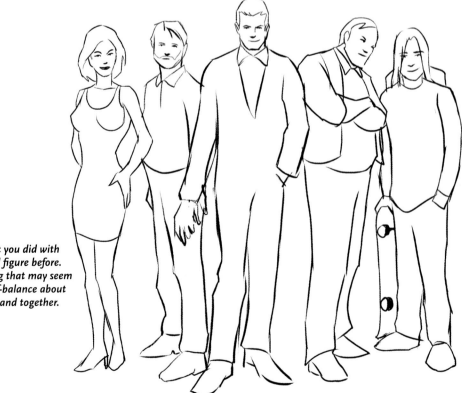

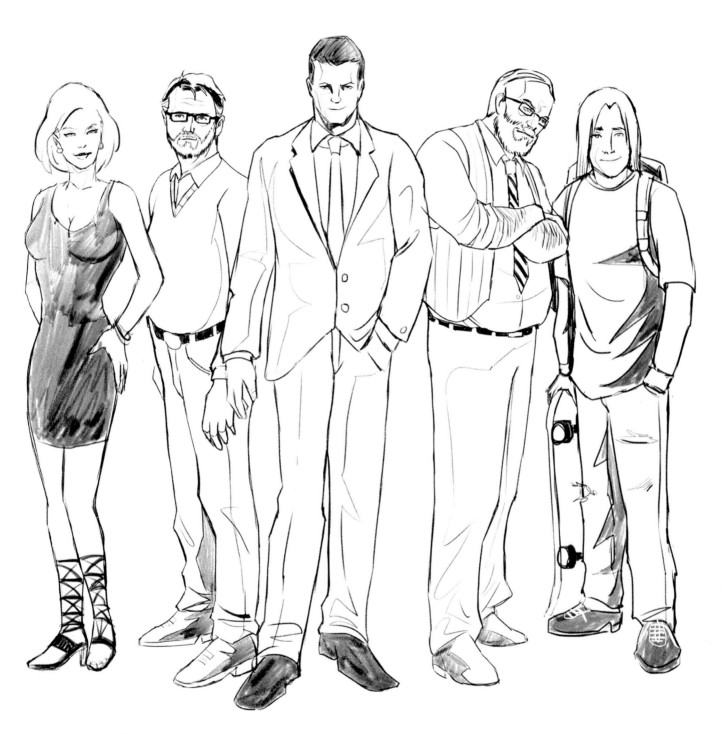

As you solidify the pencil art, some problem areas may appear where one or more characters might need to be modified to look right when standing with the others.

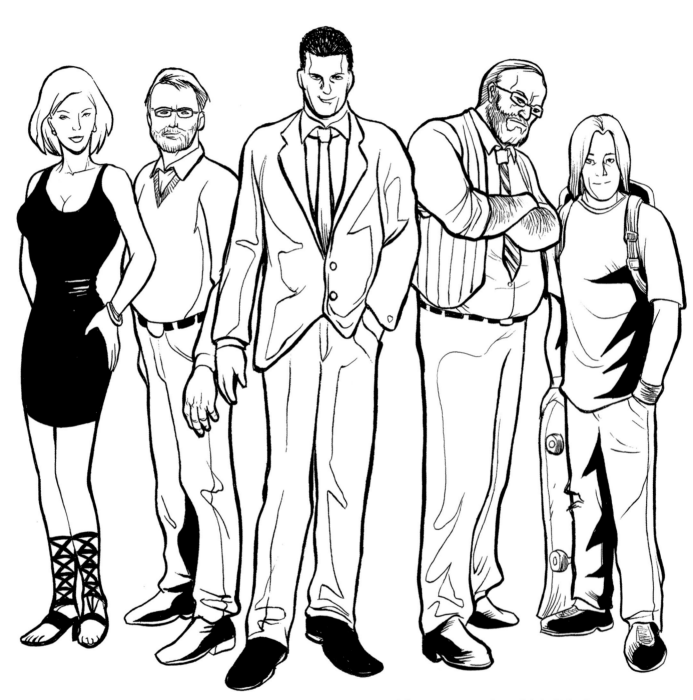

You might want to try putting a slightly thicker line around the superhero-in-civilian duds to emphasize that he's the main character.

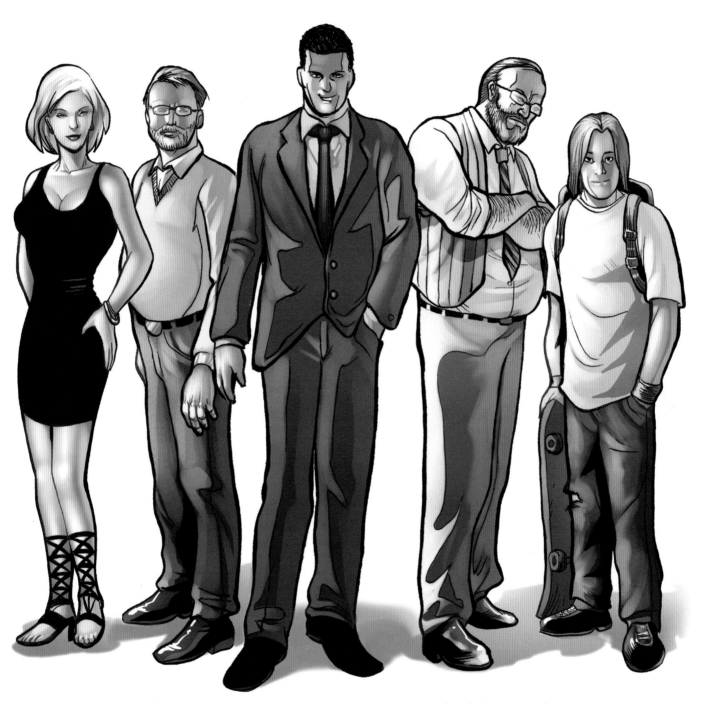

In the coloring stage, you have one more opportunity to bring the hero forward.

Superheroes often do battle with otherworldly creatures.

HERE THERE BE MONSTERS

You know, superheroes don't just find themselves thwarting the sinister schemings of salacious supervillains; they also often find themselves confronting the denizens of the dark who are determined to rain down destruction and death. I'm talking, of course, about *monsters*, those horrific creatures that come in various shapes and sizes. You know how long storytellers have been spinning tales of monsters? For as long as they've been spinning tales about heroes.

The Greek poet Homer was writing about monsters almost 3,000 years ago. In his epic poem *The Odyssey* Homer had his hero, Odysseus, fight through a gauntlet of monsters, including a Cyclops, the cannibalistic Laestrygonians, the seductive Sirens, and the six-headed sea creature Scylla. Another famous monster you might have heard of is the serpent-haired Medusa. The ancient Greeks created her, too. Her mere gaze turned men into stone. Thankfully, she was beheaded by the demigod Perseus.

As great as they were, though, the ancient Greeks can't take credit for everything. It was the Anglo-Saxons from more than 1,000 years ago who narrated the story of their fictional hero Beowulf killing not only the ferocious Grendel but also Grendel's equally ferocious mother. And if that wasn't enough, Beowulf ended his life killing a dragon. And lest we forget, the Norse god Thor famously battled the hostile Giants. (Considering how many years I spent writing *Thor*, you can think of me as something of a "thunder god expert.") Undeniably, monsters are one of the most commonly used opponents for heroes from all cultures.

But creating effective monsters for your superheroes to tangle with isn't as easy as just drawing big, hairy, ravenous brutes. There is more to monsters than that. To create effective monsters, you have to understand that they are the physical manifestations of our common fears.

A haunting sixteenth-century painting of Medusa by the Italian artist Caravaggio.

OUR FEAR

The most memorable monsters scare the living daylights out of us. But have you ever wondered exactly *how* they scare us? I want you to think about what has frightened people over the centuries. What did the ancient Greeks or the peaceful farmer living in medieval times fear? Back then, the world was so large and unknown, people feared practically everything beyond their familiar surroundings. What came out of the forest in the middle of the night? Perhaps common mammals like deer . . . or perhaps bloodthirsty predators! What would happen if people sailed out into the vast ocean? Perhaps they would find a new land . . . or perhaps they would find an enormous leviathan that would devour their ship!

Simply put, since the dawn of civilization, our collective imagination has transformed our fears into monsters. Once that happened, it was inevitable for monsters to get incorporated into our stories. Of course, our collective fears changed as human civilization progressed. Humans were no longer afraid of the forest or the sea. Instead, they became afraid of other things, and that meant they created new monsters to replace the ones that no longer frightened them. For instance, many commentators have remarked that as a monster, Grendel represents the distinct medieval fear of the lower classes rising up against the aristocracy. It's

In the late sixteenth century, Flemish cartographer Abraham Ortellius imagined the waters around Iceland to be inhabited by all sorts of monstrous sea creatures.

CREATIVE SOLUTIONS

Imagine different ways to overcome a monster other than just fisticuffs and violence. For instance, when the Fantastic Four first met the shape-shifting alien Skrulls, the story could have easily been resolved by having the four superheroes tear apart the Skrulls' invading spaceship. Instead, the Fantastic Four resorted to deception: By being shown pictures from comic books, the Skrulls were led to believe they would be slaughtered if they dared invade Earth. For good measure, Mr. Fantastic hypnotized the remaining Skrulls into believing they were really cows. Thus, the Fantastic Four demonstrated their ingenuity and resourcefulness. Similarly, when Spider-Man created an antidote that turned the Lizard back into Dr. Connors, he demonstrated both his scientific acumen and his compassion for Dr. Connors's situation. Again, the crucial thing to remember is that your superhero embodies several different exceptional qualities, and the manner in which your superhero defeats a monster tells the reader which of these qualities are paramount.

And besides, physical strength alone won't work against some monsters, like vampires. Sure, you can drive a stake through a vampire's heart to take him out of commission, but most superheroes refrain from resorting to that kind of violence . . . even against the undead! Again, you must imagine other means of prevailing over the monster.

no coincidence that the Transylvanian Count Dracula was created during the Victorian era when the English feared an invasion from Europe.

Let's talk about a more recent monster, one with a name I'm sure you'll recognize: Godzilla. What kind of collective fear does Godzilla represent? Well, if you don't know, Godzilla was created by a Japanese film company for a movie that debuted in 1954. According to the story, Godzilla was a towering prehistoric dinosaur that had been mutated from the fallout of an American hydrogen bomb test in the Pacific Ocean. As they watched the seemingly indestructible and unstoppable nuclear monstrosity ravage Tokyo, Japanese film audiences couldn't help but be reminded of what their country had experienced not ten years earlier. That's when two of their cities—Nagasaki and Hiroshima—were destroyed by atomic bombs at the end of World

War II. You see, the Japanese knew full well the lethal power of radiation, and Godzilla tapped into the Japanese culture's remembrance of that devastation. The fear of nuclear annihilation didn't remain isolated to Japan. It didn't take long for that fear to spread around the entire globe. Heck, it's a fear I tapped into for many, many comic book stories during my Marvel heyday.

As a survival mechanism, fear can help us avoid dangerous situations or prepare us for hostile confrontations. But being scared all the time isn't healthy. It can lead to panic or emotional breakdowns. So why in the world would we even want to have monsters as part of our popular entertainment? Why read (or write) stories about monsters if we know it will ultimately make us unnecessarily experience an emotion that isn't pleasant? To come back to Godzilla, why would the Japanese want to be reminded of

the horror of Hiroshima and Nagasaki? Well, to answer those questions, let's consider the ancient Greek concept of catharsis.

CATHARSIS

The term *catharsis* was first used by the philosopher Aristotle more than 2,000 years ago. Translated from the Greek, *catharsis* means "cleansing" or "purging." In the context of our reaction to being frightened, it means the removal of pent-up extreme emotions through the experience of them. In other words, it means you first need to *get* scared in order to stop *being* scared. Once you get the fear out of your system, so to speak, you become emotionally balanced, ready to go on with your life . . . at least until your emotions get pent up again and you need a new cathartic release. Think about how catharsis can apply to superhero stories, especially ones involving monsters: The superhero—the absolute pinnacle of human nobility and virtue—takes on the monster—the physical manifestation of humanity's irrational fears. And when the superhero triumphs over the monster, not only has the world been saved, but the readers' fears and anxieties have been relieved.

One of the original posters for the 1956 American release of Godzilla *described the monster as "King of the Monsters." I couldn't have described Godzilla better than that myself.*

THE DIFFERENCE BETWEEN MONSTERS AND VILLAINS

You should also understand the difference between monsters and villains. Both can be deadly, destructive, and dangerous. They can both be motivated by the same evil impulses of greed, envy, hate, etc. However, villains and monsters are separated by the ferocity of their actions. Monsters display an uncontrollable fury that you don't usually see in most villains. A villain like Dr. Doom is megalomaniacal and coldheartedly cunning, but he isn't bloodthirsty. He isn't inherently violent like, say, werewolves or vampires are. Villains often choose their wicked ways or become criminals in response to certain circumstances. Monsters are like animals, in that they can't help being what they are. They behave as their natural instincts direct them to behave. That is the monster's plight.

THE SYMPATHETIC MONSTER

It's this plight that can, of course, turn the monster into a sympathetic figure. After being captured and caged, who could blame King Kong for menacing Manhattan? (Besides, he did it because he believed he was protecting a beautiful lady.) Back in 1963, Steve Ditko and I created a sympathetic monster for Spider-Man in the form of the Lizard. For those who aren't familiar with the Lizard, he was a scientist named Dr. Curt Connors who was determined to solve the puzzle of the regenerative abilities exhibited by reptiles. He developed and drank a serum that he believed would regrow his amputated right arm. While the serum did indeed restore his arm, it also transformed him into the ravenous Lizard, who subsequently rampaged through the Florida Everglades. Once Spider-Man learned about what happened to Dr. Connors, he had no intention of hunting down and killing the Lizard. Instead, Spider-Man created an antidote that changed the Lizard back to Dr. Connors. Thus, Spider-Man nobly helped his newfound friend cure his affliction (at least temporarily).

Have you ever read the classic British Victorian novel *The Strange Case of Dr. Jekyll and Mr. Hyde* by Robert Louis Stevenson? If so, you've no doubt already recognized how similar Dr. Connors's situation is to Dr. Jekyll's. In the novel, Dr. Jekyll drinks a potion that transforms him into the savagely sinister Mr. Hyde. I tell you this in order to relate how one year before Steve Ditko and I introduced the Lizard, Jack Kirby and I actually fused the Jekyll and Hyde concept with the monster from Mary Shelley's *Frankenstein*. We ended up with a sympathetic monster that would eventually become one of the most recognizable superheroes in the world: that not-so-jolly green giant, the Incredible Hulk. When Dr. Bruce Banner saved teenager Rick Jones from a radioactive detonation, he was bombarded with gamma rays. Rather than kill him, the radiation radically altered Banner's body chemistry, causing him to be turned—without any warning and beyond his control—into a berserk

King Kong is one of Hollywood's most classic monsters as well as the archetypal sympathetic monster. If you ask me, everyone just needed to leave the poor guy alone!

behemoth. It became a curse Banner would have to deal with for the rest of his life. But the Hulk didn't really want to hurt anyone. He mostly just wanted to be left alone. His violent outbursts, though, put him in conflict with the U.S. military and law enforcement agencies, as well as the Fantastic Four, the Avengers, Spider-Man, you name it! They came after the Hulk because they all mistook him for the callous monster his appearance made him seem to be. In the end, Bruce Banner was always left picking up the pieces of the life the monster within him had ruined.

And that's what makes stories about the Hulk so memorable for readers. It's not so much the wanton destruction and violence. It's the tragedy of Banner's situation in that he—and not the Hulk—has to deal with the repercussions of the Hulk's rampages. It's very much emblematic of how the best monster stories affect us. Anyone over the age of five knows monsters aren't real (just as we know superheroes aren't real). But the really good monster stories trigger primal emotions, like pity or fear, in their audiences, regardless of the audiences' ages.

Everyone's favorite wall crawler first ran afoul of the Lizard in Amazing Spider-Man #6.

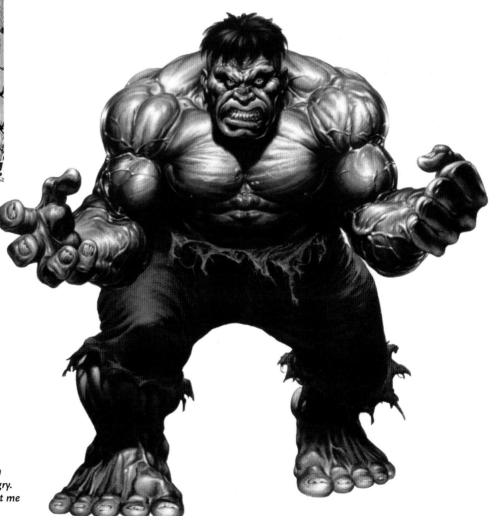

Don't make the Hulk angry. You wouldn't like him when he's angry. You're just going to have to trust me on this one.

CREATING MONSTERS THE RIGHT WAY

And now to the task at hand: creating monsters for your superheroes to fight. There are so many monster types to choose from, but let's start with aliens and vampires since they represent two distinct types of monsters.

These drawing exercises should put you in the right mindset for creating monsters. A friendly reminder, though: Unless you are creating a superhero monster (like the Hulk), your comic book isn't about the monster, it's about the superhero. So as far as your story goes, the superhero isn't serving the needs of the monster. Just the opposite: The monster's presence has to serve the needs of the superhero in some way. You want to make sure the monster accentuates some laudable aspect of your superhero. The most obvious aspect that can be emphasized is a superhero's strength. That's exactly what Beowulf demonstrated when he fought Grendel. Until Beowulf arrived on the scene, everyone who encountered Grendel died at the monster's hands. After a fierce battle, Beowulf singlehandedly slew Grendel (by ripping off the monster's arm), thereby emphasizing how much stronger and more fearless Beowulf was than every other warrior in the land.

When creating alien monsters, you're only limited by your imagination. The more bizarre an alien monster looks, the better!

ALIEN MONSTER: AVATARS

Let's create an alien version of Grendel, a creature that can only be overcome by the strongest of superheroes, and we'll call him Avatars.

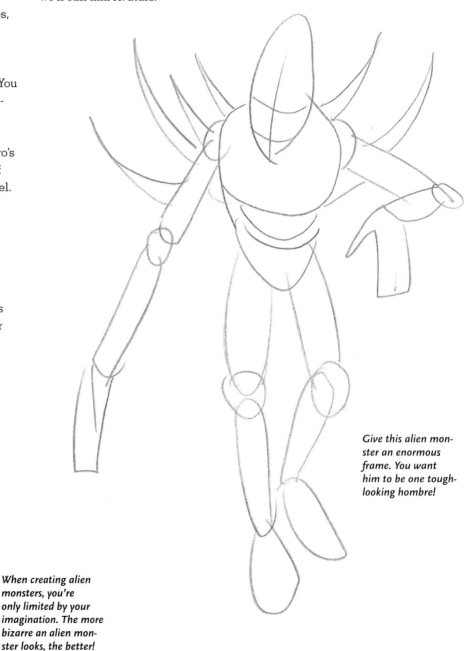

Give this alien monster an enormous frame. You want him to be one tough-looking hombre!

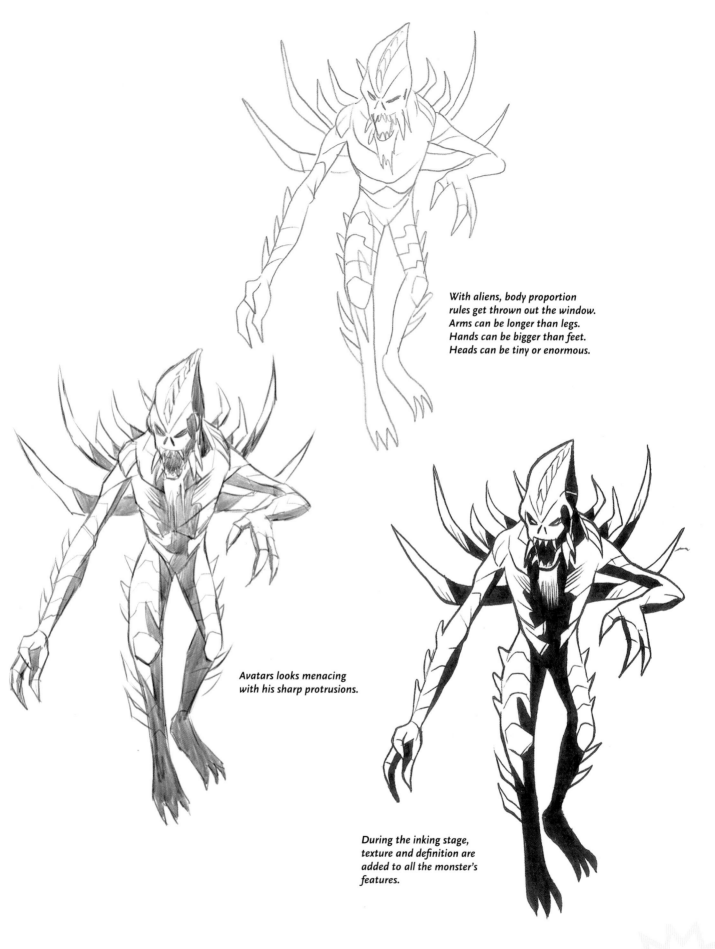

With aliens, body proportion rules get thrown out the window. Arms can be longer than legs. Hands can be bigger than feet. Heads can be tiny or enormous.

Avatars looks menacing with his sharp protrusions.

During the inking stage, texture and definition are added to all the monster's features.

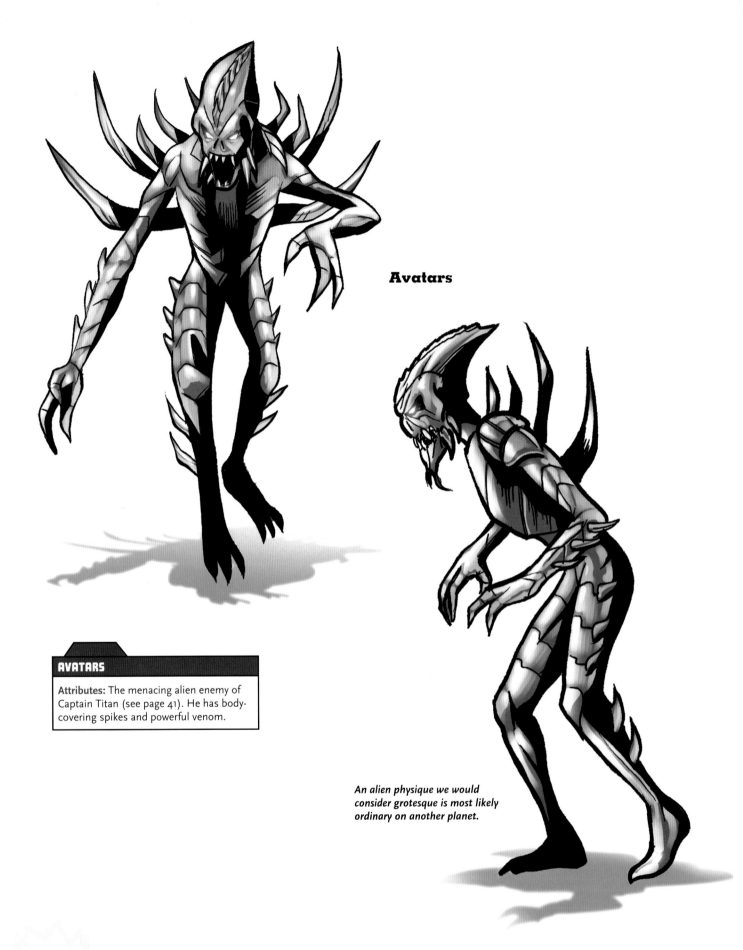

Avatars

An alien physique we would consider grotesque is most likely ordinary on another planet.

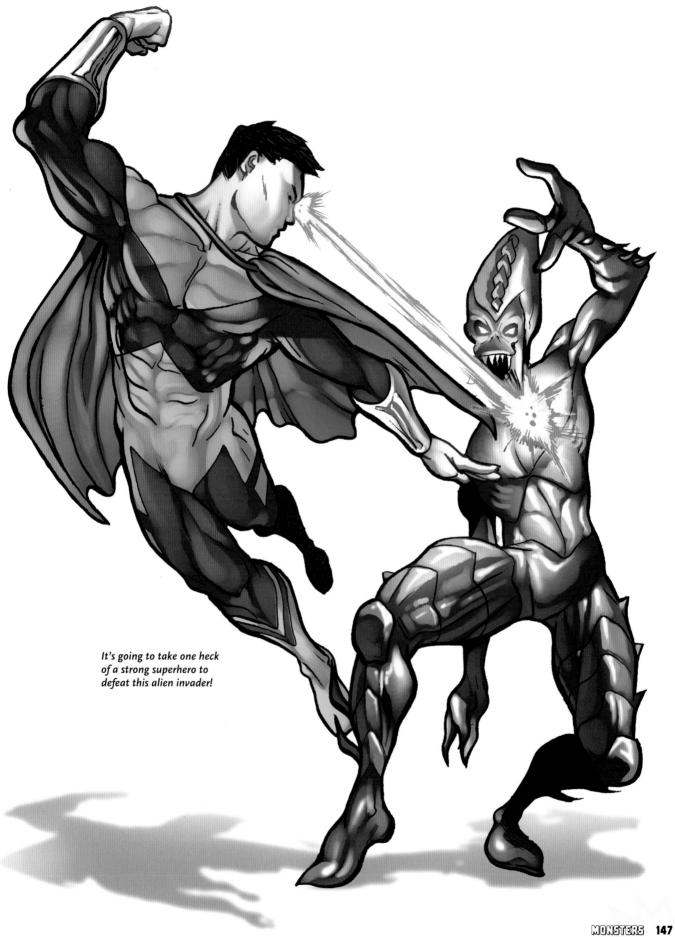

It's going to take one heck of a strong superhero to defeat this alien invader!

VAMPIRE: THE GLO

One thing this exercise will show you is just how different a vampire is from the alien monster you just created. This vampire, The Glo, is not overtly threatening, but a keen eye lets you know he's not up to good. In this way, he's much more ominous than the alien monster.

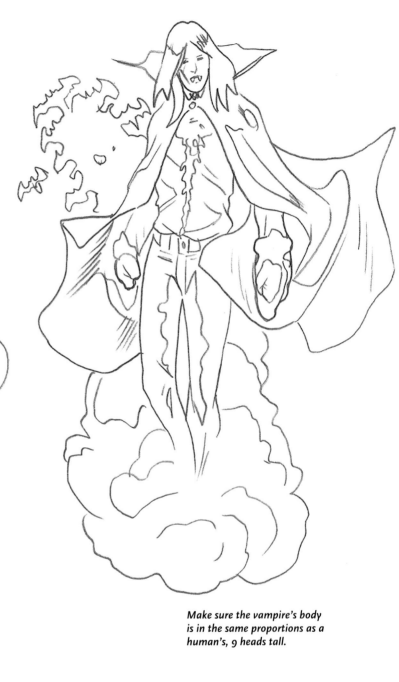

Make sure the vampire's body is in the same proportions as a human's, 9 heads tall.

Begin with a slender human frame; the vampire's slenderness belies his supernatural strength.

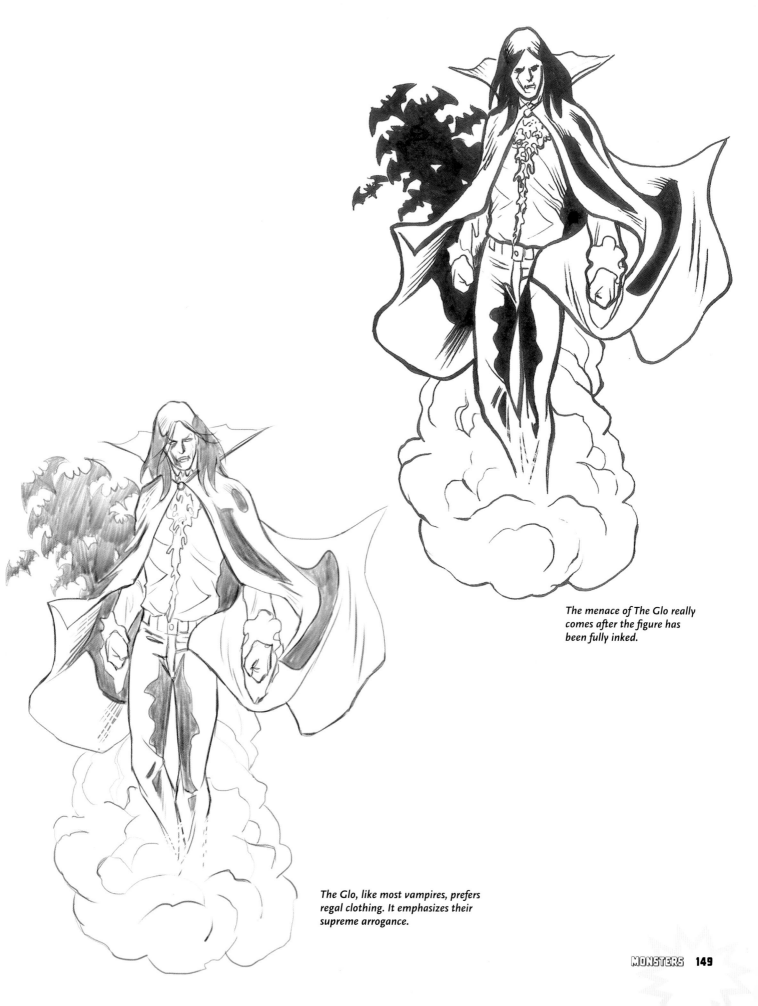

The menace of The Glo really
comes after the figure has
been fully inked.

The Glo, like most vampires, prefers
regal clothing. It emphasizes their
supreme arrogance.

The Glo

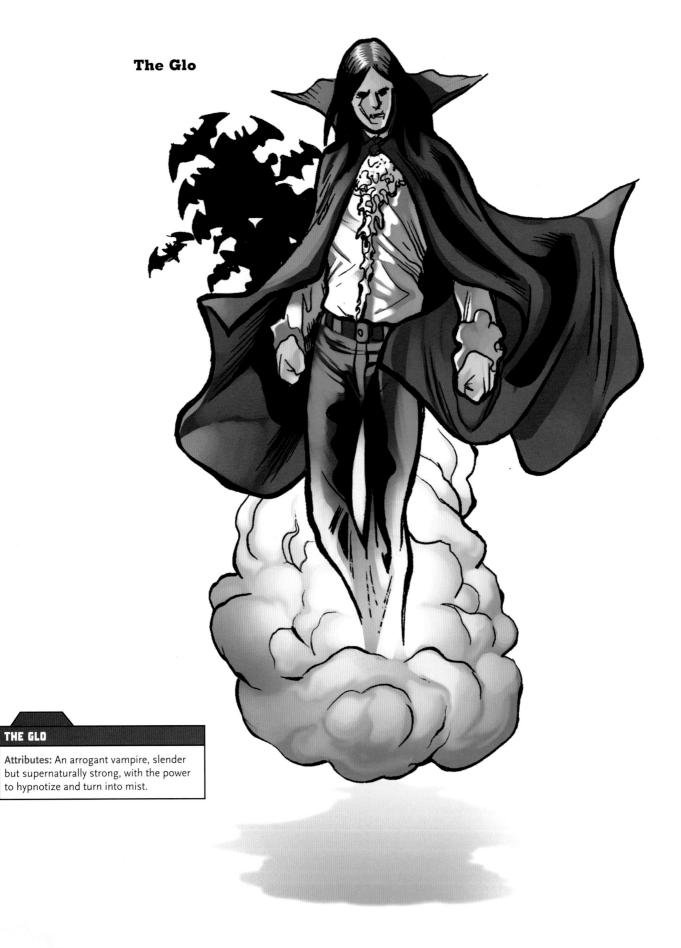

THE GLO

Attributes: An arrogant vampire, slender but supernaturally strong, with the power to hypnotize and turn into mist.

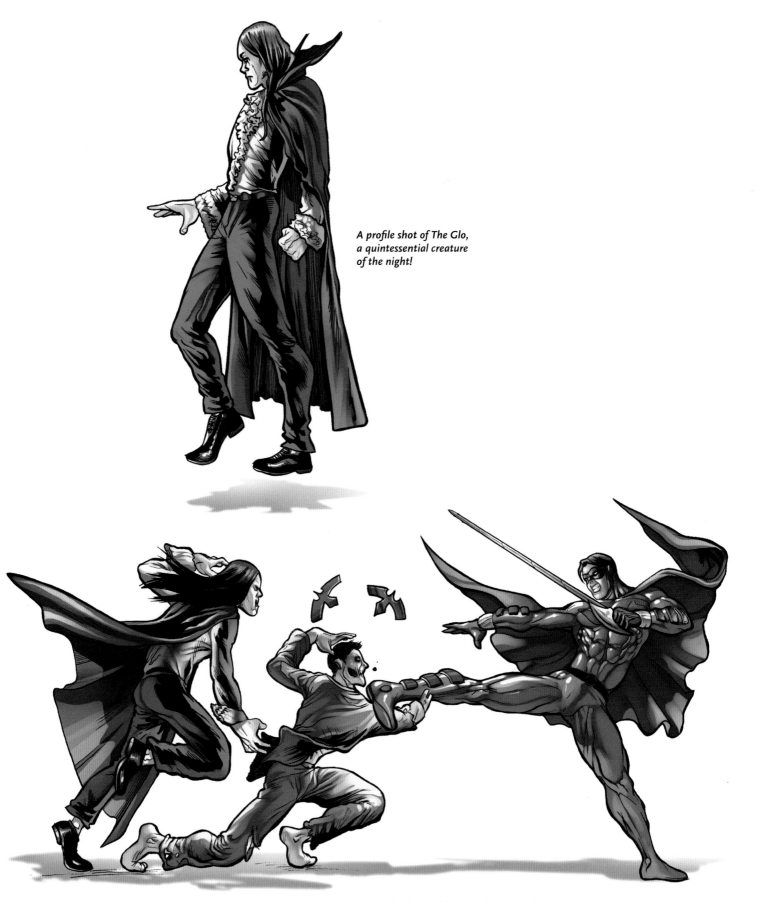

A profile shot of The Glo, a quintessential creature of the night!

Vampires don't pose like street fighters or brawlers. In fact, they prefer to rely on their hypnotic powers to overwhelm an opponent. If need be, though, they do have the physical strength to slug it out.

MONSTERS VS. SUPERHEROES

But is a monster even an appropriate adversary for your superhero? That's probably the foremost question you need to answer. Monsters don't suit all superheroes. Take Robocop, for instance. Would you have Robocop fighting giant alien flying jellyfish or a house-haunting apparition? Of course not! For Robocop, that would be absurd. Those aren't the kind of opponents Robocop squares off against.

He tackles street gangs, corrupt politicians, and giant robots. Likewise, the Green Hornet, with his partner Kato, battles the forces of the criminal underworld, not demons from Hell. Vampirella, on the other hand, *would* fight demons from Hell, as well as all other sorts of supernatural fiends. The same goes for Red Sonja, the sword-wielding barbarian who stalked the fictional Hyborian Age. Red Sonja has had to fend against all sorts of monsters, from colossal snakes to gargantuan spiders. And because of the fantastic prehistoric setting Red Sonja inhabits, none of these creatures look out of place. Can the same be said for the monsters you have created for your superhero?

If you do decide that monsters are fitting foes for your superhero, make sure you create monsters that are formidable challenges. In fact, the more formidable the monster, the better. Nothing will bore your audience faster than an easy fight. You never want your superhero to have it easy. Being a superhero is a tough job! Make them earn it!

Time and again, Vampirella has done battle with one of the most famous monsters of them all, the Lord of the Vampires, Dracula!

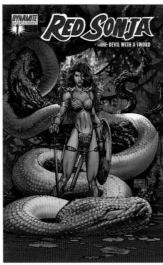

The kind of monsters Red Sonja fights against are appropriate to the prehistoric world she inhabits. What kind of world have you constructed around your superheroes?

The Lone Ranger is a hero on whom many, many superheroes have been modeled . . . but would you have him and Tonto shooting at squids from outer space or giant tarantulas from beneath the earth's surface? It would be rather silly, wouldn't it?

ORIGINALITY

Here's my challenge to you: Don't just recycle the same monsters that have already been created. Let's be honest: We've all had our fill of zombies and werewolves and vampires and demons, etc., etc., etc. What's the point of creating more of *them*?

Instead, be unique! Be creative! Remember the monsters created in the past reflected the anxieties and fears people experienced during those times. But if your superhero safeguards the twenty-first century, you need to consider the anxieties and fears of modern times. And you need to create monsters that are the physical manifestations of those fears.

So what exactly scares us these days? Irreversible climate change? Global pandemics? Something else? Think about it!

Essential Elements
You should create monsters that:
- Embody a collective fear.
- Are appropriate for the superhero you created.
- Are formidable threats.
- Illuminate some virtuous component of your superhero (his or her strength, ingenuity, or compassion).
- Aren't derivative of monsters of the past.

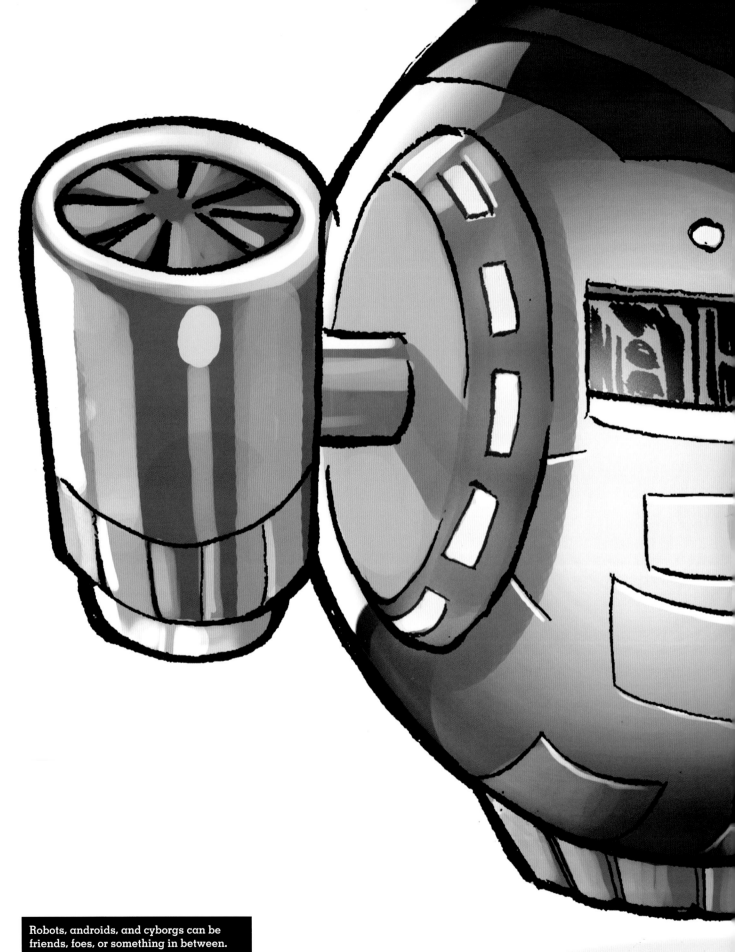

Robots, androids, and cyborgs can be
friends, foes, or something in between.

MECHANICAL FRIENDS AND FOES

Pop quiz, true believers! Think back to the original *Star Wars* movie and tell me which characters appear on screen first. Who do you see first? Here's a hint: Think about the movie's opening scene when the Stormtroopers board Princess Leia's ship. Oh, were you going to guess Princess Leia? Well, if you were, you'd be wrong. The first characters seen in *Star Wars* are—drumroll please—C-3P0 and R2-D2, the two robots! In fact, the movie spends almost all of its opening time on C-3P0 and R2-D2. But *Star Wars* isn't really about C-3P0 and R2-D2. They're just supporting characters. So, then, why start the movie with the robots?

Well, when you think about it, introducing the robots before the other characters helps establish the humanity of the movie. Before viewers learn about such unimaginably destructive weapons as the Death Star or such awesomely cosmic concepts as the Force, they see the robot equivalent of the Odd Couple: fussy worrywart C-3P0 bickering with his feisty best friend, R2-D2. Isn't it wonderfully ironic that two of the most human

characters in *Star Wars* are robots?

The robots' mechanical lives are put in contrast to the audiences' flesh and blood existence, and that contrast draws their attention to their human emotions, their human needs and wants, their human frailties, their human will.

But wait! I've been referring to C-3P0 and R2-D2 as robots. As we all know, *Star Wars* doesn't classify them as robots; they're "droids," short

for "androids." What's the difference between a robot and an android, you ask? For some writers, those two terms are practically interchangeable and indicate a distinction in appearance only. For other writers, though, those two terms can have substantially different meanings. Let's take a detailed look at the definitions of robots and androids, and then you can decide for yourself how big the difference is.

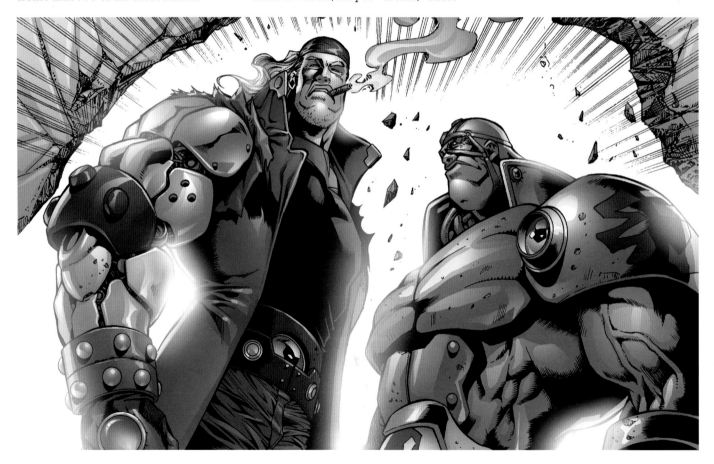

ROBOTS

The most basic definition of robot I can provide for you is this: A robot is a machine that can perform tasks on its own, demonstrating some form of independence via artificial intelligence. As you know, robots aren't just the wild imaginings of science fiction writers. We have fully functioning robots right here in the present day. The automobile industry uses robots to assemble new cars. The military uses robotic planes that can fly themselves. There are even robots that can mow lawns, vacuum and mop floors, and serve drinks, all without our supervision or guidance.

While the invention of complex, mechanical robots is fairly new, the concept of metallic humanoid automatons is rather old. Thousands of years old, actually! And it spans across several different cultures, from Greece to China to Egypt. One of the earliest recorded examples is Homer's use of robots in his epic poem *The Iliad* in which he described them as "golden maidservants" that "looked like real women." A twelfth-century Muslim inventor created a water-powered automated four-man musical band, complete with a drummer. And is it any surprise that in one of his notebooks, fifteenth-century Renaissance master Leonardo da Vinci sketched plans to construct his very own robot?

But neither da Vinci nor anyone else before him specifically used the word *robot*. That word wasn't introduced until 1920 when a Czech play from playwright Karel Capek about a robot-making factory was published. The play was titled *Rossum's Universal Robots*. Not long after that, science fiction entered its heyday, and robots were frequently seen in movie serials and comic strips as well as on magazine covers. Heck, back when I first started writing comic books, we used robots all the time! After Nazis, they seemed to be our favorite choice of opponent for our superheroes.

ROBOTIC RULES

It was around this time that one of the most famous science fiction authors of all time, Isaac Asimov, created

behavioral rules for his robots. Asimov did so because he felt the robot stories he had been reading all had the same plot: Robot gets created, robot tries to destroy its creator, robot gets destroyed. (If you recognized that this is the same plot that *Frankenstein* has, congrats, you get the prize!) Annoyed with that plot formula, Asimov wrote a different kind of robot story, one in which robots behaved benevolently toward humans.

Asimov formulated "The Three Laws of Robotics." They were rules that his robots *had* to obey. The first law stipulates that a robot may not

injure a human being (or allow a human being to be harmed). The second law requires a robot to obey all orders given to it by human beings (unless it is ordered to harm a human being). And the third law directs a robot to protect its own existence (again, unless that means it has to harm a human to do so). These laws are part of a robot's programming and therefore can't be disobeyed, just like we can't disobey the law of gravity, no matter how hard we might try to (and please don't try too hard as you'll only hurt yourself).

![Pep Comics cover, Jan. No. 1, introducing The Shield, G-Man Extraordinary, 10¢, 64 pages all color. Also Bentley of Scotland Yard, The Comet, The Midshipman and others.]

The Shield made his debut in this 1940 comic book. Like just about every other superhero of that era, the Shield battled his fair share of robots!

Fear not! Robby the Robot from the 1956 movie Forbidden Planet has been programmed to help you, not hurt you!

CREATE YOUR OWN ROBOT

Does this mean the robots you create also have to follow Asimov's rules? Of course not! So why am I telling you all this, you ask? First, as I keep emphasizing throughout this book, strive to be original! Don't just copy what other people have created. Do something no one else before you has done. That's what Asimov did! He noticed a thematic pattern in robot stories and made sure to do something completely different. You should be challenging yourself to do likewise: Create a robot unlike all the ones seen in comic books and novels and movies. Give it a shot right now with the following exercise.

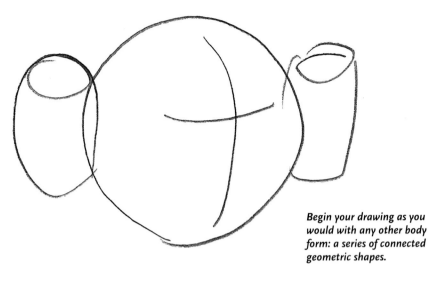

Begin your drawing as you would with any other body form: a series of connected geometric shapes.

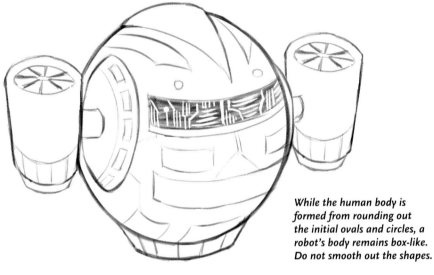

While the human body is formed from rounding out the initial ovals and circles, a robot's body remains box-like. Do not smooth out the shapes.

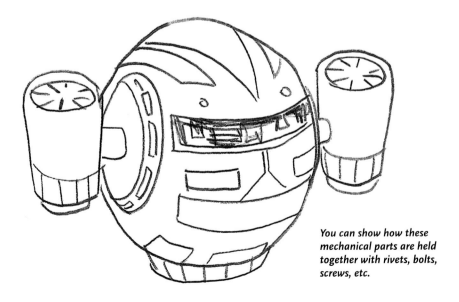

You can show how these mechanical parts are held together with rivets, bolts, screws, etc.

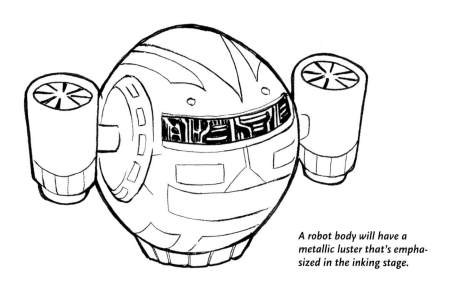

A robot body will have a metallic luster that's emphasized in the inking stage.

Lu-Lu

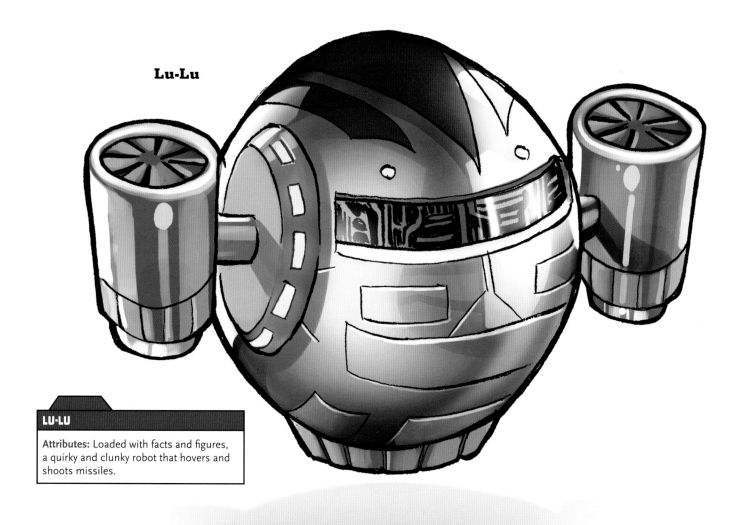

LU·LU

Attributes: Loaded with facts and figures, a quirky and clunky robot that hovers and shoots missiles.

HUMANS VS. ROBOTS

It is important to remember that robots lack free will. They behave in very predictable ways and always in accordance with how their creators have directed them to behave. I guess you could say what I'm getting at is that one of the robot's common roles in a story is to have its predictable behavior remind us of our own *unpredictable* nature. To prove my point, think about how differently you behaved today as opposed to yesterday. Today you're excited to be reading this wonderful book about creating superheroes, but yesterday you might have been bored . . . or sad . . . or anxious, and so on. Behavior is determined greatly by moods and circumstances, and these can change from day to day, even hour to hour. What's more, as you go through life, you inevitably become someone different than you were when you were younger (you're going to have to trust me on this). Our life experiences change us and transform us. The things that interest you now will most likely not interest you later in life (maybe even sooner than you expect). Over time, I've seen many people's personalities change; they became more serious than they were when they were younger, or more easygoing, or more responsible, or more hardworking, or more generous.

This is the fundamental difference between robots and humans: People change, robots can't. This makes writing a comic book starring a robot superhero very challenging. If a character can't change and grow (that's what we literary types call a "static character"), the stories become stale and predictable. Static characters eventually produce boring stories. To maintain the interest of your fans, you'll need to figure out how to turn your static robot into a dynamic one. Perhaps someone provides your robot with new programming? Or perhaps the robot's programming malfunctions? If you can't change the robot, perhaps you can instead change its surroundings? Does your robot need a new supporting cast? Can you move the robot to a new setting?

Worry not about challenges, my friend! Embrace them! Your imagination will provide you with the solution if you allow it to.

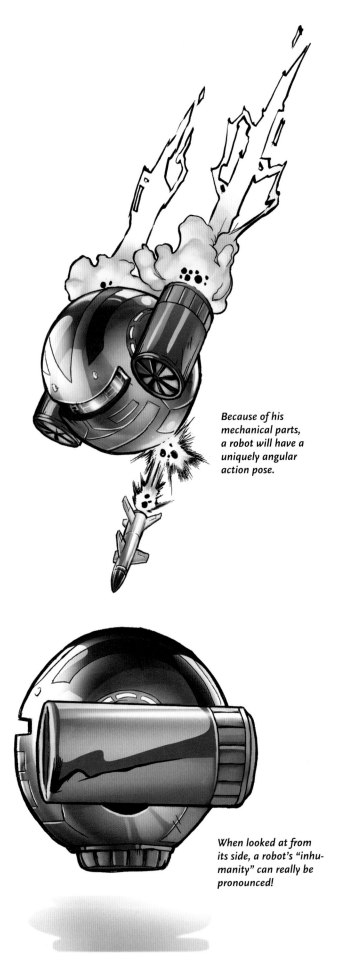

Because of his mechanical parts, a robot will have a uniquely angular action pose.

When looked at from its side, a robot's "inhumanity" can really be pronounced!

ANDROIDS

What exactly is an android? Well, the answer to that question depends on who you ask. Many consider androids to be nothing more than robots that look like humans. Whereas a robot has distinctive metallic machine-like features, an android is covered with an approximation of flesh. An android's skin can look so authentic that it is mistaken for a real human's. From this perspective, an android may look different than a robot, but it still presents the same story challenges for a writer. You're still dealing with a static character, incapable of change. Again, though, challenges can be overcome if you set your mind to overcoming them. Solutions can be found.

Let's consider one of Hollywood's most famous androids: Data from *Star Trek: The Next Generation*. Data was a tragic figure: His desire to be more human was foiled by his incapacity to experience emotions. This meant that Data was going to be the same character from one season to the next. Despite this, Data remained one of the *Star Trek* fans' most beloved characters. Why? For one, he was part of an ensemble cast, so not only did the spotlight not stay on Data long enough for viewers to grow bored with him, the other human characters surrounding Data were very dynamic. Second, on *Star Trek* the characters visited a new planet every week. This gave Data an endless supply of new characters to interact with. These two factors helped keep Data interesting in the eyes of *Star Trek*'s viewers.

But not all androids act like Data does. And truth be told, other androids captured the public's fascination well before Data showed up on the small screen. Did you know androids have been a staple fixture of pulp science fiction magazines and comic books for as long as robots? In fact, the very first superhero that appeared in 1939's *Marvel Comics #1* was an android: the Human Torch. No, I'm not talking about Johnny Storm of the Fantastic Four. I'm talking about Jim Hammond, the android that burst into flames when exposed to oxygen.

As written and drawn by the legendary Carl Burgos, the Human Torch

The very first Marvel superhero was an android—the Human Torch!

had a distinguished career during the Golden Age of comic books: He joined the New York City police force, had a couple of prize fights against the Sub-Mariner, and later the two of them teamed up with Captain America to help the Allied Forces during World War II. Just as remarkable as his adventures was the fact that the Human Torch could experience emotions. This android had feelings! This was no mere human-looking robot that just carried out the directions of his programming. The Human Torch was truly an "artificial person" who could feel lonely or compassionate or confused or proud. This android acted nobly, my friends! And not because of his programming, but because he *chose* to act nobly.

He was an android that would become one of the most popular Avengers of all time! He was the Vision! By inhabiting the original Human Torch's body, the Vision carried on that famous android's legacy.

Alas, nobility only gets a superhero so far, especially when sales of his comic book fall to the point where it has to be canceled. By the late 1950s, the original Human Torch had been extinguished (and perhaps it was for the best because if the original Human Torch had stayed around, who knows what we would have done with Johnny Storm once we started up the Fantastic Four).

I actually briefly resurrected the original Human Torch just so he could be manipulated to battle his successor in *Fantastic Four Annual #4*. Only a couple of years after I did that, writer Roy Thomas cooked up a brilliant story that involved the original Torch . . . or rather the original Torch's body. Get this: "Rascally Roy" (as I loved to call him) used the body of one android to create another android in order to defeat a mad robot. *Avengers #57* introduced the Vision, an android created from the remains of the original Human Torch by the murderous Ultron, a robot that had been created by Hank Pym aka Ant-Man, aka Giant Man, aka Goliath, aka Yellowjacket (jeez, how many names could we give that guy?). Ultron sought to use Vision to lure the Avengers into a trap, but the Vision eventually switched sides and helped the Avengers defeat Ultron. Like the hero whose body he now inhabited, the Vision demonstrated he had free will. He *chose* to do the right thing, earning him a place on the Avengers' roster. And while he was an Avenger, the Vision also showed he was no static character. He was a man of action and complex emotion. At times the Vision expressed angst and rage, but most of all, he demonstrated that even androids can be romantic. He

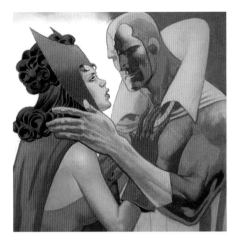

Can androids fall in love? The Vision sure did!

fell in love with another Avenger, the Scarlet Witch, and the two not only got married but they also had kids.

This is all meant to say that android behavior runs the gamut. At one end of the behavioral spectrum is Data whose programming makes it impossible for him to emote or even change as a character. At the other end of the spectrum are the original Human Torch and the Vision, both of whom can not only express the full range of emotions but also demonstrate the free will to countermand their programming and behave according to their impulses and conscience.

The manner in which your android behaves depends on its purpose in your story and its relationship to your other characters. Would it be better to have an android that is distinct from your other characters because of its lack of emotions? Or do you think an android that is as human as the other characters is more appropriate?

Something to think about as you sharpen your pencil and create your own android superhero.

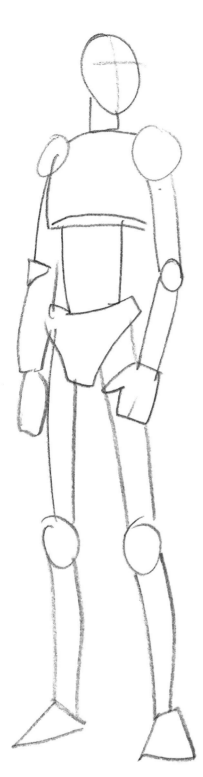

While having a human form, androids might not have graceful human movements, so an android's body posture can look stiff.

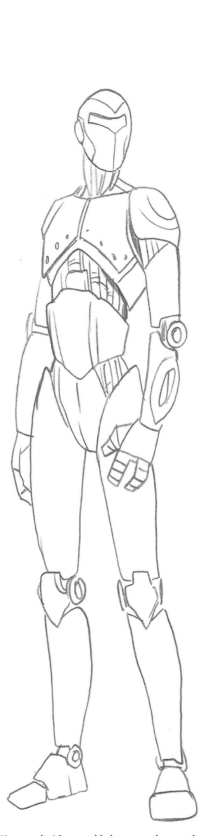

Since androids resemble humans, they need to have the same body proportions.

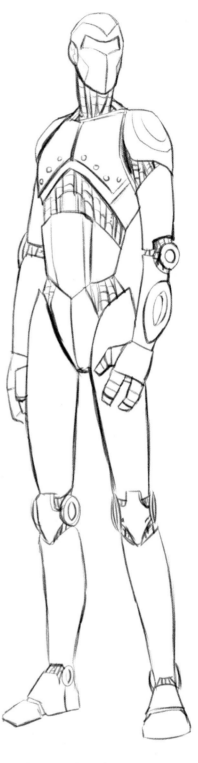

Is there something about your android that would hint he's not human? An electronic spark in his eye perhaps?

Alexi-Bot

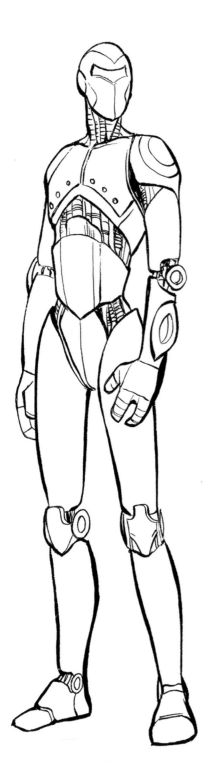

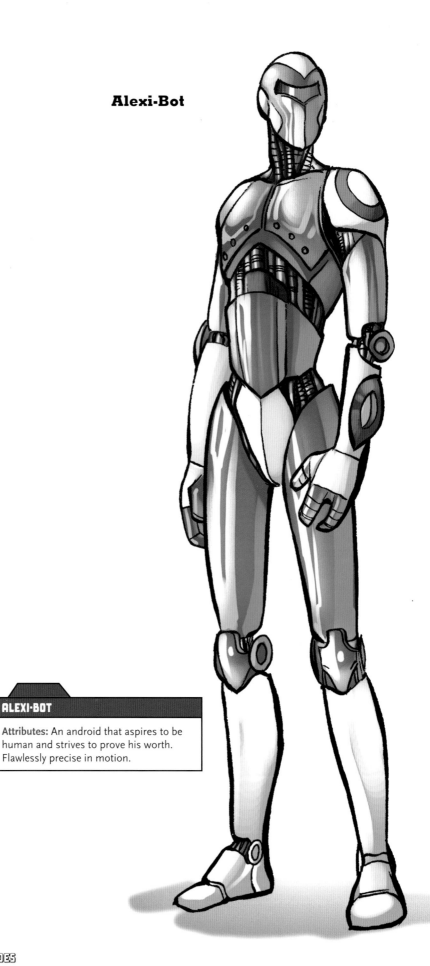

No metallic luster on this android!

ALEXI-BOT

Attributes: An android that aspires to be human and strives to prove his worth. Flawlessly precise in motion.

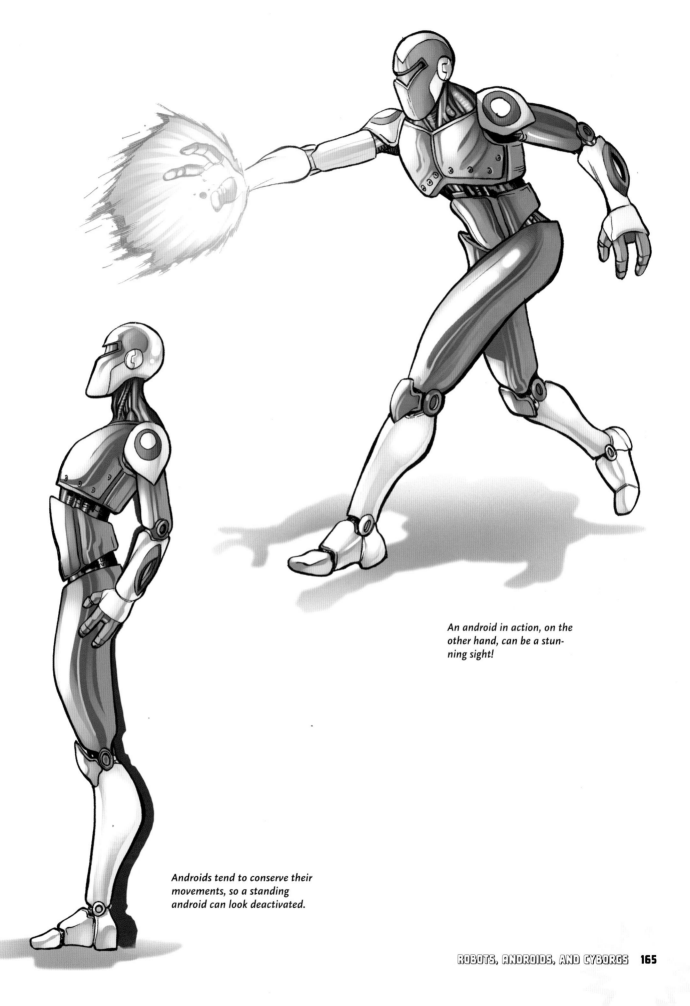

An android in action, on the other hand, can be a stunning sight!

Androids tend to conserve their movements, so a standing android can look deactivated.

CYBORGS

Maybe you're not sure if you should create a robot or an android at all. If that's the case, you're in luck because I still have one last option for you to consider: the cyborg! Short for "cybernetic organism," the cyborg is a person whose body has been infused with technological components. Whereas a robot is a machine, and an android is a machine that looks like a man, the cyborg is the machine *in* the man! The most famous cyborg of them all is Steve Austin from the television show *The Six Million Dollar Man*, which premiered in 1974. You heard of him? If not, Austin's story is that he becomes "The Bionic Man" after a malfunction causes a new aircraft he was test piloting to crash. As a result of the accident, Austin loses both of his legs as well as one arm and an eye. These lost body parts are replaced with advanced cybernetics, giving Austin superhuman strength, telescopic vision, and the ability to run fast and leap high. Austin puts these abilities to use for a secret American intelligence agency.

At the same time that TV viewers were tuning in to *The Six Million Dollar Man*, Marvel Comics published its own cyborg superhero, Deathlok. After that, it didn't take long for cyborgs to become a fixture of science fiction–themed movies, television shows, and comic books. It's an impressive list that includes the Borg from *Star Trek*. Heck, even Darth Vader is a cyborg! He even helped turn his son into a cyborg (of a sort) after he sliced off Luke's hand in *The Empire Strikes Back*.

The neat thing about a cyborg is his internal struggle between his humanity and his robotics. (That is, the struggle is neat from the writer's perspective. I can imagine it's not much fun for the cyborg.) A convincing portrayal of a cyborg leaves readers wondering how much the character is in control of his machinery and how much the machinery is in control of him. No fears about static characters here! A cyborg embodies internal strife and change. Something to consider as you ponder what kind of "artificial person" you want to create.

Deathlok the Demolisher! A dead American soldier is reanimated in a postapocalyptic future as a cyborg. Although he battles evil corporate and military regimes, Deathlok's biggest war is internal as he struggles to maintain his humanity.

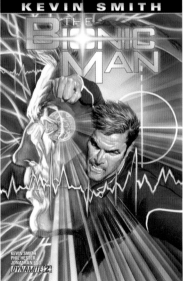

Steve Austin is the world's most recognized cyborg thanks to the popularity of the 1970s television show The Six Million Dollar Man! *He would go on to inspire other fictional cyborgs.*

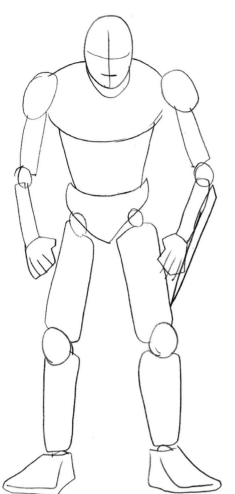

Depending on how much technology is fused within the man, a cyborg's form can appear rather bizarre and inhuman.

Determine here what parts of the cyborg's body are technological and what parts remain human. A convincing cyborg makes the reader wonder how much of his humanity is left.

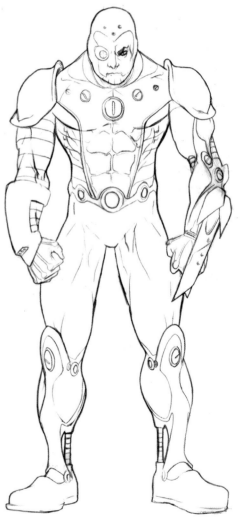

Machinery requires lots of detail, but at the same time it all needs to blend with the remaining flesh and muscles.

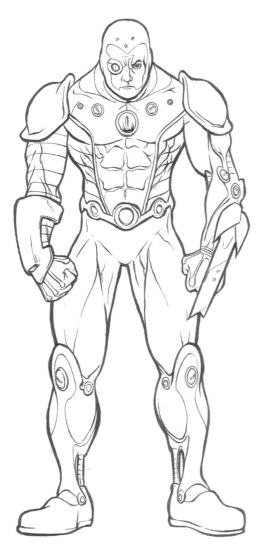

Cutthroat

Inking a cyborg can be tricky since the conflicting parts of the body will create different textures, sometimes radically so.

CUTTHROAT

Attributes: Will not stop until its target is terminated

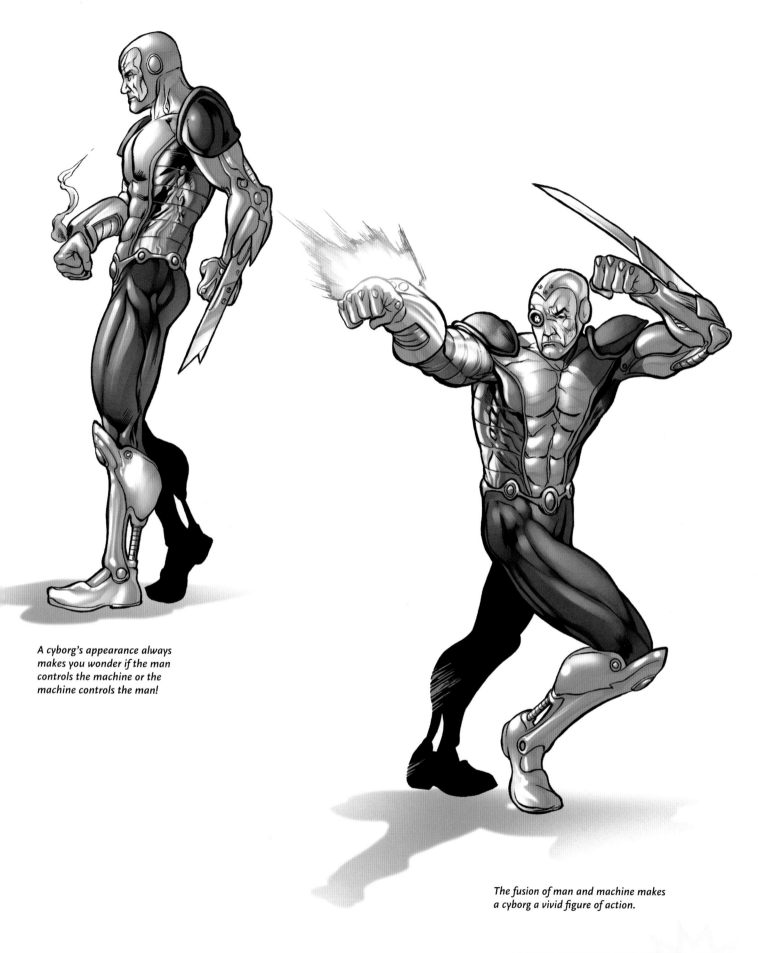

A cyborg's appearance always makes you wonder if the man controls the machine or the machine controls the man!

The fusion of man and machine makes a cyborg a vivid figure of action.

An understanding of animals will help you create convincing companions for your superhero.

(SUPER)MAN'S BEST FRIEND

As you've moved through the steps of creating superheroes, you've found yourself creating all sorts of heroes, men, women, teens, brutes, vixens, robots, aliens, monsters, etc. Well, to truly round out your education in hero creation, let's talk about animals. No, not a bunch of raucous individuals, but *actual animals*.

Believe it or not, in order to give your hero a faithful four-legged or fine-feathered or even fabulously-finned friend, you have to do more than sew a matching cape to a collar. Animals are characters, too, and they need the same amount of courageous characterization as every other hero or villain. In addition, an understanding of how to draw animals will actually help you create a convincing world for your superhero. After all, it's not like you can call your character the Scorpion, the Beetle, Red Wolf, or the Falcon without understanding what each of these creatures do and how their corresponding powers or abilities apply to those heroes and villains.

FAITHFUL FRIENDS

Since classic heroes serve as the foundation for our modern superheroes, I think it's only fair to take a look at some classic animals before we begin. This way you can get an idea of the important part animals play in these senses-shattering stories.

Did you know that in Homer's epic poem *The Odyssey*, Odysseus has a faithful dog named Argos who for twenty years waited for his master to return home? After so long, poor Argos is too weak to stand but still manages to lower his ears to show Odysseus that he recognizes his master even through his disguise when the rest of Ithaca could not. The poor pooch passes away and Odysseus, the great hero, cannot help but shed a tear for the loss of his faithful friend. That sad tale takes only a few lines in Homer's epic poem, yet it speaks volumes about the hero Odysseus and the power of a pet.

Animals play a very important part in our lives and in our literature. They can sniff out crimes without super-computers or superpowers. They have amazing natural instincts, unending dedication, and often an uninhibited sense of morality—all of which can be used to provide companionship for your hero while adding depth to his character. Heck, there must be something special about animals for so many heroes and villains are named after them.

A strange visitor from another planet—no, not Superman, but Krypto the Superdog! Krypto has all the powers of Superman and a matching cape as well.

CREATURES GREAT AND SMALL

In the world of comic books, there is quite an extensive history of animals acting as devoted sidekicks to their superhero friends. There are everyday pets such as Superman's super-pooch, Krypto, or Speedball's frisky feline, Hairball. There are exotic animals like Red Wing, the Falcon's feathered companion, and Lobo, the wolf friend of Red Wolf. And of course incredible creatures such as Ka-Zar's sabertooth sidekick Zabu, Moon Boy's prehistoric pal Devil Dinosaur, and Lockjaw the inhuman dog of . . . well, the Inhumans. There's really no reason not to consider using animals either as sidekicks, supporting characters, or even for occasional cameos. In this chapter I'll show you examples of all of these aspects of animals in comics. I'll also demonstrate how to feature superpowered animals that act like humans themselves.

Devil Dinosaur (above) was a pal to Moon Boy, while Lockjaw (left) is not really a pet as much as he is one of the Inhumans.

ILLUSTRATING ANIMALS

Okay, let's get started creating some super-animals to accompany your superheroes. For your first assignment you are going to create a pair of animal sidekicks (a dog and a rabbit). Let's build them for the S-Type hero, Captain Titan, and then we'll create a second pair of pets (a cat and a mouse) for the B-Type hero, Searchlight.

DOGS

First, let's look at dogs:

Since dogs (like humans) come in all sorts of shapes and sizes (and breeds), you will need to decide in advance what kind of dog you are going to want to illustrate for your super-pet. Since we are going with the S-Type hero, let's pick a strong, power-ful type, say a German shepherd.

Dogs, like humans, come in all sizes, shapes, and breeds.

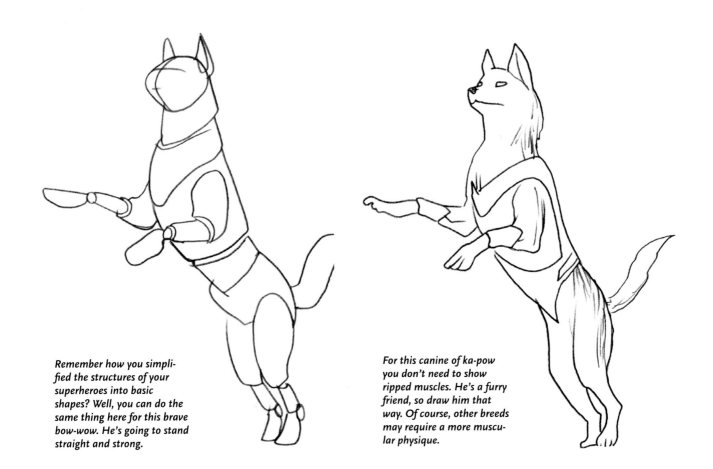

Remember how you simpli-fied the structures of your superheroes into basic shapes? Well, you can do the same thing here for this brave bow-wow. He's going to stand straight and strong.

For this canine of ka-pow you don't need to show ripped muscles. He's a furry friend, so draw him that way. Of course, other breeds may require a more muscu-lar physique.

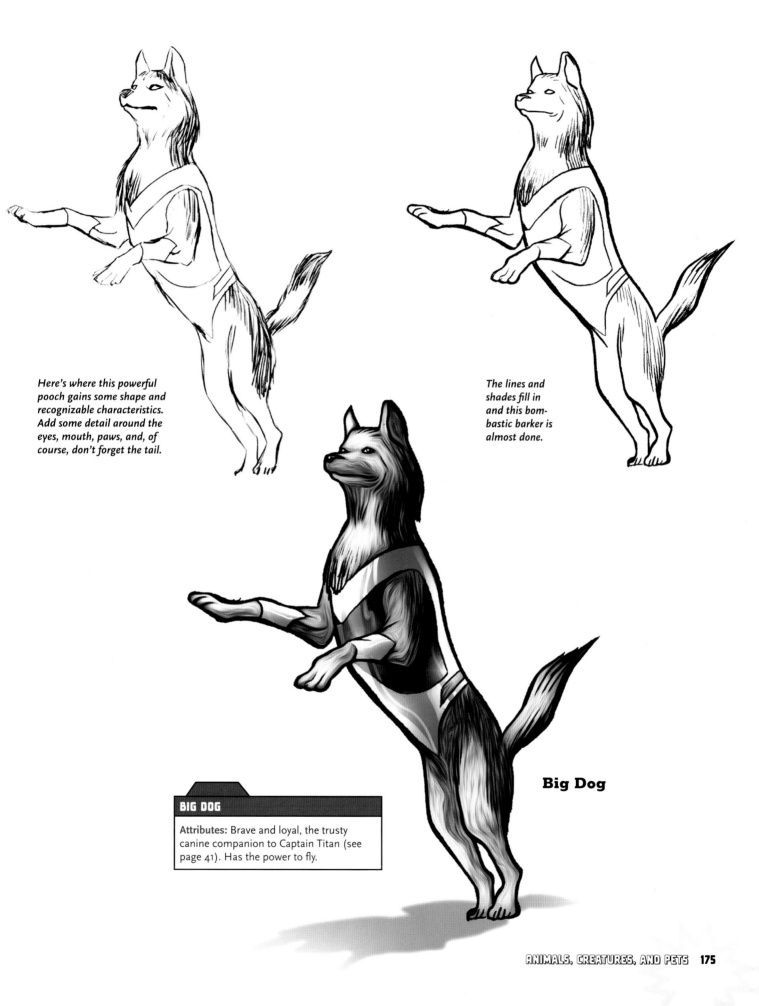

Here's where this powerful pooch gains some shape and recognizable characteristics. Add some detail around the eyes, mouth, paws, and, of course, don't forget the tail.

The lines and shades fill in and this bombastic barker is almost done.

Big Dog

BIG DOG

Attributes: Brave and loyal, the trusty canine companion to Captain Titan (see page 41). Has the power to fly.

BUNNIES

Interestingly enough, drawing a bunny really isn't that much different than drawing a human, as it is merely a collection of circles and ovals. When learning how to draw animals, I have always been told by my artist buddies that as with humans, it's usually a good idea to begin with a real model or a reference photo.

One of the best ways to start any illustration is to begin with a reference photo, not so you can swipe, but so that you have a point of reference as to how you want your illustration to go.

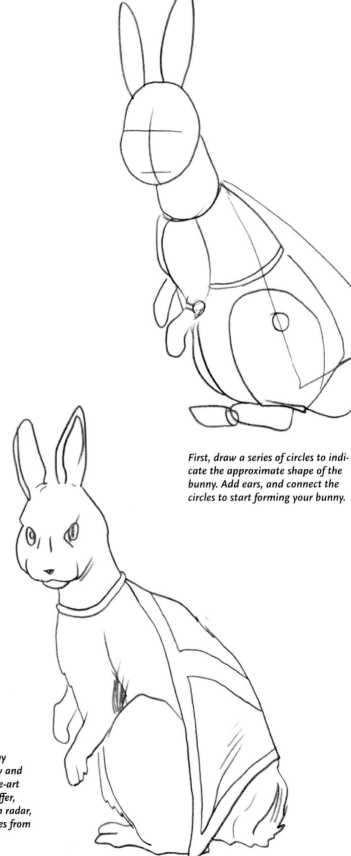

First, draw a series of circles to indicate the approximate shape of the bunny. Add ears, and connect the circles to start forming your bunny.

Begin detailing this heroic hopper by rounding the shapes in a fluffy body and adding the details of his state-of-the-art crime-fighting system: his super sniffer, eagle eyes, and of course his built-in radar, his ears! Be sure to erase the outlines from the previous step.

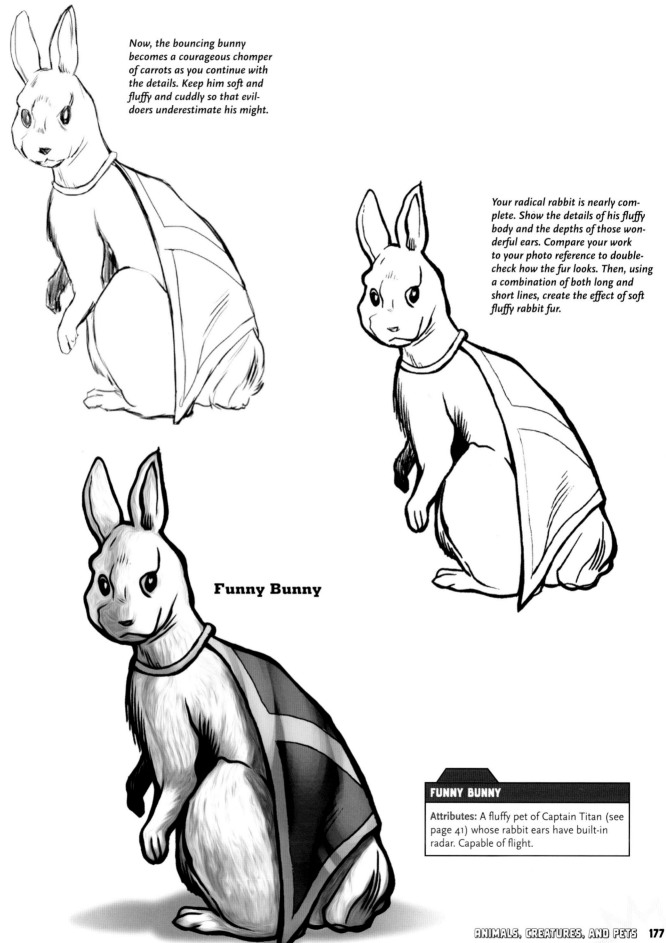

Now, the bouncing bunny becomes a courageous chomper of carrots as you continue with the details. Keep him soft and fluffy and cuddly so that evil-doers underestimate his might.

Your radical rabbit is nearly complete. Show the details of his fluffy body and the depths of those wonderful ears. Compare your work to your photo reference to double-check how the fur looks. Then, using a combination of both long and short lines, create the effect of soft fluffy rabbit fur.

Funny Bunny

FUNNY BUNNY

Attributes: A fluffy pet of Captain Titan (see page 41) whose rabbit ears have built-in radar. Capable of flight.

CATS

For the most part, pet people can be divided into two types: dog lovers and cat lovers. While dog people tend to be a little more outgoing, or extroverts, cat people are a bit more aloof, or introverts, because that's just how cats themselves tend to be. Personally I prefer my pets to be on the printed page, as they are far easier to take care of than the real-life variety. Still, cats are one of the most popular pets throughout the world, and learning how to draw them is an equally popular subject with aspiring artists.

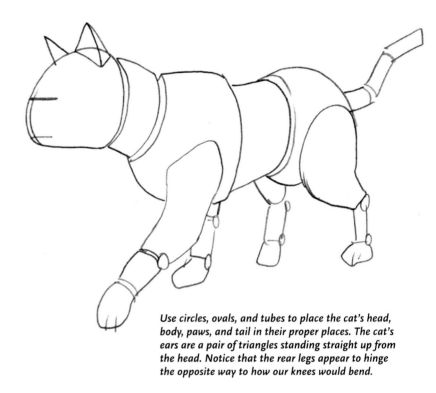

Use circles, ovals, and tubes to place the cat's head, body, paws, and tail in their proper places. The cat's ears are a pair of triangles standing straight up from the head. Notice that the rear legs appear to hinge the opposite way to how our knees would bend.

Cats used to be worshiped as gods in Egypt, and they intend to never let us forget that.

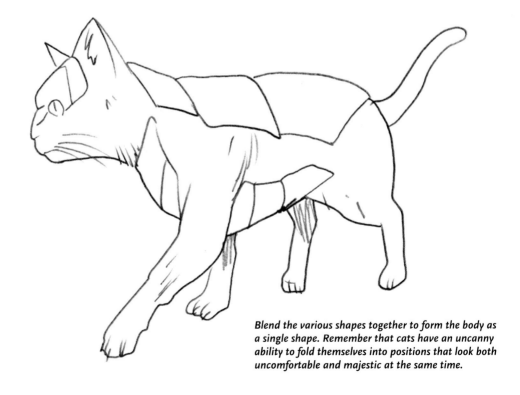

Blend the various shapes together to form the body as a single shape. Remember that cats have an uncanny ability to fold themselves into positions that look both uncomfortable and majestic at the same time.

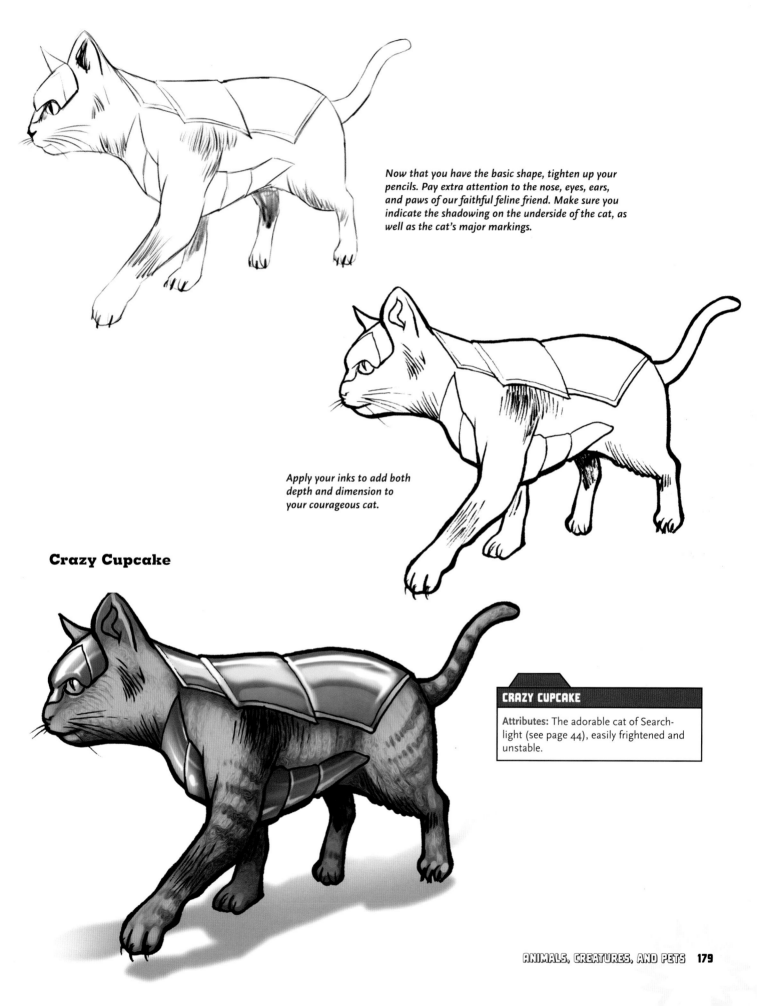

Now that you have the basic shape, tighten up your pencils. Pay extra attention to the nose, eyes, ears, and paws of our faithful feline friend. Make sure you indicate the shadowing on the underside of the cat, as well as the cat's major markings.

Apply your inks to add both depth and dimension to your courageous cat.

Crazy Cupcake

CRAZY CUPCAKE

Attributes: The adorable cat of Searchlight (see page 44), easily frightened and unstable.

MICE

Hey, now that you've made your cat,
I have to ask: What is a cat without a
mouse to chase? So, let's see what we
can do about that.

*Before it was a high-tech computer
peripheral, a mouse was just a rodent.*

*Use circles, ovals, and tubes
and basic shapes to begin the
design of our pint-size pal.*

*Now let's bring all the parts
together into a single shape.*

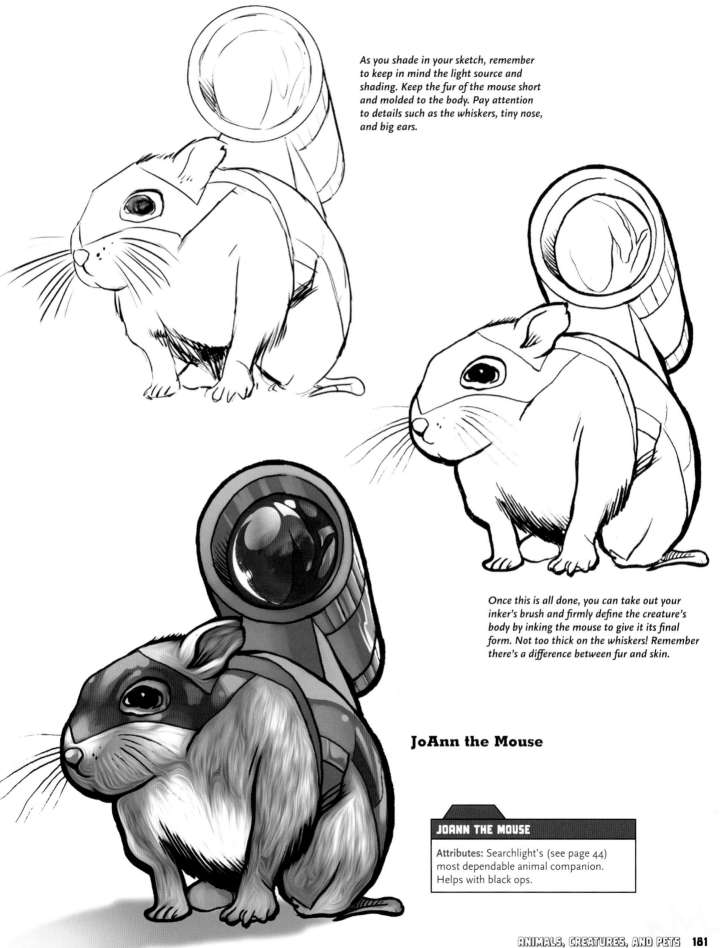

As you shade in your sketch, remember to keep in mind the light source and shading. Keep the fur of the mouse short and molded to the body. Pay attention to details such as the whiskers, tiny nose, and big ears.

Once this is all done, you can take out your inker's brush and firmly define the creature's body by inking the mouse to give it its final form. Not too thick on the whiskers! Remember there's a difference between fur and skin.

JoAnn the Mouse

JOANN THE MOUSE

Attributes: Searchlight's (see page 44) most dependable animal companion. Helps with black ops.

WEREWOLVES AND OTHER ANTHROPOMORPHIC CREATURES

All right, now that you've gotten some of that initial warm-up stuff out of the way, let's go to where the current animal action is these days in comics: werewolves. Yeah, I know that vampires are all the rage with teen girls these days, but I feel that is more of a passing fad. I've always been partial to werewolves myself. Plus—speaking from an artistic point of view—werewolves make for a more visually appealing character, especially when they are going through their transformation. (Also, as a writer, the dichotomy of a character who is trapped by a curse that will morph him into a ravenous creature of the night for three days every month is a great starting point.)

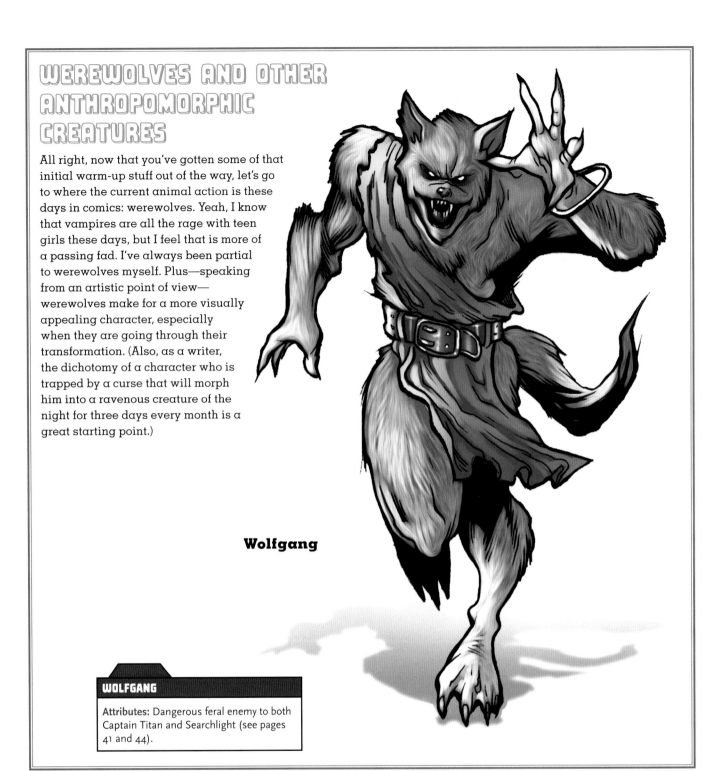

Wolfgang

WOLFGANG

Attributes: Dangerous feral enemy to both Captain Titan and Searchlight (see pages 41 and 44).

NOW COMES THE ACTION!

So you've had some practice getting down the stock shots of our animal sidekicks; now it is time to put them into the mix of action, fighting crime alongside their human superhero partner.

As you illustrate these heroes and their pets, it is always important to go through all of the steps covered and to look at photo and illustrative references, noticing how animals, like humans, are simply cubes, spheres, and triangles wrapped around skeletal sketches and then covered in hair, fur, or feathers. You need to see the lines and angles of your animal, the curves and intersections of the joints, how the skin is stretched over the bones of the creature, and then how the fur, hair, or feathers is then layered over that.

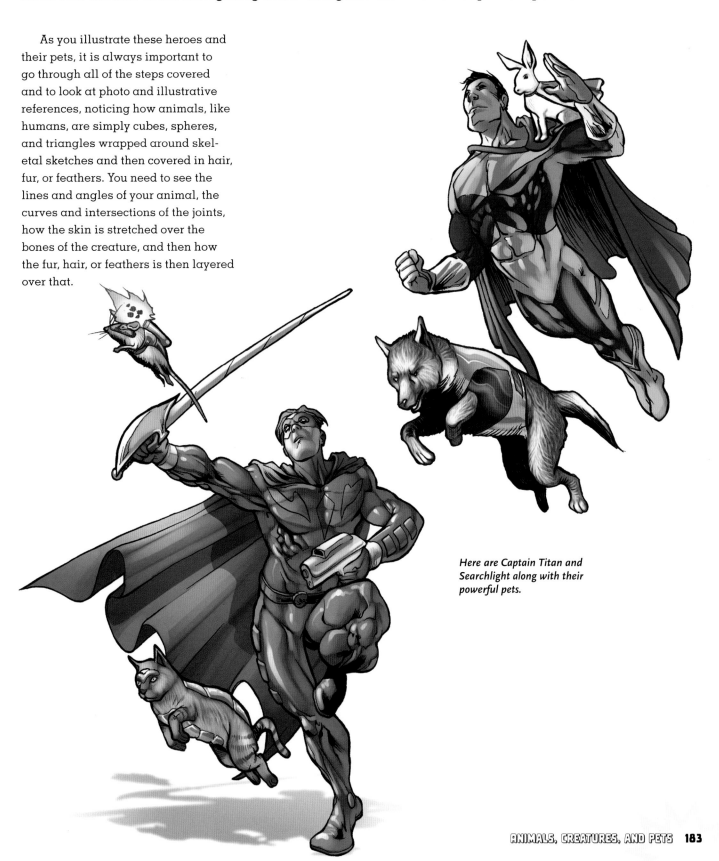

Here are Captain Titan and Searchlight along with their powerful pets.

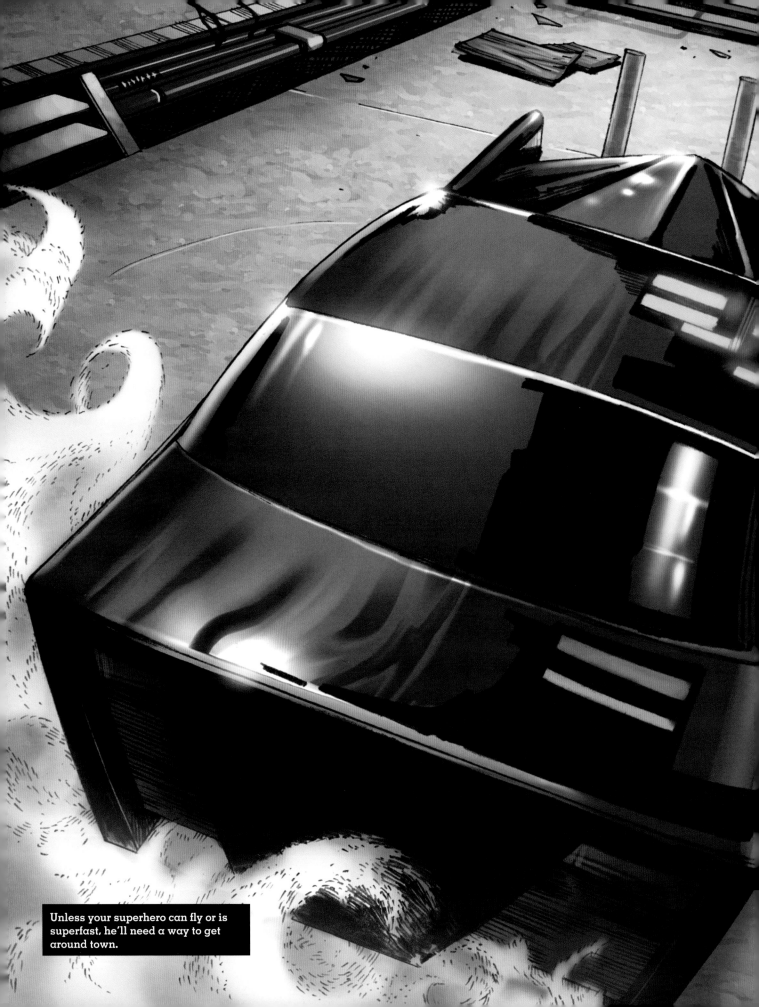

Unless your superhero can fly or is superfast, he'll need a way to get around town.

GETTING AROUND TOWN

In this chapter let's give some thought to how your superhero is getting around town . . . or the country . . . or the universe. If you're giving your superhero the ability to fly, that solves a lot of transportation problems. However, there *are* more imaginative ways to enable your superhero to defy gravity. Consider, as always, the ancient Greeks. Even *their* gods and heroes needed help to propel themselves through the air. For instance, in order to pull the sun across the sky—a task he was obligated to do every day—Apollo used a chariot drawn by four horses.

While we're on the subject of mythology, allow me to mention that my version of the Norse god Thor couldn't fly on his own. Only by holding on to his magical hammer while throwing it forward could he soar through the sky. Quite unique, don't you think? And that's what I'm getting at, true believers! You want your superheroes to fly? Then think of unique ways for them to do so!

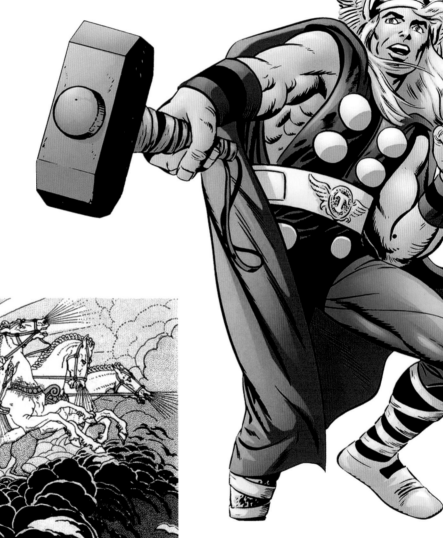

Thousands of years ago, the ancient Greeks imagined their god of the Sun, Apollo, rode a chariot every day to drag the sun across the sky. Now we see equally fantastic vehicles in superhero comic books.

Marvel's god of thunder flies because the force of his thrown hammer carries him through the air, as demonstrated in this image drawn by one of Thor's best writers and artists, Walt Simonson.

WHEELS FOR YOUR SUPERHERO

Perhaps you've decided that flight—regardless of how it's accomplished—isn't suitable for your super-hero. You require a more conventional mode of transportation, something like an automobile. If so, you need to remember that cars aren't just vehicles that get us from one point to another. Let's face it: People take cars very seriously. Not only are they one of our most expensive possessions, they're also symbols; they represent us.

What we drive lets people know who we are. To illustrate, let me ask you what kind of car you hope to own one day. A sports car? A luxury car? A convertible? A pickup truck? An electric car? The car you choose to drive says a lot about the kind of person you want people to think you are. Perhaps you want to present your-self as someone who loves adventure and excitement or as someone who is tough and rugged or as someone who is concerned about the environment (it's rather easy to determine which car symbolizes which lifestyle, isn't it?).

You might be wondering what all this has to do with creating superheroes. My point is that your readers will make judgments about your superheroes just by looking at the vehicles they drive. The vehicles need to embody your superheroes' noble qualities. If they don't, your readers will get some wrong ideas about your superheroes.

Let's look at an automobile that is a perfect representation of its driver: James Bond's Aston Martin. If you don't already know, the Aston Martin is a luxury sport car, much like the Lam-borghini or Porsche. It's built in Great Britain, and the model that James Bond drives comes with some "unique" acces-sories, to say the least. Thanks to the ever-resourceful Q Branch, Bond's car has been equipped with bulletproof windshields, a passenger ejector seat, retractable machine guns and rocket launchers, among other gadgets that all international superspies could use in a jam. What makes the Aston Martin the perfect vehicle for James Bond is that the car and the character share the same qualities: They're both Brit-ish, they both have style and class, and they're both very, very dangerous. The car personifies the character, and vice versa. That's the kind of symbolic link you should be looking to create when you match up your superhero with a vehicle.

Superheroes' means of transportation need to be as extraordinary as they are.

THE MANY MODELS OF THE BATMOBILE

What's the symbolic link between the most famous of superhero vehicles, the Batmobile, and its owner, Batman? The answer depends on which Batmobile we're talking about. The first car that Batman used for his crime-fighting exploits was introduced in 1939 and was nothing more than a big red convertible sedan. It took a couple of years before the Batmobile got a darker paint job and a big bat-shaped hood ornament. But that would prove to be only the first of many, many changes made to the Batmobile over the decades.

You need only look at the Batmobiles that were designed specifically for other media to see what I mean. We can start with the modified Lincoln Futura Batmobile that was used in the 1960s *Batman* television show. Jumping forward twenty years, *Batman* film director Tim Burton made the Batmobile into a wonderfully exaggerated Corvette. And just when you thought *that* was the wildest version of the Batmobile you'd ever see, *Batman Begins* director Christopher Nolan unveiled the twenty-first-century Batmobile as a military prototype vehicle! All of these Batmobiles have their fair complement of gadgets and weaponry, and each of them personifies Batman in a distinctive way. The Batman of the 1960s television show is a dashing do-gooder while the Batman from the early twenty-first-century films is a combative crime fighter. One need only look at the Batmobiles from the television show and the movies to see how different these versions of Batman are! In other words, the Batmobile alone allows readers (and moviegoers) to understand each Batman's personality, demeanor, and tactics.

Is this your favorite version of the Batmobile? If not, perhaps your favorite Batmobile reflects best what kind of superhero you prefer Batman to be.

UPDATING YOUR SUPERHERO'S WHEELS

Sometimes a superhero's vehicle can be redesigned several times, yet it doesn't alter our perception of the superhero's identity at all. Consider the most supernatural superhero of all, Ghost Rider. Since his introduction in 1972, the demonically possessed motorcyclist has been zipping across the country on anything from a standard cruiser to a chopper to a heavily armored futuristic sport bike (with wheels of fire!). But regardless of the type of bike he's riding, Ghost Rider's image remains the same because of how the public perceives motorcycling in general. Ever since the mid-twentieth century, and thanks to such classic movies as *The Wild One* and *Easy Rider*, motorcycles have been depicted as vehicles ridden by restless (sometimes criminal) men who have few (if any) attachments. Motorcyclists enjoy the freedom to go wherever their bike will take them. Given that stereotype, it doesn't matter *what* motorcycle Ghost Rider mounts himself on. Just the fact that he's riding a motorcycle means he'll be inevitably viewed as a rugged rebel and an outlaw on the run (and one with a flaming skull to boot!). Again, the vehicle personifies the superhero. Can Ghost Rider be Ghost Rider without his motorcycle?

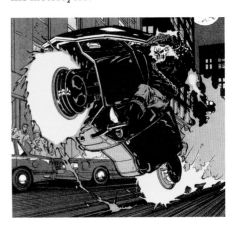

Ghost Rider is a superhero inextricably linked to his means of transportation. You can't think of Ghost Rider without also thinking of his motorcycle. Remember the kind of effect a vehicle will have on your superhero's identity as you consider which vehicle to provide him or her with.

USING VEHICLES TO SOLVE PROBLEMS

Let me tell you about the time Jack Kirby and I had to think up a vehicle for the Fantastic Four. The Human Torch was the only member of the group who could fly, and we had to figure out a method for them to make their way around New York City. Now we weren't going to have the Fantastic Four flying around town in some common helicopter. After all, Mr. Fantastic is a scientific genius! Something had to be created that demonstrated his brilliance. So Jack designed a four-seat flying car that could separate into four compartments, each of which could then be piloted by one of the members. Naturally, we called this vehicle the "Fantasti-Car"! Readers loved it; at least most of them did. Some of the readers disliked the oval design so much they dubbed it the "Flying Bathtub." Ouch! Talk about tough love! That kind of criticism, though, only encouraged Jack to design an even better Fantasti-Car, which we introduced a mere nine issues after the first Fantasti-Car appeared. (Hey, we knew how to placate our readers!) The Fantastic Four have been flying around in variations of the Fantasti-Car ever since, but more importantly for our purposes, the vehicle reflects and emphasizes Reed Richards's inventiveness. That's what makes it a "fantastic" superhero vehicle.

THE BASICS

All this talk about gadget-enhanced cars and flaming motorcycles and fantastic flying bathtubs reminds me of one of the essential facts of superhero stories. It's actually the most defining fact of superhero stories when you think about it. Never lose sight of the fact that superhero stories are fantasies. I mean, where else but in a superhero comic book will you find a motorcycle with wheels of fire? How does that even work exactly? How does the fire hold up the weight of the motorcycle? Does that make sense? *Should* it make sense? Within the context of the story, sure, it should make sense. But don't feel like you need to have a PhD in aerodynamics or mechanical engineering to create a superhero vehicle. Superhero stories rely on what's called pseudoscience—that's the *illusion* of science—to make their stories work.

Don't let the laws of physics deter you from creating a vehicle that will knock your readers' socks off! If it suits your superhero, keep it! At the same time, let's acknowledge that not all superheroes need to have those fantastic kinds of vehicles. If your superhero requires something more mundane—if that's what will truly reflect who your hero is—then give him or her something more mundane. Nothing can be more mundane than what the Punisher drives. He calls it his "Battle Van." But let's face it, it's nothing more than an ordinary cargo van filled to the gills with all sorts of weapons and hi-tech equipment. Regardless, it's the perfect vehicle for the Punisher because it's so inconspicuous. The Punisher doesn't need a vehicle that sticks out. As a fugitive from justice, he needs something just the opposite, something practical that will let him operate without drawing attention to himself. Does your superhero work undercover? Does he or she prefer to avoid both the public spotlight and the attention of the authorities? Then you should consider creating a vehicle similar to the Punisher's Battle Van.

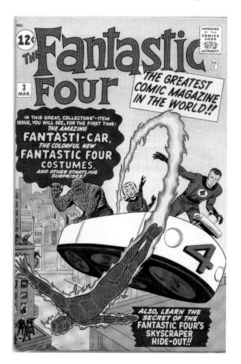

Fantastic Four #3 introduced the Fantasti-Car and since then, the World's Greatest Superheroes have never had to worry about New York City traffic!

The Punisher usually travels via his Battle Van, which is large enough to hold all the weapons he needs for his one-man war on crime but inconspicuous enough that he doesn't draw the attention of the law enforcement agencies that are looking to arrest him.

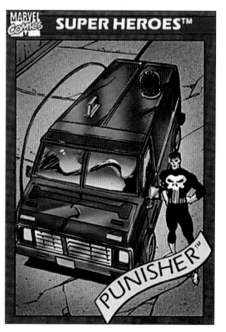

DRAWING YOUR HERO'S VEHICLE

At this point, I think I've given you enough tips and guidelines that you can go ahead and design a vehicle for your superhero.

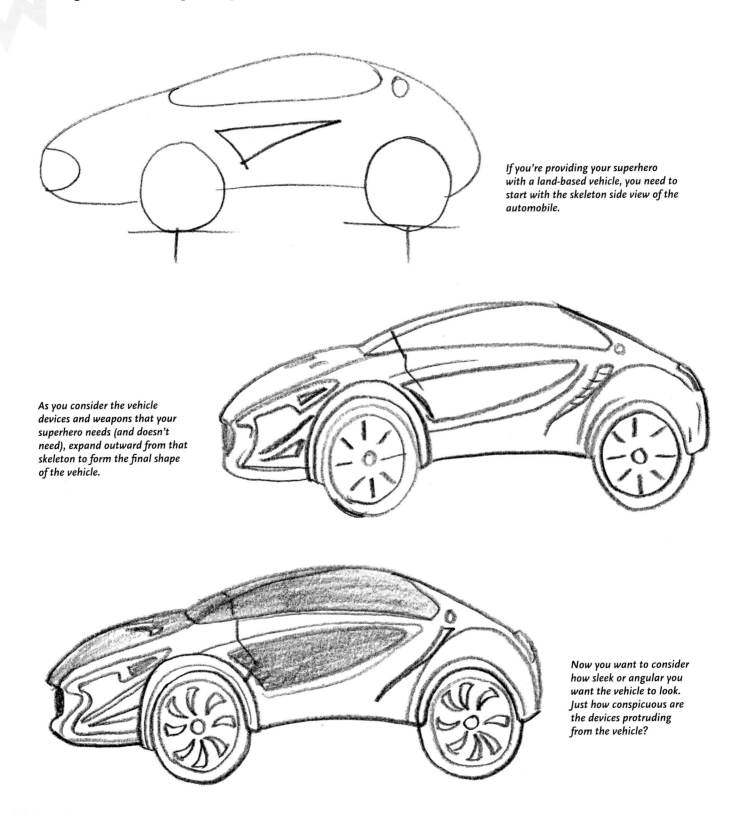

If you're providing your superhero with a land-based vehicle, you need to start with the skeleton side view of the automobile.

As you consider the vehicle devices and weapons that your superhero needs (and doesn't need), expand outward from that skeleton to form the final shape of the vehicle.

Now you want to consider how sleek or angular you want the vehicle to look. Just how conspicuous are the devices protruding from the vehicle?

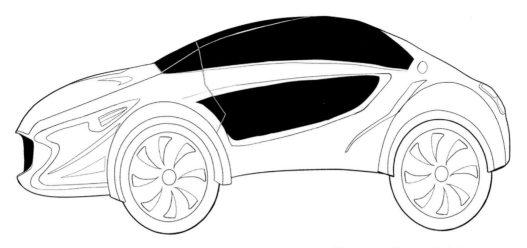

After the pencil stage, the inking stage determines how smooth or rugged the vehicle will look.

Mach S

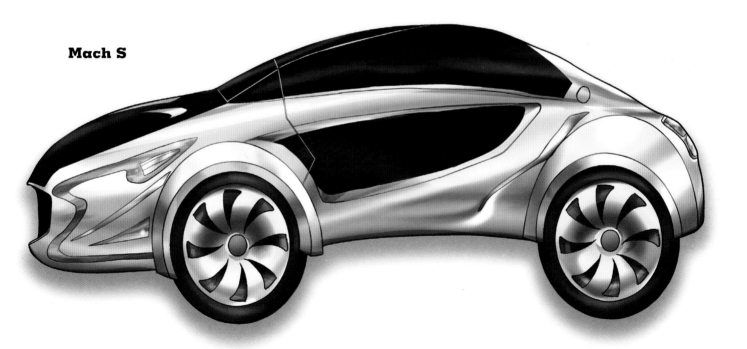

MACH S

Attributes: The extremely powerful and versatile car belonging to Searchlight (see page 44).

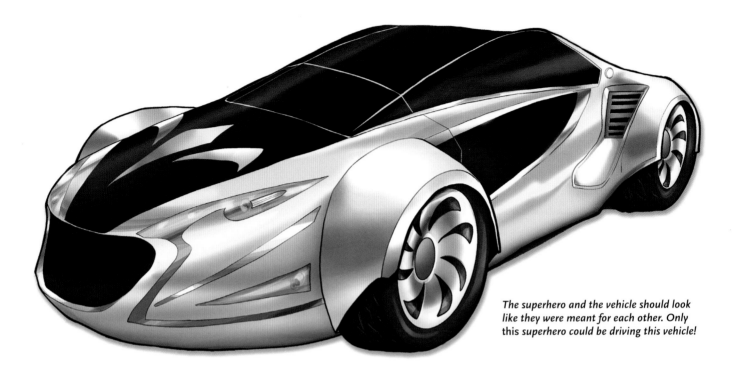

The superhero and the vehicle should look like they were meant for each other. Only this superhero could be driving this vehicle!

From a bird's-eye view, it's apparent how different this vehicle is from an ordinary automobile.

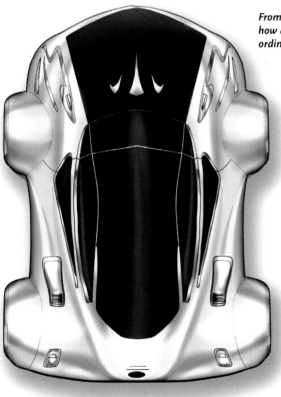

From its front, a superhero's vehicle can look intimidating to the criminals it's pursuing!

CAR CHASES (AND WHY THEY DON'T WORK IN COMIC BOOKS)

No matter what vehicles you create for your superheroes, the one thing you really shouldn't be creating them for are car chases. Why do I say that? Well, tell me the last time you saw an extended car chase in a comic book, and I'm talking about the kind of thrilling, sitting-on-the-edge-of-your-seat car chase that you've seen in movies like *Bullitt*, *Mad Max*, or *The Fast and the Furious*. Go ahead. Think about it. Take your time.

Give up? Comic books aren't the appropriate storytelling medium for car chases (or sporting events or courtroom dramas, for that matter), and that's because the mechanics of comic book storytelling are incompatible with car chases. When you're watching an exciting car chase, did you ever think about *why* it's exciting? *How* it's being made to excite you? It's all about the camera work and the illusion of movement that the camera provides. Of course, you're not *really* moving when you're watching a car chase. You're sitting in a theater seat (or on a couch if you're at home) looking at an image on a screen. But the illusion of movement that's being provided by the camera work is so convincing that you can't help but get excited.

Comic books don't work like that though. When you're reading a comic book, it's not the comic book that controls the pace at which you read. *You* are in control of how quickly or slowly you read. And when you're reading a comic book, you're mentally connecting a sequence of static images. In other words, you're looking at pictures that don't move! Both of those factors mean the kind of excitement that's generated by a movie car chase can't be replicated in a comic book. A remarkably talented artist might be able to pull off a car chase for a page or two, but any comic-book car chase longer than that will only bore readers.

Team America *was a Marvel Comics series based on a motorcycle toy line. The comic book featured lots and lots of motorcycle races. No surprise then that the comic book had to be canceled after twelve issues.*

THE BEST USE OF VEHICLES

There are better storytelling uses for superhero vehicles than car chases. For instance, comic book writers often use vehicles not only to create action, but to also take a break from the action. To illustrate, let's imagine the Avengers all hopping onboard their favored means of rapid transportation—the Quinjet—in order to travel to a dire situation that requires their intervention. Ever wonder why the Avengers need a Quinjet in the first place? Couldn't Iron Man and Thor just fly the other Avengers over to where they needed to go? Or couldn't the group just run over to Dr. Strange's pad and ask him to magically transport them to their destination? The Quinjet just doesn't seem like a necessary vehicle for the Avengers when you think about it.

That is, unless the writer of the story wants to provide a period of downtime, a lull in the action to let the readers catch their breath before the action starts anew. During this downtime, the superheroes are together in a confined space, and they can't help but talk to each other. What the characters talk about can be just as interesting as the action they're headed toward. They can discuss plot developments, summarize the story for new readers' sakes, or just banter among themselves. Readers need to see the superheroes interacting so they can understand how they all relate to one another. There's no better opportunity for character interaction than when the superheroes are en route to a battle or disaster. So the next time you're reading a comic book and see superheroes assembled onboard a vehicle, pay attention to how the writer takes advantage of the break in the action.

SPACESHIPS

All this time I've neglected to mention the most extraterrestrial of superhero vehicles: spaceships! But in a way, I *have* been talking about spaceships because designing a spaceship is really no different than designing any other kind of vehicle.

The same rules apply: (1) Be unique, and (2) make sure the spaceship embodies the personality of your superhero (or superheroes if you're creating a larger starship) in some way. With regard to the first rule, understand that you are limited only by your imagination. Look at the spaceships designed for some of the most popular science fiction franchises on television and film: *Star Trek, Star Wars, Battlestar Galactica*. Each of these franchises is populated by many, many spaceships, all of different shapes and sizes. Despite the enormity of their fleets, none of their spaceships resemble each other or even resemble anything that preceded them.

If they can be original, you can too! There's no excuse for *not* creating something distinctive and unique. That's perhaps the most important lesson I can ever teach you.

The Colonial Viper from Battlestar Galactica is one of the most unique spaceship designs you'll ever see. Rather than duplicate the kind of spaceships shown in Star Trek or Star Wars or any other sci-fi movie, the Battlestar Galactica creators made sure to create something original and distinctive. You should do likewise!

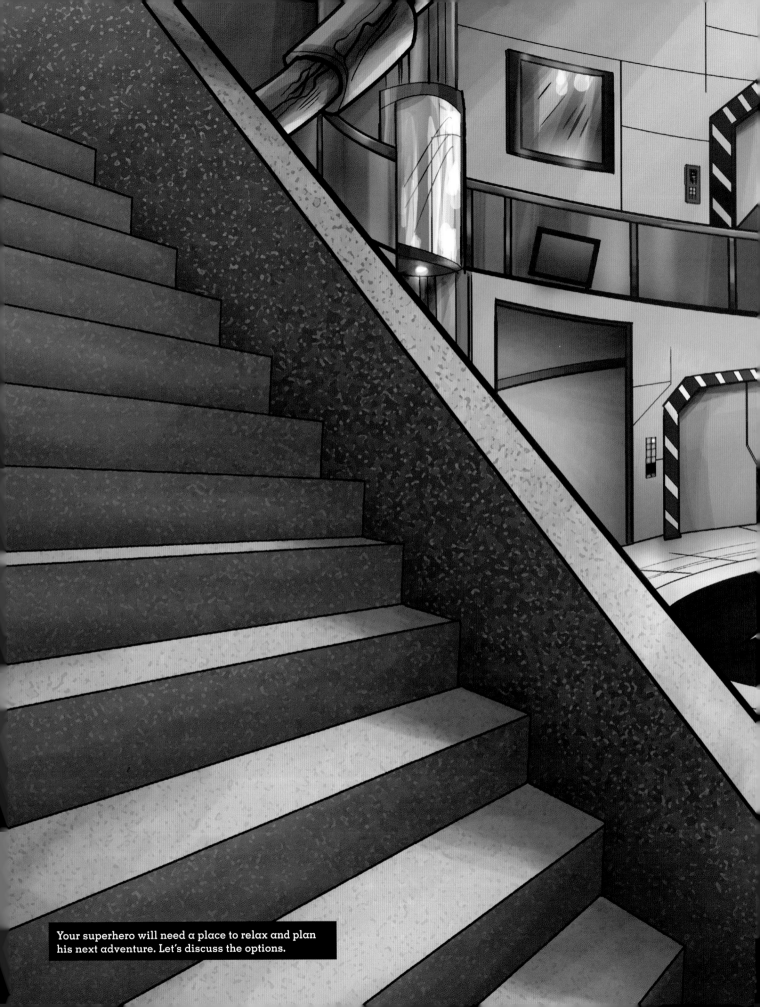

Your superhero will need a place to relax and plan his next adventure. Let's discuss the options.

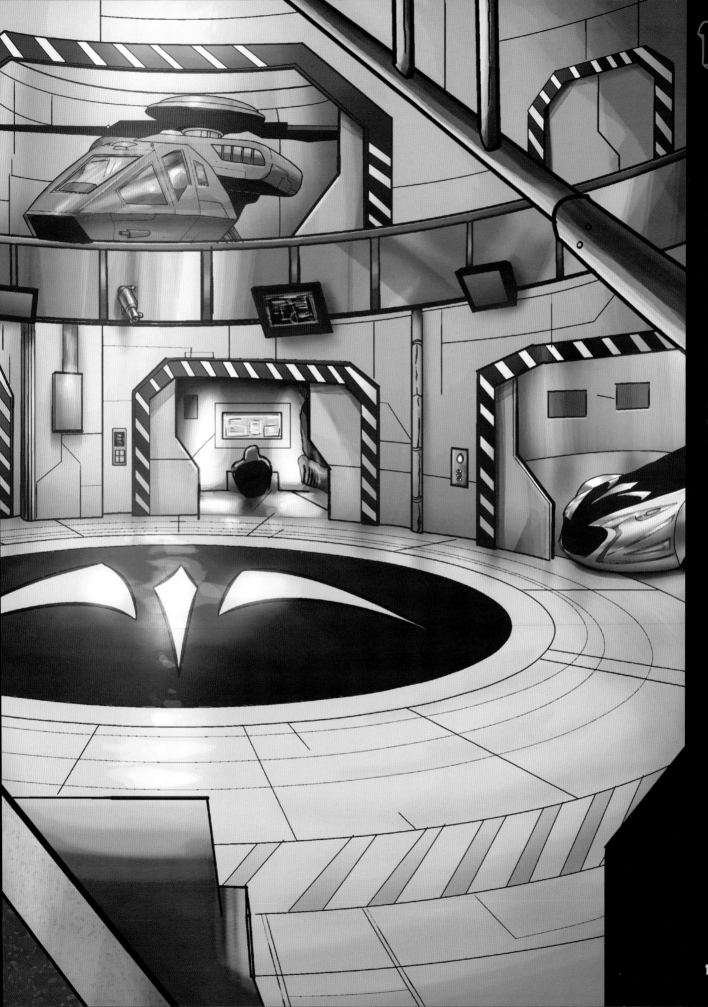

A PLACE TO GET AWAY FROM IT ALL

Where do you go when the stresses of everyday life get to be too much—when even the apps on your smartphone cease to provide any solace? (That was rather poetic of me, wasn't it?) Do you close the door to your room and scream? Get in your car and go for a drive? Go to the movies in the middle of the day? Everybody needs to get away at some point to recharge the ol' batteries and just have some quiet thinking time. Even superheroes.

Yes, even tireless do-gooders can't be on duty 24/7. Even they need a break—if not a vacation, then a place to chill and to map out, in peace and quiet, their next foray against injustice. They need a hideout.

TYPES OF HEADQUARTERS

The Marvel super-dupers have their share of happening hideouts (aka headquarters).

For instance, filed under "Basic," there's the desert cave the Hulk used to hide out in. It wasn't much to look at, but as any real estate agent will tell you, "Location, location, location."

Professor Xavier's Institute for Higher Learning would for sure qualify as a hideout as well as a headquarters. Its public face is that of an elite boarding school—when in truth, it's the X-Men's combination headquarters and training facility.

Doctor Strange's Sanctum Sanctorum would also be a hideout/HQ, since no one knows that the Greenwich Village townhouse it occupies is anything special aside from its unusual architectural design.

Then there's the Baxter Building, home of the Fantastic Four, although, since it is in midtown Manhattan, I'm not sure if it qualifies as a "hideout" so much as a headquarters. Ditto for Avengers Mansion, especially since it's known to all the tourists who gawk at it.

You could say the same for whatever pad Peter Parker inhabits at any given time, although its hideout section is usually a closet. But, hey, a hideout is a hideout, even if it does smell like mothballs!

The X-Men's former hideout—aka the Xavier Institute for Higher Learning—was hidden inside and beneath a mansion on Graymalkin Lane in Salem Center, New York.

New York's Cooper-Hewitt National Design Museum on Fifth Avenue is housed in what had been the Andrew Carnegie Mansion. It's the type of building that inspired the look of the superhero hideout/headquarters, Avengers Mansion.

THEMATIC CONNECTION

Your superhero most likely already has an apartment or a house for his civilian identity. His hideout is more workplace than dwelling. It's where he or she goes to focus on how to be the best superhero possible. You could also think of the hideout as a business's headquarters. Everything in it should reflect the superhero's "brand." By that, I mean that the place should be filled with cool-looking items that reflect your hero's past, friends, philosophy, and preferences in gadgets and weaponry. It should also reflect your hero's personality and, if possible, the themes that dominate the hero's life and mission.

Thinking this way means that if—or rather *when*—your hero becomes a huge hit across multiple media platforms, you'll have a ready-made supply of items that can be adapted from your comic to become toys, games, rides, and so on! And all because *you* were foresighted enough to design a hideout that echoes the theme of your hero's adventurous life! You're a genius—as well as rich and good-looking!

The Phantom's hideout is Skull Cave, as seen here in Dynamite's The Last Phantom #10. *Its name (and exterior shape) reflects the character's regular use of a skull theme.*

CREATING THE HIDEOUT

For this lesson, you're going to create a spread. It'll be a really large drawing. Think of it as akin to drawing a map or architectural diagram of a large space: an airplane hangar, a ballroom at a hotel, a school gymnasium—something big and airy. But the hideout should be dramatically lit—there should be shadows all over everything. You might even think of it as taking place at night, since the B-Type's secret lair, hidden from plain sight, is illuminated by stark, bold lighting to make the place—and the things and people inside it—look as stark and dramatic as possible.

"Wait a second, Stan!" I hear you cry out in confusion. "Are you now telling me that part of my job as a super-hero creator is to be an *architect*?"

Well, yes . . . and no. You *are* designing a space, which is what architects do. The good news here is that your designs only have to give the *illusion* of being functional. No one's going to build them in the real world.

IT ALL STARTS WITH THE CONCEPT

Let's take a look at the process of creating your hero's hideout. In this instance, the hideout you're creating should belong to a B-Type hero like Searchlight. Remember, the hideout should, ideally, reflect the hero's main imagery.

There are no hard and fast rules for hideouts beyond the fact that they have to function as spots where heroes can be alone (or in the company of trusted allies) to do what they have to do so they can keep doing their hero thing. As you might expect, the state of a hero's hideout has a lot to do with his or her financial state. If the hero has access to great wealth, then he or she can trick out a huge space with the most cutting-edge doohickeys and can store all sorts of weaponry and memorabilia in it. If the hero's living hand-to-mouth, or even has a decent-paying day job that doesn't leave much room for luxury, then he or she'll be lucky if he has a large closet or a basement to keep spare costumes in.

Since this chapter isn't about how to draw closets, I'll assume Searchlight has access to oodles of cash and brilliant scientific and technological brains (probably his own, mostly), to design, build, and transport the stuff that will be in his hideout.

Let's figure Searchlight's hideaway is a warehouse that he owns, through several shell corporations, in an industrial section of town. Since he owns the place, there's nobody working at the warehouse, and he stores lots of large crates that are mostly empty but give the impression of a business in operation.

The *real* heart of the hideout is in the basement, which is large—approximately 100 feet wide and 80 feet long, with 20-foot-high ceilings. Please note, though, that in comics, the dimensions of the hideout can expand as needed to accommodate objects or story points. You're not dealing with real-life space; you're dealing with *imagined space.* Could you fit a skyscraper in the hideout? Of course not—that would be beyond any reasonable suspension of disbelief. But could you fit, say, a fleet of trucks? Sure, no problem.

The Green Hornet's secret hideout isn't too shabby.

DRAWING THE HIDEOUT

Here are the steps for drawing a dramatic spread of Searchlight's spacious hideout, the Fighting Fortress. Don't get too worked up about doing a spread—yet! For something this large, you might want to work out the drawing in thumbnail sketches on sheets of 8½ x 11-inch paper and then blow the best one up to full size and do the pencils and inks from that. (Some of you have probably been working that way all along, anyway.)

In the next chapter, you're going to draw spreads with a whole mess of characters in them. But you can worry about that later. Right now, let's just draw a hideout!

The Fighting Fortress is essentially a large room, one the size of a public space— say the lobby of a skyscraper office building or a restaurant banquet room.

Here's where you define the contours of the space and also fill it up with all sorts of cool stuff. Make up your own wild gadgets and decor, too!

In this stage, you add detail to the basic construction you just did. Make sure to indicate light sources that create dramatic shadows.

The inking should simultaneously make clear what each of the objects is, and should also heighten the moody shadows—but without obscuring details.

The Fighting Fortress

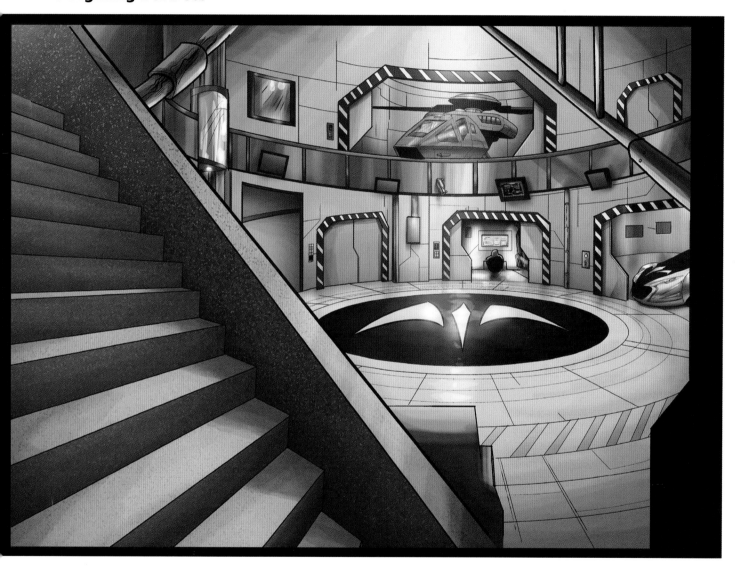

THE FIGHTING FORTRESS

Attributes: A safe haven for all superheroes to gather before they fight their villains and monsters.

HELPFUL HIDEOUT DECORATING TIPS

And now, your bighearted Uncle Stan's gonna give you some suggestions for the kinds of features you'll want to include in the hideout you're designing. The hero is going to outfit the pad with objects specific to his or her skills, history, and personality. You'll figure out the overall look and contents as you develop your hero's powers and backstory. But here's a list of some features just about every hideout/headquarters bigger than a studio apartment will most likely have some or all of:

COMMUNICATIONS CENTER

This area will have multiple computers and flat-screen monitors, covering events in cities all over the globe, maybe even out in space.

WEAPONS AND GADGET CENTER

Here's where we'll find mostly sci-fi-looking hi-tech gadgets, as opposed to a conventional arsenal. Coolness should trump practicality.

LIBRARY

Yes, most everything is digital now. But have *you* thrown out all your books? Neither has your hero. There should be literally thousands of books. You can imply this; no need to draw every book!

TROPHY AREA

Here's where Searchlight keeps memorabilia from adventures he's been through. Batman famously has a giant penny and a full-sized statue of a dinosaur in his cave. Come up with something outlandish and cool-looking for *your* hero.

MEMORABILIA AREA

This is where our hero keeps personal memorabilia—cherished items relating to his or her origin or family, perhaps—on display.

GARAGE

This zone houses our hero's nifty transportation, possibly several different kinds. Imagine your dream cars—and then multiply their coolness factors by ten!

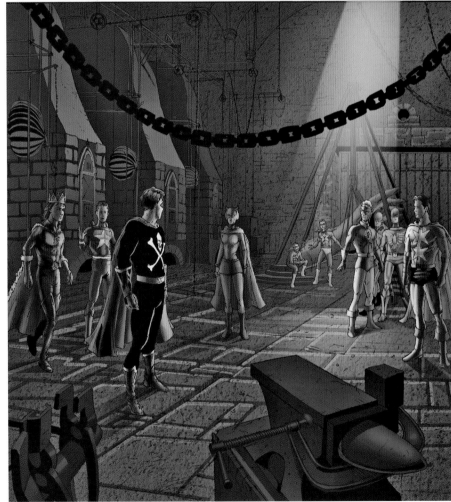

Look at all the antiquities in this hideout.

HANGAR

Searchlight's got at least one kind of flying vehicle—plane, chopper, jetpack, and/or something else altogether. And there's got to be an exit of some kind, so he can actually get his flying machine out of (and back into) the place!

GYM

This physical fitness area should be outfitted like the most expensive private health club, with all the latest weight training and cardio equipment.

ENTRANCES (AND EXITS)

There should be some clearly shown way that the hero gets into and out of the hideout, whether on foot, or coming or going via car or plane. No one may notice it in this overall drawing—but you sure will when you're drawing a story in which the hero has to get into or out of your spiffily designed hideout!

Special Assignment!
Here's something that I think can really help you with the whole hideout thing:

Take a walk around your neighborhood and go to some big, indoor, public places—museums, restaurants, theaters, health clubs—and see how large spaces and the objects in them look and feel. Get a sense of real-world perspective. Take some photos to use for reference, from as many different angles as you can. I'll wait while you do that.

And don't forget to use a bookmark so you can meet me right back here!

The revelation of a superhero's hideout can often make for a jarring experience for readers—and the character who discovers it!

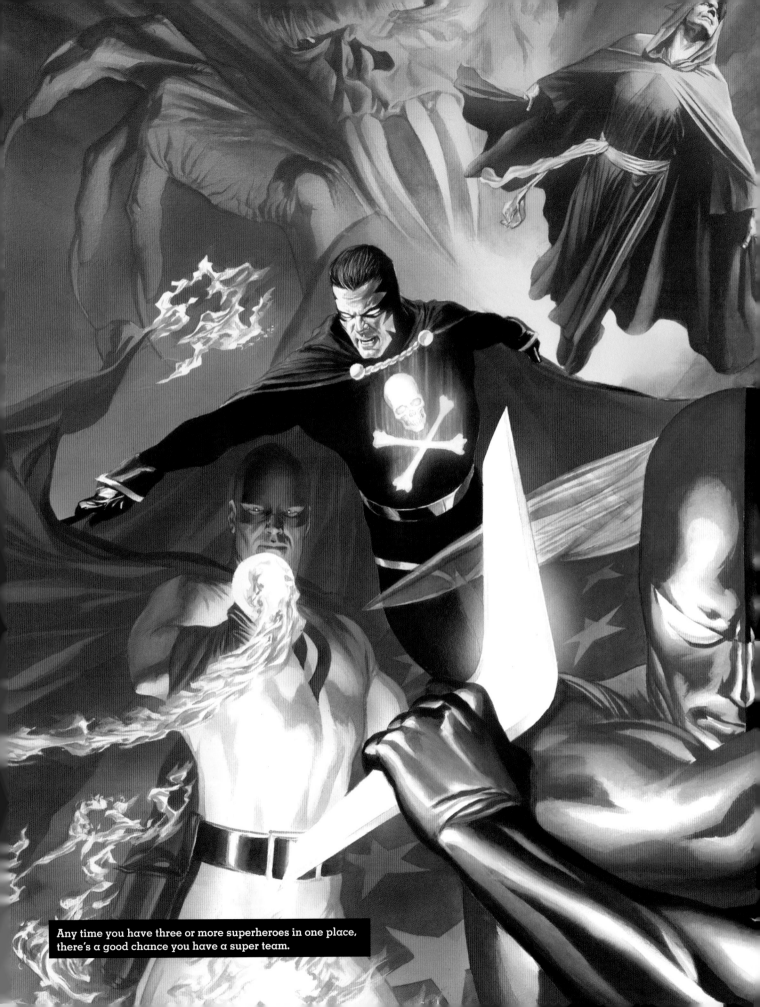

Any time you have three or more superheroes in one place, there's a good chance you have a super team.

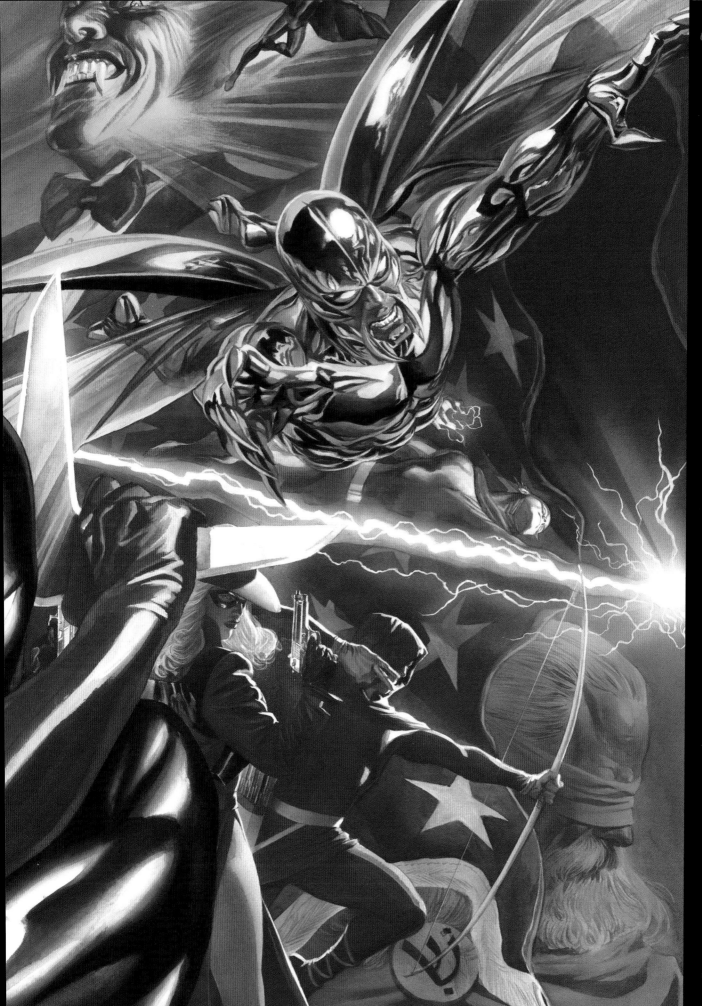

PUTTING TOGETHER YOUR TEAM

People love the idea of a team, whether it's in sports or adventure stories, as much as they dig the concept of a solo hero going it alone or of a "buddy team" pairing up to fight the good fight. Teams fulfill different entertainment needs and enable readers to play out different kinds of fantasies. Teams are a lot like families—except they're families that you get to choose!

During my years at Marvel, I gained a "team" that consisted of various combinations of writers, artists, editors, support staff—and for a short period in the 1950s, it consisted pretty much of just me, keeping things together while the comics industry rode out some rough times.

Through it all, I always tried to keep up the image of Marvel as a *team*, which I dubbed the Marvel Bullpen. (That's an expression I borrowed from baseball, where pitchers warm up in an area called the bullpen.)

THE WINNING TEAM

Even when the Marvel artists all worked from home and the part of the office referred to by staffers as "the bullpen" was populated mostly by people doing art and lettering production work, I still wanted to make people have the sense of Marvel as a figurative, if not literal, bullpen; that the people making the comics were part of a *team*. And that the *readers* were on that same team, not just rooting for us but, in some indirect way, responsible for the content of the comics they loved. It's like when you

root for your school basketball team or your hometown baseball team; you get so emotionally involved that their victories—and defeats—become yours.

And that's the way it is with superhero teams. Whether it's the Avengers, the X-Men, or the Fantastic Four—people love to read about teams. All those colorful characters cavorting about! All those plots and subplots! The intrigue! The romance! The back-and-forth dialogue! You really feel like you're getting a heckuva lot when you're reading about a superteam!

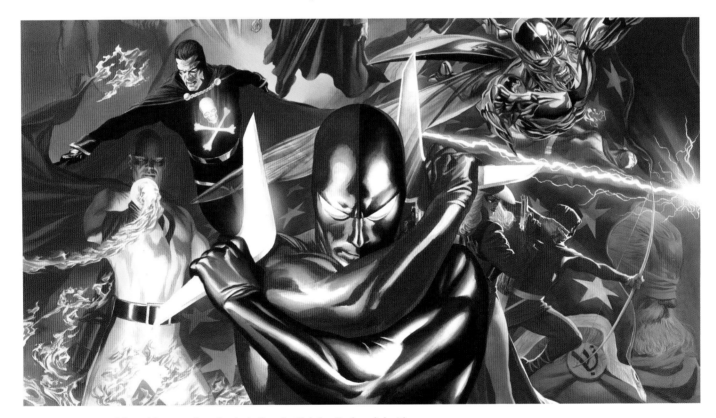

Great superheroes of the golden age of comics, including the Fighting Yank and the Flame, came together in Dynamite's Project Superpowers #0 *to form a team of superheroes, as shown in this dynamic cover by Alex Ross.*

GOOD NEWS AND BAD NEWS . . .

For writers and artists, there's good news and bad news when it comes to creating superhero teams.

The *good* news, of course, is that it's exciting and creatively stimulating to write and draw stories about the interactions, both physical and psychological, between groups of powerful and fascinating characters. When you're hitting on all cylinders, there's no greater thrill than making superhero team comics.

The bad news is that it's a lot of work. I mean, in a given battle between a team of superheroes and supervillains, you sometimes literally need a scorecard to see who's in what condition and where they are on the landscape. Plus, you have to develop multiple characters and plotlines in the same amount of space you would use for a solo character's adventures.

But what's worth striving for that isn't challenging? (And besides, with lots of characters, there are fewer backgrounds to draw!)

SUPER TEAM ORIGINS: REAL WORLD AND FICTIONAL

From a business standpoint, the reason for forming a superhero team is usually commercial. "Hey, these characters are popular on their own! Imagine how popular a mag with *all* of them would be!"

The exceptions to the "more equals more" approach are teams that *start out* as teams—and then have individual heroes eventually spin off into their own solo series. *The Uncanny X-Men* and *Fantastic Four* comics both debuted with all-new heroes (although the Human Torch was based on the 1940s and '50s hero of the same name). Eventually Wolverine and other X-Men (and women) got their own series and miniseries. Ditto for the Human Torch and the Thing of the FF.

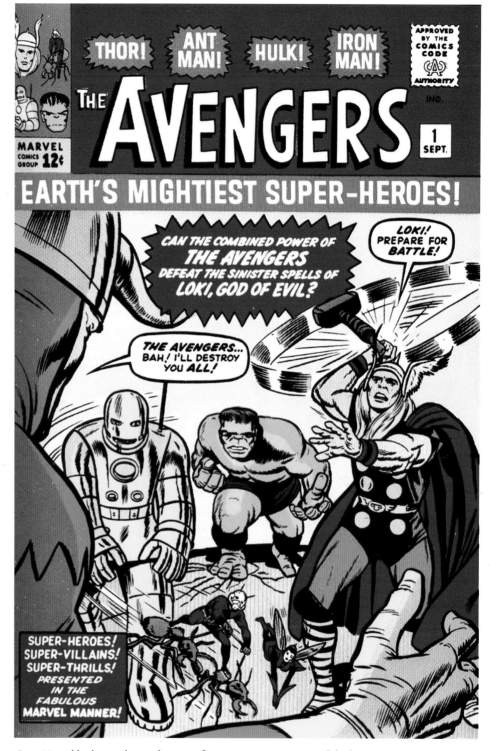

Once Marvel had enough superheroes to form a new super team, we did. The Avengers got together for the first time in—wouldn't ya know it?—Avengers #1! The art is by the titanic team of Jack Kirby and Dick Ayers!

WHAT'S THE MAGIC NUMBER?

So what's the optimal number of members a super team should have? Well, some say that four is *fantastic*, while others think that six is *sinister*. The real answer is: whatever number works for you and the stories you're burning to tell. And don't forget, a team can have a zillion members—like the X-Men or the Justice League—but not everyone has to show up for every adventure.

For the purpose of this chapter, which is the summation of all you've learned from studying this titanic tome, I'm going to request you draw a couple of different scenes (a group shot and a battle tableau) with a team made up of—don't hate me—*eight members*.

Wait! What was that thudding sound?

Oh—I hope you didn't hurt yourself when you blacked out! Come on, take a whiff of these smelling salts and get back to the drawing board! You want to get your time and money's worth out of this book, don't you? Well, drawing a super team is where you get to put together all the things you've been practicing between chapters. (You *have* been practicing between chapters, haven't you?) And if you drew that supporting cast a few chapters back, then you've *already* drawn a group. And what is a team but just another kind of group?

See? You're halfway there already and you haven't even picked up a pencil.

TEAM CHALLENGES

Here are the members of the team I want you to put together:

- Captain Titan
- Searchlight
- Miss Mechanix
- Lady Locke
- The Devourer
- Scandalous
- Big Boy
- The Dark Hood

Yup. That's eight characters, all right.

Now, of course, drawing the team is going to be challenging, but for different reasons than you might think.

Over the course of this book, you've already designed a bunch of nifty superhero and supervillain characters.

You've learned to draw them at rest and in motion, in their super-identities and their civilian guises, in battle with supervillains and chilling with their supporting casts. But now, more than ever, you have to focus so you can draw a super team.

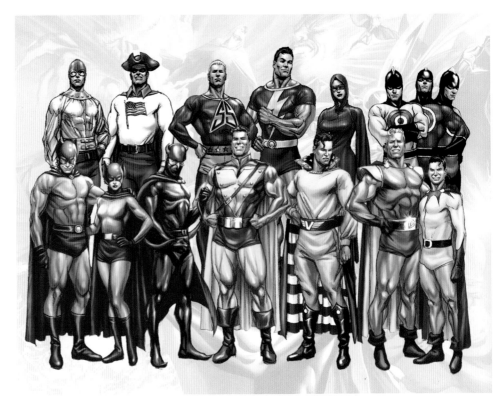

Many super teams get a group picture taken to preserve a particular era for all time.

SMILE FOR THE CAMERA!

For the team pinup shot, you have to ask yourself these questions about the drawing:

- How do you arrange the characters in the space?
- How do they each show off their powers?
- How do you design this mass of superhumanity so it's pleasing to the eye and not chaotic?
- How do you determine who's closer to the reader and who's further back?
- How do you visually indicate who the leader is or—if there isn't one—that they're all equal? (To answer this, generally, the larger the figure, the more important the reader will see them as being. So the leader will often be front and center.)

Now that you're thinking about all these considerations, let's get down to brass tacks. (Whatever that means! Seems that people are always getting down to them, though, so who am I to argue?) We're going to do this group shot as a spread (oh, calm down! You can do it!) and we'll have it set in the B-Type hero's hideout that you designed and drew in the previous chapter. This will serve as your team's headquarters.

What's in a Name?
You should come up with a nifty name for your team, something snappy like, say, the Stansters. Or maybe not. Whatever you decide to call them, the name will help you figure out the look and feel of the group.

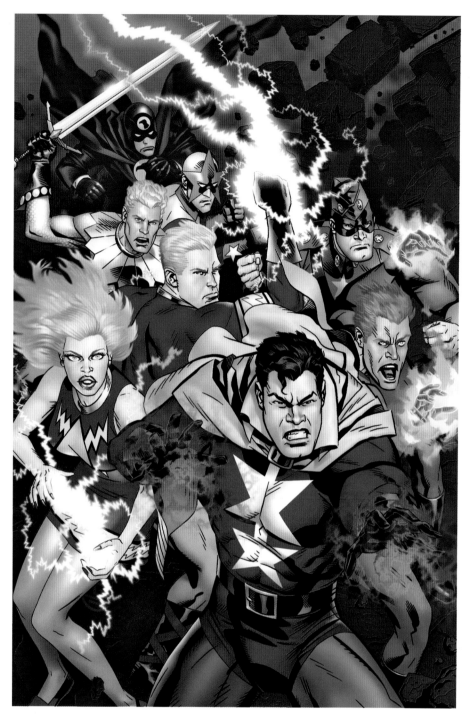

Here's an example of a super team in action.

ADD SOME ACTION

And because I'm not giving you *enough* to deal with here, let's have the characters interacting with the items in the section of the hideout they're posing in. What do I mean by "interacting"? Well, one team member could be standing atop a piece of equipment, another could be dangling from some cables near the ceiling, another could be leaning against Searchlight's vehicle. And so on. Ideally, you'd want each one using his or her powers or gimmicks in some way, but in a group shot, that's not always possible for every character. If nothing else,

each character should be posed in a way that conveys his or her attitude! (Remember we had a big discussion about attitude in chapter 2?)

Now, you may not get all this into your team drawings, especially the early ones, but you should be thinking about these things at least a little.

For inspiration, you might want to use the shot of the 1990s X-Men below. For more inspiration, you have your own comics, and of course, the ever-intriguing Internet. Look at classic movie posters about groups and teams, as well as comics.

More Things to Consider
To get to know—and therefore show—more about your team, you should also ask yourself things like:

What brought them together? Do they like each other? Are they jolly and boisterous or grim and gritty? Or are they a mix of different attitudes? Are any of them romantically involved with each other? Did they elect a leader? Did one of them appoint him- or herself the leader? Or do they have no leader at all, and so have a sort of chaotic vibe?

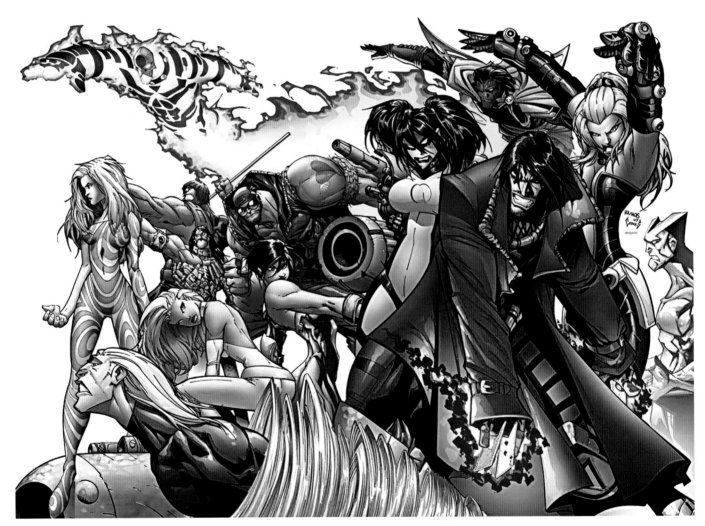

Here's a shot of a version of the X-Men from the 1990s. Note how, despite the many members of the team, each one can be clearly seen, and many of them are displaying their superpowers.

THE GROUP SHOT

Okay, let's get down to drawing that super team of yours!

Here's where you work out the basic poses of the team members, as well as the section of the hideout they're in. You'll probably have to do several versions until you feel it's working. Since some of the types are similar to each other, body language and attitude will be as important in differentiating them as their costumes.

You might want to do a basic drawing of each character on a separate piece of tracing paper, then you can move them around until you get just the right design.

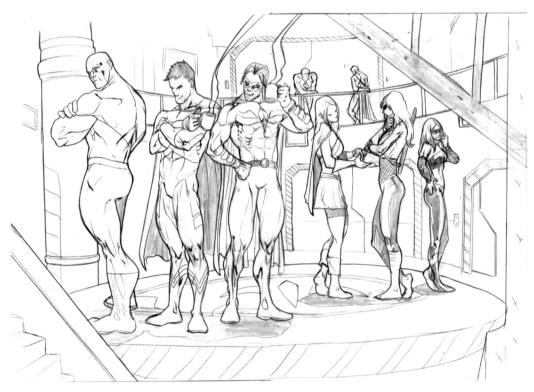

Once you have the figures posed and situated the way you want, tighten up the pencils.

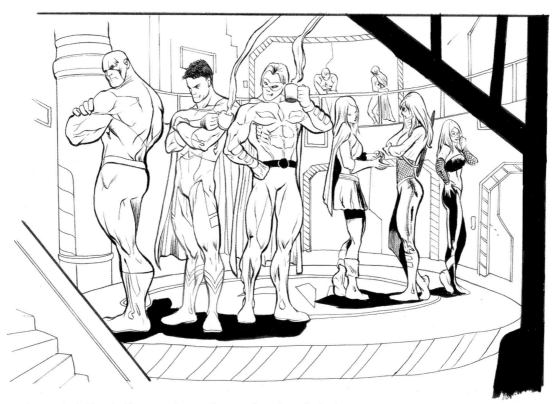

When you're inking the figures, make sure they stand out from the background and from each other.

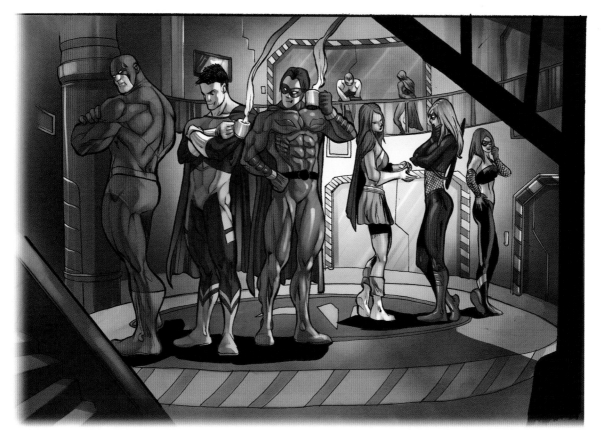

The color version is where you have another chance to establish depth in space. If one character is colored too much like one he or she is in front of, you might have to move some figures around.

SUPERHEROES VS. SUPERVILLAINS

Face it—your super team may look cool, but they won't spend all their time posing for pictures. Nope, they have a mission: to fight supervillains. And that's what you're going to draw—as another spread—your super team in battle with Mario Mans and Cheex.

I can imagine the relief you're feeling—all you have to draw is two supervillains. Well, that's true, but . . .

(Don't you love it when I add a "but . . ." to a sentence. You just *know* something great is coming up!)

But . . . let's face it, eight heroes against two non-superpowered villains? What kind of a battle is that? The good guys have the bad guys outnumbered *four to one!*

Oh, did I neglect to tell you about the *weapons* that the baddies have? I knew I forgot something!

IMAGINATION UNLEASHED!

Well, here's another place where your imagination can run wild. The heroes will have their established (by you) powers and technology. But the villains should have stuff that makes them *overwhelming.* You might put Mario Mans in a high-tech tank with plasma beams blasting from several turrets! How about if Cheex was in a robot exoskeleton that echoed his theme and personality and that was firing

projectiles and grenades? Go to town! Despite the fact that there are two villains and eight heroes, the feeling should be that the heroes barely have a chance.

I'd strongly recommend you go the thumbnail route here, as well. Figure out your image's design before you start drawing at full-size and in detail.

So what are you just standing there for? It's action time!

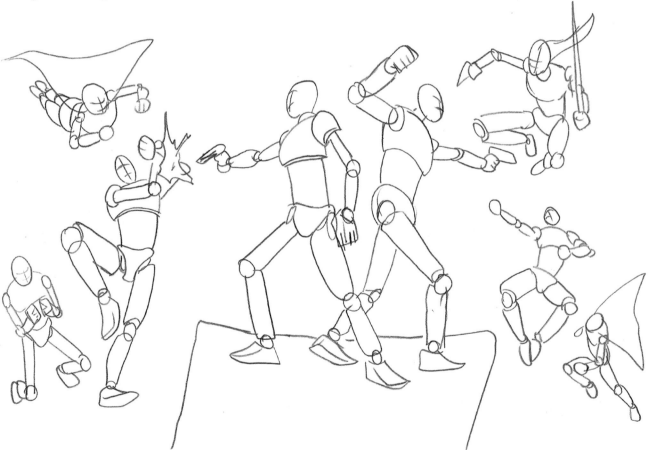

Figure out the best angle for this scene.

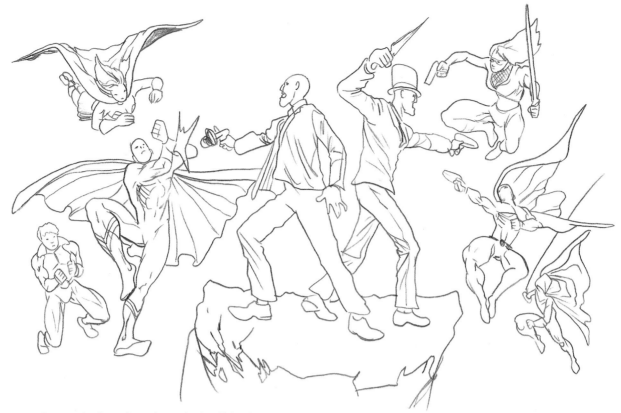

Once you've figured out the angles for all the characters, start adding
dimension to them. Remember the basics: circle, square, triangle.

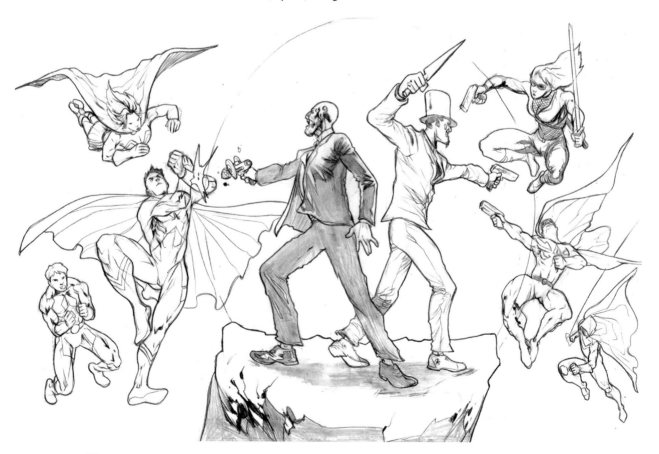

As you fill in details in the pencils, the scene should really come to life. It should feel like
something out of the most special-effects-filled movie you can think of.

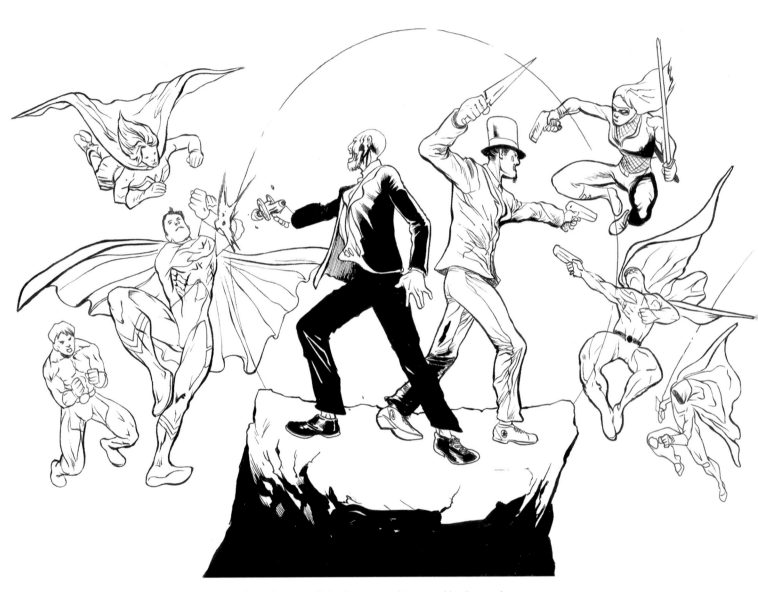

Inking this scene is going to be really tricky given all the characters, objects, and background details involved. Do the best you can on this one. You'll be doing plenty more over time.

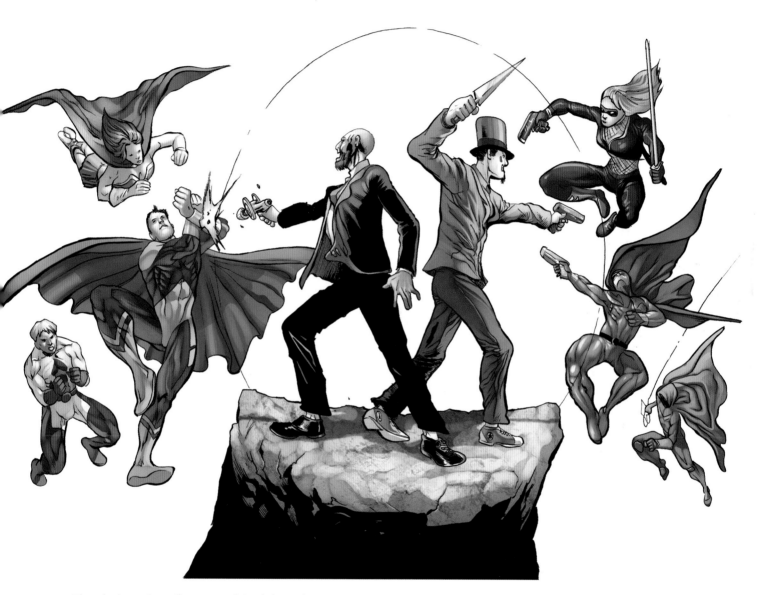

The color has to be really strong and simple here. There's too
much going on to get real fancy.

YOU'RE DONE—NOW GET STARTED!

Well, you made it. Here you are at the end of the lessons in this book. But I bet that now that you've gotten here, you're probably looking back at what you drew for the earlier chapters and thinking, "That's okay, but I could do much better now." You might even consider repeating the lessons and exercises, starting from the beginning of the book. Indeed, that's what a career as a superhero artist and creator is about: keeping at it so you get better and better.

If you get good enough, someone may even pay you to learn on the job. Notice how the art of your favorite artists improves over the course of their careers. Artists never stop learning and growing. Of course, since your aim is probably to tell superhero stories, you'll need to at some point get out your copy of *Stan Lee's How to Draw Comics,* and start doing panel-to-panel storytelling with the superheroes and supervillains you've designed. (Did you really think I'd get to the end of this titanic tome without plugging just one more thing?)

After all, making comics isn't just drawing single illustrations, no matter how nifty they are. It's doing a series of great illustrations that tell a story.

But for the moment, give yourself a well-earned pat on the back. Go say hello to your friends and family, who probably haven't seen you all that much since you started studying this book, stop and smell a rose or two, and relax! But not for too long. Soon it'll be time to sharpen those pencils and get back to work!

I look forward to seeing your superhero comics on the racks at my friendly neighborhood comics shop or even in the brave new digital world! Until then, what can I say but . . .

Excelsior!

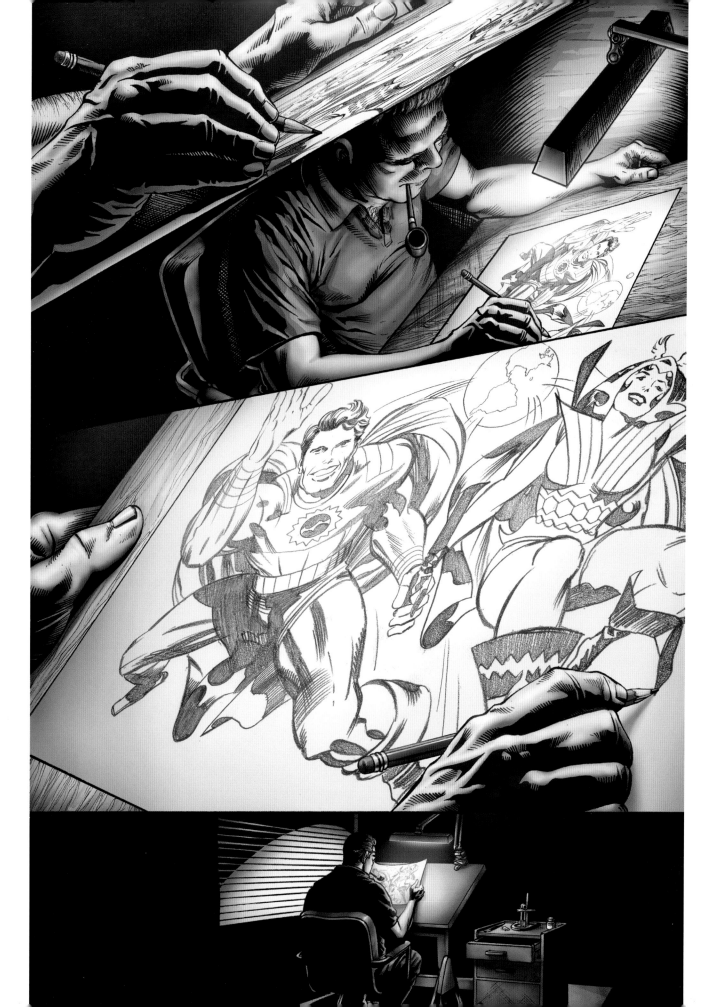

SUGGESTED READING, WEBSITES, AND SUPPLIERS

READING

GENERAL ART TECHNIQUE

Bridgman's Complete Guide to Drawing from Life by George B. Birdgman (Sterling, 2009)

Digital Prepress for Comics: The Definitive Desktop Production Guide, Revised Edition by Kevin Tinsely (Stickman Graphics, 2010)

Drawing Dynamic Hands by Burne Hogarth (Watson-Guptill, 1989)

Drawing the Human Head by Burne Hogarth (Watson-Guptill, 1989)

Dynamic Wrinkles and Drapery by Burne (Watson-Guptill, 1995)

Facial Expressions: A Visual Reference for Artists by Mark Simon (Watson-Guptill, 2005)

Human Anatomy for Artists: The Elements of Form by Eliot Goldfinger (Oxford University Press, 1991)

Perspective! For Comic Book Artists by David Chelsea (Watson-Guptill, 1997)

Re-Inventing Comics: How Imagination and Technology Are Revolutionizing an Art Form by Scott McCloud (Harper Paperbacks, 2000)

Understanding Comics: The Invisible Art by Scott McCloud (Harper Paperbacks, 2000)

MORE ABOUT STAN LEE

Bring On the Bad Guys by Stan Lee (Simon & Schuster, 1978)

Excelsior! The Amazing Life of Stan Lee by Stan Lee and George Mair (Fireside, 2002)

How to Draw Comics by Stan Lee (Watson-Guptill, 2010)

How to Draw Comics the Marvel Way by Stan Lee and John Buscema (Fireside, 1978)

How to Write Comics by Stan Lee (Watson-Guptill, 2011)

Origins of Marvel Comics by Stan Lee (Simon & Shuster, 1974)

Sons of Origins of Marvel Comics by Stan Lee (Simon & Shuster, 1976)

Stan Lee and the Rise and Fall of the American Comic Book by Jordan Raphael and Tom Sturegeon (Chicago Review Press, 2004)

Stan Lee: Comic Book Genius by Steven Otfinoski (Children's Press, 2004)

Stan Lee: Conversations by Jeff McLaughlin (University Press of Mississippi, 2007)

Stan Lee's Amazing Marvel Universe by Roy Thomas and Stan Lee (Sterling, 2006)

WEBSITES

www.comicbookresources.com
www.dccomics.com
www.dynamite.com
www.marvel.com
www.newsarama.com

SUPPLIERS

COMIC BOOK AND MANGA ART BOARDS

Blue Line Pro
www.bluelinepro.com

Canson Fanboy Comic Paper
www.fanboypaper.com

Eon Productions
www.eonprod.com

PERSPECTIVE GRIDS AND ECONOMICAL LARGE-FORMAT SCANNERS

Art & Comics Store
www.artandcomicstore.com

ART SUPPLIES

Dick Blick Art Materials
800-828-4548
www.dickblick.com

Michaels
www.michaels.com/art-supplies

Jerry's Artarama
800-827-8478
www.jerrysarartarama.com

Pearl Paint
www.pearlpaint.com

Rex Art
800-739-2782
www.rexart.com

Utrecht Art Supplies
www.utrechtart.com

INDEX